For Lin Onus

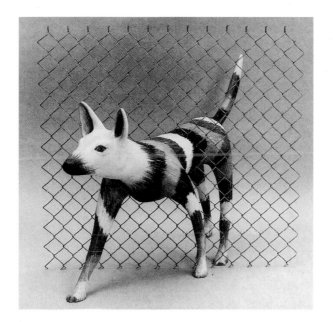

CONTEMPORARY ABORIGINAL ART

SUSAN McCULLOCH is *The Australian* newspaper's visual arts writer and the co-author (with her late father, the critic Alan McCulloch) of Australia's major art reference book *The Encyclopedia of Australian Art*. She has had a long-standing, passionate interest in the art of Aboriginal Australia and travels as often as possible to the remote regions of the country. In her work as *The Australian*'s visual arts writer, she has also helped put on the public agenda some of the issues surrounding Aboriginal art.

FRONT COVER: This dramatic photograph was taken in 1995 by Penny Tweedie, who documents modern Aboriginal life. The strength of the hand and sureness of touch by famous Utopia artist Emily Kame Kngwarreye is clearly demonstrated.

BACK COVER: Lin Onus, *Barmah Forest* (detail), 1994. This painting won Onus the Aboriginal Heritage Award in 1994. It has a strong emotional impact with its beauty and message of a 'jigsaw' piece missing from the lives of many indigenous peoples.

Contemporary
Aboriginal Art

A guide to the rebirth of an ancient culture

Susan McCulloch

ALLEN&UNWIN

PAGE ONE: Lin Onus, *Dingoes; dingo proof fence* (1989), detail from the series *Dingoes*.

PAGE TWO: Michael Jagamara Nelson, *Wild Yam* (1989), from the Western Desert.

FAR RIGHT: Bob Burruwal, *Walka-Fish at Bolkjdam* (1997), from Maningrida in Arnhem Land.

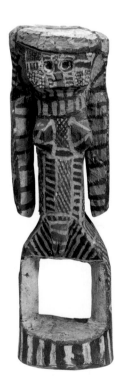

ABOVE: Enraeld Djulabinyanna, *Bima's Friend* (c. 1955), from Melville Island.

ACKNOWLEDGMENTS
The author would like to thank the following people for their assistance and support in the preparation of this book. The family of the late Lin Onus, whose encouragement and advice meant so much to the shaping of the book in its early stages; Barbara Beckett, who is so much more than an excellent designer—without her understanding of the concept of this book and the enterprise to bring it to fruition, it may well not have existed; Patrick Gallagher, of Allen and Unwin, for his faith and support; Siobhan O'Connor, for her consummate editing skills, Margo Neale, curator of indigenous art whose professional expertise and personal encouragement is, as always, valued highly; Sotheby's auctions for their generous supply of transparencies and especially their Aboriginal art director, Tim Klingender; Anthony Wallis from the Aboriginal Artists Agency; the many community art coordinators who have been extremely supportive; Emily McCulloch Childs who helped research the new edition; gallery directors who supplied transparencies, in particular William Mora from William Mora Galleries, Bill Nuttall from Niagara Galleries, Christopher Hodges from Utopia Art, Gabrielle Pizzi from Gallery Gabrielle Pizzi, Alison Kelly from Alison Kelly Gallery Melbourne, Kevin and Jenny Kelly from Red Rock Art, Kununurra, the staff of Aboriginal Gallery of Dreamings, Melbourne and Peter Harrison from Kimberley Art. Robert Edwards and Dick Kimber gave generously of their time in interview—their knowledge and expertise is much appreciated.

And, most importantly, the artists of Aboriginal Australia, without whom this wonderful art movement would not exist.

First published in 1999. This edition published in 2001.
Copyright © Susan McCulloch 1999, 2001

Allen & Unwin, 83 Alexander Street, Crows Nest, NSW 2065, Australia
Phone: (61 2) 8425 0100, Fax: (61 2) 9906 2218
E-mail: info@allenandunwin.com Web: www.allenandunwin.com

National Library of Australia Cataloguing-in-Publication entry:
 McCulloch, Susan.
 Contemporary Aboriginal art: a guide to the rebirth of an ancient culture
 Bibliography.
 Includes index.
 ISBN 978 1 86508 305 6

1. Aborigines, Australian—Art. 2. Art, Australian—Aboriginal artists. I. Title.
704.039915

Designed by Barbara Beckett and map artwork by David Carroll and Colin Seton
Edited by Siobhan O'Connor and index by Barbara Crighton
Set in Janson Text by Barbara Beckett Publishing Pty Ltd
Printed in China
10 9 8 7 6 5

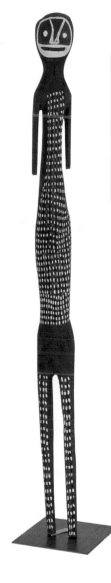

CONTENTS

In 1963, anthropologist Professor Elkin wrote in the foreword to one of the first comprehensive books on Aboriginal art—Karel Kupka's *The Dawn of Art*, that:

There is an aspect of urgency about this work for contact with the commercial world threatens rapidly to take the soul of northern Arnhem Land art.

Similar sentiments motivated a number of patrons of Aboriginal art, particularly from the 1950s and into the 1970s to collect Aboriginal art with a kind of salvage mentality, believing that the government's assimilationist policy would be successful in wiping out Aboriginal culture entirely. Remnants of the visual culture therefore needed preservation in museums like fossils of a bygone age.

Commercial interest, though sporadic until the late 1980s, was seen to contaminate this cultural production, as Aboriginal artists responded to the needs and interests of an audience outside the culture.

In fact, it would appear that since the 1970s these commercial interests have been the catalyst by which artists have been stimulated to find new ways to continue encoding cultural traditions in the visual form. Art became the means by which the soul could remain whole while the body was under threat.

So great has been the production of art and artefacts that, within one generation, there now exists an urgent need for the production of a guide book such as this to assist the enthusiast to negotiate the complexities of the now extremely diversified and dynamic terrain of art that extends far beyond Arnhem Land.

The multiple strains of art which have evolved reflect the different types of pressures Aboriginal groups from diverse regions are subject to and the manner in which they adapt old stories to new materials and changing circumstances. Art has became for many a liberating process in which strategies of resistance and accommodation enabled an active indigenous presence to survive in an environment where the processes of preservation through museum-style collecting ironically invited cultural domination and appropriation.

Contemporary Aboriginal urban artists from the 1970s, in particular, embarked on a process of indigenising the colonial experience and penetrating white art spaces in an effort to make visible the right to be an Aboriginal artist. As the author of this

book notes: 'Western notions of aesthetics are rarely the prime motivation of Aboriginal artists.'

Susan McCulloch's interplay of text and image, interwoven with artist's voices, floating quotes and accessible, informative text, logically leads the reader into discovering those more pressing motivations such as connections to Country, political intent, cultural revival and maintenance. Works of art are seen to be both sites of negotiation and arenas for ceremonial activity revealing the nature of tradition and change. This book is therefore more than a guide book, or at least a guide book to much more than art objects. Rather, it is a unique mix of art and guide book covering art from some twenty different regions. Not only are the numerous stylistic differences clearly attributed to the vastly different Australian landscape, but they are also attributed to the historic circumstances and the emergence of individual artists. McCulloch is careful to reinforce the cultural themes which unite Aboriginal people across time and place, while clearly avoiding homogenization.

The book constantly acknowledges a commitment to the view that, as with all things alive and thriving, this art, like the culture it represents, is organic and evolving. Buyers or appreciators need not fear stepping out of the bounds of the familiar or the stereotypical art form, but instead are encouraged to see the cultural intention behind the experimental and the new. For it is this adventurousness on the part of consumers that allows, for example, the Papunya artist Michael Jagamara Nelson, known for the Parliament House forecourt mosaic and the epic Sydney Opera House mural, in new 1998 works (page 2), to step outside the classical traditions of Desert art—as the familiar dot and circle style has become known—and produce works of a modernist appearance. Brilliant colours extend his colour register beyond the earth colours to create almost neon effects; energetic gestures are swiped across minimal surfaces in the retelling of the stories related to the wild yam lightning stories. Nelson is exercising the right to do what non-Aboriginal artists and his urban counterparts do in pioneering new artistic regions—a right ironically denied, through market expectations, to many artists from remote areas. These artists have historically been pigeon-holed and denied the benefits of cross-cultural exchanges in which artists from the dominant culture are encouraged to engage. They have been encouraged instead to remain within the

FOREWORD
by Margo Neale

confines of a style that, with time, was viewed as being as petrified as the traditional works of previous decades because, in the main, the white art market for indigenous art cannot abide change.

The Dreamtime is referred to throughout as an ever present restorative power in maintaining and strengthening cultural belief, acknowledging that indigenous art is not an historic period locked into a distant past as it is understood in European history. It is, as Susan McCulloch notes, a continuing tradition in which success remains dependent on the retention and reinterpretation of a strong traditional and spiritual base, 'a combination of innovation within tradition allied with a strong visual sensibility and skill that has made the art of Aboriginal Australia unique worldwide in contemporary art practice'.

In this process, urban artists are positioned on a continuum extending back to the nineteenth century, prompting a reassessment of the term 'urban' to mean more than simply a place of residence. Rather, it becomes a term which refers to a body of artists whose response to the colonial experience finds contemporary expression in new materials, techniques and subject matter available through the urban environment. For many artists living in towns and cities, it is about making visible their Aboriginality after decades of erasure; for others from remote regions, it is an opportunity to experiment with different forms of expression made possible by access to urban materials, techniques and technologies.

There is always a risk in producing an easy-to-follow guide to a subject as complex as indigenous art of oversimplifying and compromising accuracy for clarity. This well-researched catalogue of art deals with reference material, listings and extended discursive texts which raise current contentious issues, as well as historic material. Being a long-time supporter of Australian art in her work as the visual arts writer for the *Australian* newspaper, McCulloch has shown dedication to the area of indigenous art, travelling extensively to places the names of which most people cannot even get their tongues around. She has helped to put on the public agenda issues of great sensitivity and potential volatility such as appropriation and authenticity.

Further distinctions exposed in this guide include the deficiencies of a marketplace only familiar with the processes for assessing white art. The method of production, cultural lineage,

indeed the very existence and evolution of Aboriginal art is diametrically opposed to the experience and understanding of even the most avid collector of Eurocentric art, let alone the beginner in the field. This book goes some way to answering so many of the questions that have prevented many from experiencing the rewards that informed exposure to this uniquely Australian art makes possible.

This usefulness will also extend to the many indigenous art students and amateur artists, to vendors and buyers, to professionals in the industry and to general enthusiasts who are seeking an overview. With its real and accessible information gained from real experience, this book provides a broad spectrum of knowledge of the cultural domain in which this art operates, enabling understanding and tolerance, demystifying where appropriate and offering the reader a point of entry into this most vital and volatile art practice.

MARGO NEALE
PROGRAMME DIRECTOR, ABORIGINAL AND TORRES STRAIT
ISLANDER ART
NATIONAL MUSEUM OF AUSTRALIA, CANBERRA

The revitalisation of Australian Aboriginal art has been one of the great success stories of modern art. Critic and writer Robert Hughes has described Australian Aboriginal art as 'the world's last great art movement' and the first director of the Aboriginal Arts Board of the Australia Council and former museum director, Robert Edwards, as the 'greatest flowering of art probably anywhere, anytime.'

The author with a Yuendumu artist in front of the mural of Yuendumu's Warlukurlangu Artist's building.

Since the early 1970s, from the ruins of an all but decimated culture, Aboriginal art has become Australia's largest visual art industry. One researcher estimates its sales as more than $100 million annually.[1] If so, it outstrips the sales of work by Australia's non-indigenous artists by three to one—an extraordinary situation considering that Aboriginal people comprise only 1.7 per cent of the Australian population.[2] Of the 250 000 who form this 1.7 per cent, an extraordinarily high percentage of between 5000 and 7000 people are estimated to be engaged in the regular making of art or craft. This is equivalent to the number of non-indigenous artists based in capital cities who are drawn from the total Australian population of around 19 million.[3]

As well as fuelling what has become a large industry—from which non-Aboriginal people benefit as much (and some would say more) as the artists and communities themselves—the rise in popularity of this art has had a huge impact on Australian culture. Internationally, it has brought a fame to Australian art rarely before experienced. For non-indigenous Australians, it has enabled a rare opportunity to learn something of Aboriginal culture while appreciating the aesthetic properties of a new and vital form of artistic expression. For the artists themselves and their communities, it has become a source of both economic independence and cultural pride.

While the cross-hatched barks of Arnhem Land and the multi-layered 'dot' paintings of central Australia have become the most widely known of the Aboriginal art forms, they are only two among a range as diverse as the people who create it and the vast Australian landscape itself. The ochre colour-field abstracts of

the Western Australian Kimberley painters, the bright 'naïf' watercolours of Fitzroy Crossing artists and the widely divergent individual expressions of urban artists are other forms of an art which has become the prolific expression of a revived and richly evolving tradition. New movements spring up continually; new materials are tried as artists of all generations reinterpret both the recent and ancient past.

This book aims to introduce the modern development of this art, the geographic locations in which it is produced, the wide variety of styles employed and biographies of some of its most well known artists.

In the two years since this book was first published, the acclaim with which this art is accorded has grown. As have new developments in already well established communities and the emergence of some entirely new movements. In travelling whenever possible to the art producing areas in the Kimberley, Central Australia and Arnhem Land and more recently Far North Queensland, I am inspired by the busily productive nature of so many communities and the rapport between community co-ordinators, some private operators, artists and communities—vital to the production of vibrant art.

Major exhibitions such as the 2000 Adelaide Biennial's indigenous exhibition, the Art Gallery of New South Wales's exhibition Papunya Tula, Genesis and Genius and the Queensland Art Gallery's Lin Onus retrospective have brought indigenous art into the public gallery sector more prominently, as have the opening of large and imaginative display areas for indigenous art in institutions. Commercially, there are now more art galleries than ever before showing indigenous works (many of whom are listed at the back of this book). Its resale market has increased enormously, as have the numbers of indigenous exhibitions touring internationally.

This level of activity shows no sign of abating, helping to gain for the art of Aboriginal Australia a stature extraordinary for an art movement only some 30 years old.

SUSAN McCULLOCH
VICTORIA, 2001

PREFACE

11

INTRODUCTION TO CONTEMPORARY ABORIGINAL ART

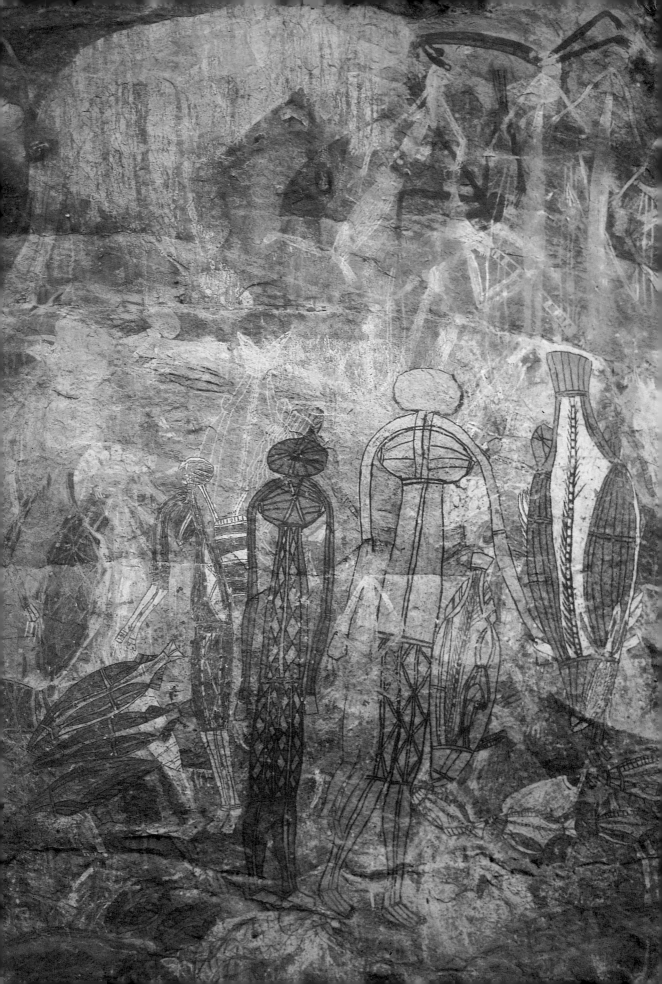

In June 1997, a small painting by Central Desert artist John Warangkula Tjupurrula painted in 1973 attracted worldwide attention by breaking all auction records for an Aboriginal work when it sold at Sotheby's Aboriginal art auction in Melbourne for $206 000. Three years later, the same painting resold for $486 500. In July 2001, a painting by Kimberley artist Rover Thomas beat this record when it was sold by Sotheby's to the National Gallery of Australia for $786 500. Fetching far more than the previous record, the sale indicates the huge leap in interest in an art movement just 30 years old.

Until the start of this movement in the early 1970s, especially in the Central and Western Desert areas, Aboriginal culture had been in danger of being almost entirely subsumed by European civilisation. Two hundred years of white occupation had brought to Australia's indigenous population death, dispossession of lands and debilitation in many forms. As late as the 1930s, Aboriginal people had suffered massacres, as well as decimation through introduced diseases and altered ways of life. More recently, alcohol and other drugs, and poor European diet have become major health risks.

Societies, close knit and well ordered for tens of thousands of years, became fragmented. Fragile lands were degraded by the overgrazing of introduced animals. While some Christian missions established throughout outback Australia provided sanctuaries, shelters and centres for food distribution in times of drought and flood, the imposition of a foreign belief system and the active repression of the practice of traditional customs led to the further unravelling of indigenous societal bonds.

Between 1910 and 1960 under the Australian government's 'assimilation' policy, the aim of which was to 'rehabilitate' Aboriginal people for inclusion in European society, a number of programs were implemented. One was to remove Aboriginal children not of full blood from their homes to be brought up in foster homes or orphanages; another was to set up, in the Central Desert regions, a number of Aboriginal-only communities to join those already established by missionaries. To form these settlements—many of which later became important art-producing communities—people were literally rounded up from their tribal lands. Little thought or consideration was given to the effects of forcing those of different tribal heritage to live in close proximity, while the imposition of restrictions of movement

INTRODUCTION TO CONTEMPORARY ABORIGINAL ART

LEFT: A cave painting of humans and fish in Kakadu National Park, one of the richest and most extensive rock art areas of Australia.

PREVIOUS SPREAD: The sun sets over seemingly endless sandy plains of the Central Australian desert— their silence broken only by the occasional bird call.

RIGHT: Australia's major indigenous art-producing communities shown with their nearby towns, rivers and waterways, and the highways, roads and tracks which lead to them.

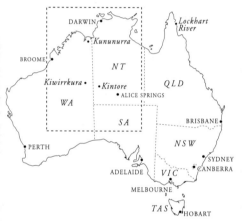

ABOVE: Map showing some of Australia's newer art-producing communities in relationship to Australia's capital cities and regional centres.

prevented people from fulfilling important cultural and food-gathering journeys.

A similar dislocation to that experienced by the Central and Western Desert people was imposed upon those of the vast Western Australian region of the Kimberley. In Australia's Top End—Arnhem Land, the Tiwi Islands and the Torres Strait Islands—the government and missionary presence was less restrictive, with people often able to continue to live close to the land and maintain their belief systems while at times also incorporating Christianity. This was particularly so in the 150 000–square kilometre Arnhem Land region, which became an Aboriginal reserve in 1931.

Social change

It was not until 1967, however, that Aboriginal people, previously ironically not regarded as 'Australian citizens', were given the vote. During the 1960s and 1970s, a growing social conscience awakened largely through the civil rights movements of America and later South Africa, and the initiatives of Aboriginal people themselves, led to a growing demand throughout Australia for both land rights and compensation for Aboriginal people. This was given further impetus in 1972 with the election of Australia's first Labor government for twenty-five years, led by Gough Whitlam, which made land rights a priority reform on the political agenda.

Pivotal to the success of this was the 'outstation' or 'homelands' movement in which people were assisted, through servicing of basic food, health and sometimes educational facilities, in moving back to traditional areas. Throughout the desert areas, the Top End and the Kimberley, people moved in family groupings to set up permanent camps or build houses on their traditional lands.

By the late 1980s, most of the formerly government-established and many of the missionary stations had been handed over to the control of Aboriginal people.

The growth towards Aboriginal control of communities has been accompanied by a unique art development, the impact of which is especially noticeable in the desert communities where the practice of the new means of visual representation has come to be one of the most constructive aspects of daily life.

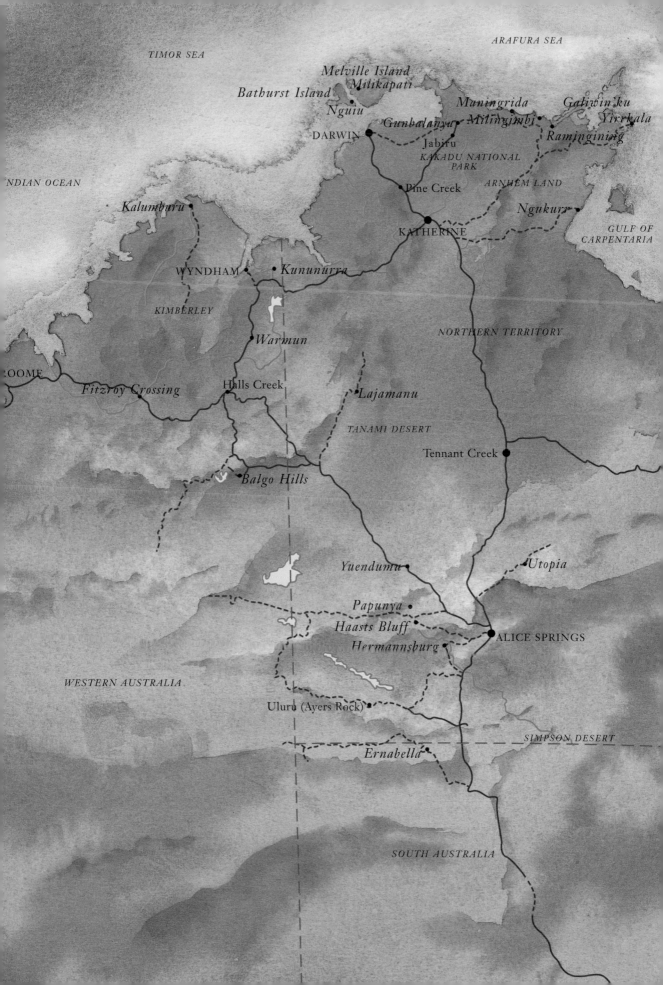

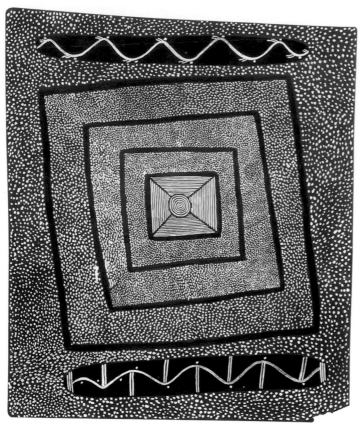

Anatjari Tjakamarra, *Kangaroo Rat Dreaming* (1972). This small painting, produced by one of the original painters at Papunya in the early 1970s, created a stir when it sold as *Cave Dreaming* at Sotheby's auctions in June 1996 for $74 570. Bought by the Art Gallery of Western Australia, it was renamed *Kangaroo Rat Dreaming* after research into its history determined that it was related to the journey of the ancestral Kangaroo Rat.

An art movement regenerates

The renaissance of modern-day Aboriginal art started at the tiny Central Desert community of Papunya, 230 kilometres from Alice Springs, with the arrival, in 1971, of a young New South Wales teacher, Geoffrey Bardon.

In 1960, Papunya had been the last community to be established under the federal government's assimilation policy. Most of its 600 or so population were Pintupi from the Central Desert, with significant numbers also of Arrernte, Anmatyerre, Luritja and Warlpiri people.

When he arrived, the mood of the community, Bardon says, was 'divisive, depressed and lacking in either cohesion or direction … Whites refused to shake hands with them for fear of catching diseases. Blacks were seldom allowed in government cars or any white car at all. All about the settlement were filth and dissolution … there was a great deal of white theft of Aboriginal food and beer from the kitchen. Anything could be taken from Aborigines without effective protest.'[1]

Bardon was initially fascinated by the children's drawings of traditional designs in the sand. 'I would stand among the spinifex with the red sand dunes about, surrounded by [the drawn] sinuous lines that were images of water or possum … And so it was, within a few days of my arrival at Papunya, that I saw in the humble red sand beneath my feet the children's outlines of the Aboriginal designs and in them the ultimate meaning of the centre of our continent.'

The 'vivid sight' of these designs led him to seek out explanations as to their meaning and to suggest to the children that they re-created the drawings in the classroom in watercolour on paper. Next a mural project was planned. Its painting was watched with interest by the rest of the community—especially a group of senior men. Then, says Bardon, '… seven men …

started painting on the far, empty wall. I noticed that [one particularly] alert fellow … Kaapa [Kaapa Mbitjana Tjampitjinpa, who became a pivotal figure in the painting movement] seemed to be in charge of the other painters, telling them what to do.'

Keen to encourage the elders to paint their stories with their own symbols rather than the figurative Western images they may have believed were wanted by the white teacher, Bardon intervened:

I pointed at the wall and said to this Kaapa, 'Are these ants proper Aboriginal honey ant? Nothing is to be white fellow.' All the work suddenly stopped and six other painters crowded about to look at the honey ants. Kaapa seemed to have the answer even before the words were said. 'Not ours,' he said. 'Yours.'

'Well, paint yours,' I said. 'Aboriginal honey ants.'

He looked at me for a second and went across [to some other men]. After a few whispered words he came back and took up his brush and made the honey ant figure, or hieroglyph, then made true travelling marks around the true honey ant.

This, says Bardon was the first acrylic version of the Honey Ant Dreaming (overleaf), the major Dreaming of the area and one which has since probably become the most often painted of all Central Desert stories.[2]

The Dreaming

Like all Aboriginal art, the Honey Ant and other Papunya images were based on stories and cultural traditions deriving from the Dreamtime. In the Dreamtime, creation ancestors went on epic journeys, creating flora, fauna, landforms and celestial bodies. It is from their experiences that social mores such as marriage and kinship have evolved. Until the advent of white civilisation, the land had also sustained and nurtured its indigenous people, becoming an integral part of both religious belief and, at a more practical level, daily survival. Today, despite the vast changes that have occurred to their lands through the impact of European civilisation, Aboriginal people continue to travel where possible, along Dreaming paths which cover the continent—reconnecting with significant sites through routes which can cover thousands of kilometres.

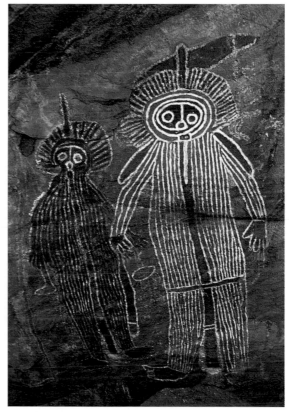

This cave painting of a Wandjina-type figure from the Katherine area in the Northern Territory shows the plenitude and richness of rock art in this region.

RIGHT: Clifford Possum Tjapaltjarri, *Yuelamu Honey Ant Dreaming* (1980). An important rendition of the Honey Ant Dreaming stories, symbols in this painting include stones exposed by flood waters (indicated by the black lines) and the abdomens of sugar ants as they cling to the sides of the nest. The dark brown 'U' shapes are people sitting at the sides of the ants' nest.

HONEY ANT DREAMING

The Honey Ant (Yunkaranyi or Yarrumpi) Dreaming is one of the major ancestral myths of the Central Desert, and refers both to the ants themselves and the ancestor figures in their image. The modern settlements of Papunya, Yuendumu and Yuelamu (Mt Allan station, 250 kilometres west of Alice Springs) are territory of the Honey Ant Dreaming belonging to the Warlpiri and Anmatyerre people. The small hills lying alongside the main settlement of Papunya are the petrified bodies of Honey Ant ancestors[3] and it was the Honey Ant Dreaming that Papunya elders chose to depict on the first mural they painted on the settlement's school walls. Stories of the Honey Ant ancestors, whose underground tracks are believed to have caused the soakages common in the area, are numerous and varied, and are depicted in detail in the art of many of the painters of the Central Desert.

Anmatyerre painter Clifford Possum Tjapaltjarri's 1980 *Yuelamu Honey Ant Dreaming* is a view of the interior of an ants' nest at Yuelamu. This important soakage, in Possum's grandmother's country, was the meeting place in the Dreaming of ancestral Honey Ants from Pine Hill, Papunya and another nearby site—the Dreaming path which continues northeast to the boundary of Anmatyerre jurisdiction over the Dreaming.

ABOVE: Molly Napangardi, *Honey Ant Convergence* (1986). Offering a different interpretation of these much-represented creation ancestors and their journeys, this large painting was one of the first to be done at the northern desert community of Lajamanu.

Unlike many other Honey Ant Dreamings, *Honey Ant Convergence*, by Molly Napangardi, a Warlpiri artist from Lajamanu, does not involve a journey. Rather it tells of two of Napangardi's female ancestors who were too busy digging for honey ants (yurampi) to see each other and killed each other with their digging sticks. One changed into a white wood which grows out of one of the rockholes; the other, into a wild fig. The painting depicts rockholes (the main circles), with honey ant tunnels shown in the outside red lines. The background pattern represents the dug-over soil; the white dots, the ants disturbed by the digging.

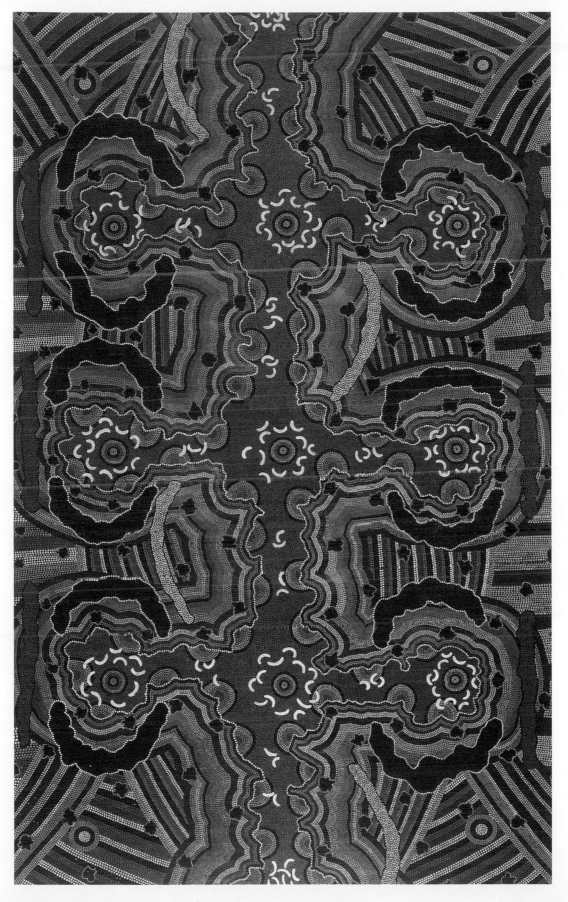

RIGHT: Emily Kame Kngwarreye, *Untitled (Awelye)* body paint design (1994). These striking monochromatic works—based on women's traditional body paintings and created as part of ceremonial practice—created enormous interest when Kngwarreye started painting them in the mid-1990s.

Aboriginal mythology is not one simple belief system, but many systems specific to the hundreds of different tribal groupings occurring throughout the continent. In the Arnhem Land region, main Dreaming beings and ancestors include the two Wagilag (or Wawilak) Sisters and the Djan'kawu brother and two sisters who traversed the sea and land, meeting the Rainbow Serpent and creating rivers, mountain ranges and other formations. In the northwest Kimberley, the supernatural Wandjina beings control rain and fertility, while in the Western and Central deserts, the ancestral Tingari brought law and culture. The Honey Ant (as in the Papunya paintings), Lizard and Fire Dreamings are just some of the major Dreaming stories of the Central Desert.

Dances and songs, designs made in sand, stories told in visual images on rock walls and bark shelters, designs painted on the body and the making of a number of sacred objects reinforce the spirit of the Dreaming. Unlike the Western notion of time-delineated history, the Dreamtime is not locked in the past, but through these and other rituals remains alive at all times, guiding and dictating customs and laws while reaffirming spiritual beliefs.

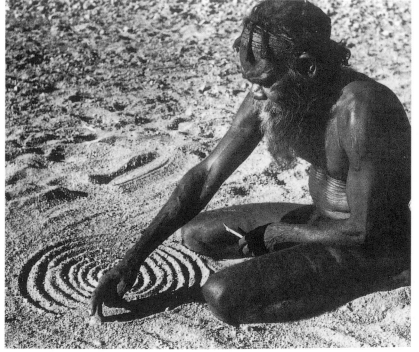

ABOVE: Taken by ethnographer and explorer Charles Mountford, this 1960s photograph shows the construction of a sand painting by a Central Desert man before a ceremony.

It is from this base that today's Aboriginal art derives. The paintings at Papunya, and all that subsequently ensued, were a continuation of, rather than a radical departure from, tradition because of this living quality of Aboriginal culture. As Papunya painter Michael Jagamara Nelson relates, a modern painting evolves as part of Dreamtime lore:

You gotta canvas, paint and brush ready. Well, first you gotta ask your father and kurdungurlu *[grandfather]. [They'll say] 'You do that Dreamin' there, which is belonging to your grandfather and father.'*

They'll give you a clue, they'll show you a drawing on the ground first. You've got it in your brain now. You know it because you've seen your father [in a ceremony] with that painting on his body and one on the ground. You'll see it, then you'll know it.'

Right, you'll start and you'll do a painting, and if you make a mistake, well you've gotta ask again. You've got to ask your father or kurdungurlu. *[They'll say] 'You've got to show it to that old man and ask him if that painting's alright.' [He'll say] 'Yes carry on, you gotta finish 'em off.' All the detail for the painting, you gotta ask that old man, they've gotta tell you about that story and Dreaming, which is which. You've got it in your brain.*[4]

Imagery in Aboriginal art

As Nelson's description indicates, Aboriginal painting, while relating to the land, is not conceived, as is much Western art, from perceived subject matter. Indeed, Western notions of aesthetics are rarely those motivating the creation of Aboriginal art. Nor does the *raison d'être* of much Western art—the artist's desire to communicate thoughts or emotions, to present the world through his or her eyes, or to comment in a highly individual way on imaginary or real life—generally apply to Aboriginal art. Rather, Aboriginal people, no matter where they are, paint what is in their heads, in their histories, as a continuation of their spiritual link with their country.

Under Aboriginal law, an artist is permitted to portray only those images and stories to which, through birthright, he or she is entitled. Within this confine, the styles of work vary widely. Some are notable for a meticulous layering and overlaying, creating works of shimmering luminosity; others have an appealingly fresh quality with bold use of colour and raw, free design; yet others are praised for their exacting portrayal in fine detail of traditional design using age-old techniques.

Even paintings such as those by the late Emily Kame Kngwarreye and Rover Thomas, which have been embraced and

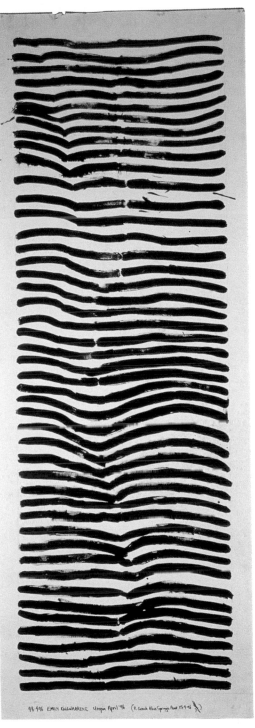

praised in Western terms for their similarity to internationally famous abstractionists, derive from this base. As writer Terry Smith describes in *Australian Painting* through an analysis of a Western Desert painting, any Aboriginal art can be viewed and interpreted at numerous levels:

> *… it works simultaneously on four levels each with two aspects to it; as depiction through inherited forms and techniques of stories from the Dreaming, both as general mythology and as a moment or moral in the particular artist's Dreaming; as a cartography of a place owned by the dreamer-painter, including journeys across it, both by the sacred originators and the artists as a hunter or wanderer; as a witness that the duty of representing and singing the Dreaming has been done, thus constituting a restatement of title or deed to the land indicated, and finally as an individual interpretation of these duties and practices varying somewhat and thus keeping alive, the obligations and the pleasures of paint.[5]*

To many viewers, the story of the work is important, while to others, the visual impact of the painting predominates. It is this combination of a strong sense of design and finely honed use of colour or surface texture and spatial relationships—underpinned by an intangible but ever present connection with the land, its creators, their stories and the artist's interaction with this—that gives many paintings of Aboriginal Australia their unique quality and power.

Traditional art background

Before the 1970s and 1980s, in the Central Desert and its neighbouring northwestern area, the Kimberley (now also home to some major art-producing areas), traditional storytelling art had largely not been made on transportable objects. Exceptions are the sacred storytelling stone and wood *tjurunga* which relate a man's history found throughout desert regions, the painted boards used in ceremonies of the central Kimberley and the carved shells found in coastal Kimberley areas.

The earliest practised permanent visual representation is that of rock art believed to be some 50 000 years old and found mainly, but not exclusively, in the many caves, crevices and walls of the rocky escarpments of Arnhem Land.

In the far northwest, images of Wandjina, the rain spirit figure, painted on cave walls can be dated to around 30 000 years, as can

the paintings on cave walls near Laura on the northern tip of Queensland. Other rock art sites are found in the Central and Western deserts, in South Australia's Flinders Ranges, around Broken Hill–Lake Mungo–Mootwingee in New South Wales and along the Murray River, in Victoria's Grampians, in the southern and northern tablelands of New South Wales, around Sydney, in the Blue Mountains and the Shoalhaven area of New South Wales and in many parts of Tasmania.

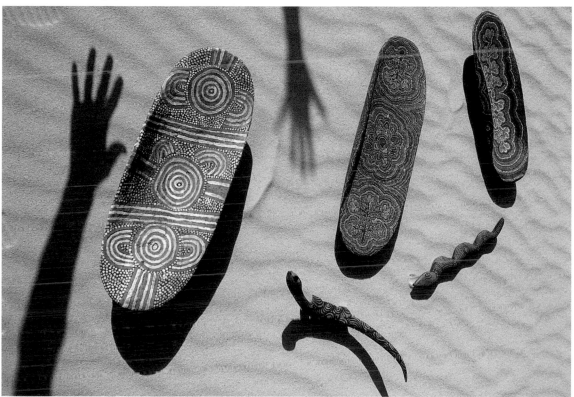

Imagery of rock art varies from region to region, although there can also be found similarities in design—circles, tracks, parallel bars of straight and wavy lines throughout.

Throughout the desert regions, sand 'painting' in which ritual designs were made on cleared areas of sand before or as part of ceremony or at other times was also an important method of passing on visual images. Not intended to be a permanent record, these were usually demolished, swept clean or simply abandoned after their purpose had been served.

From the mid-1900s, with the increase of tourism, some traditional desert artefacts, such as boomerangs, coolamons (carrying vessels) and clapping sticks, often decorated with traditional designs, were made especially for sale. Other non-

Utilitarian objects such as this coolamon (wooden carrying basket) and other carved objects are made throughout Aboriginal Australia.

traditional figurines of animals, birds and reptiles carved from wood and sometimes soapstone were also made, as was, on a more formal basis, some pottery in at least two communities—the Central Desert's Hermmansburg and the Kimberley's Balgo Hills.

A 1940s desert project

In the 1940s, however, a project undertaken by the peripatetic, Adelaide-based anthropologist Charles Mountford had interesting modern connotations. Mountford had, from the early 1930s, taken numerous excursions through vast tracts of Australia, from South Australia and Western Australia through the centre and around the Top End, to record the life and culture of Aboriginal people. On one of these expeditions—to the Warburton Range of eastern Western Australia—he had observed that when people of that area were asked to draw on paper supplied by members of the expedition, the motifs were, not surprisingly, similar to those of rock painting.

'There was, however,' he noted, 'an important difference. Whereas the motifs engraved on the rock faces … were the remnants of a dead art, without meaning to any living person— those of the [Warburton Ranges people] belonged to a living art, in which the artist had a meaning for every design he made.'

In 1940, a wish to record some of this 'living' art prompted him to visit the Mann and Musgrave ranges of central Australia. Setting up camp at the missionary settlement of Ernabella in the lands of the Pitjantjatjara and Junkandjara people, Mountford handed out brown paper and crayons (black, white and yellow only) to the men of the groups, requesting them to make 'black fellow marks'.

'As soon as the adult men became used to the new medium, which took only a few days,' he wrote, 'they made drawings that, almost without exception, illustrated their mythology.' The project was eagerly taken up by women and children as well, and soon dozens of people were making drawings.

In addition to admiring the complexity of stories able to be represented through graphic motif, Mountford and other members of the expedition were also extremely impressed by the drawings' intrinsic design elements.

'No matter whether the drawing was simple or complex,' he notes, 'there was always a natural tendency, on the part of the artist to maintain an artistic balance between the design

elements ...' This, he said, included the occasional deliberate use of motifs with no other purpose than to balance a work. Mountford continued:

A superficial examination of the art of the desert nomads would suggest that their aesthetic expressions in the graphic arts are limited almost entirely to a few cave paintings and rock marking, simple body decorations and string head-ornaments. On this assumption it would have been reasonable to assume that these people were not particularly interested in graphic representation.

This assumption however can be dismissed at once on the evidence of the crayon drawings, for when the men became used to the new mediums they straight away drew ... with confidence and skill, often producing pictures of considerable beauty.

For a while it was puzzling to account for the confidence and ability with which the men not only portrayed many aspects of tribal beliefs on the sheets of paper, but also ... obeyed, almost without exception, the laws of composition and artistic balance.

It was only when later we saw these men drawing in the sand, with equal confidence and skill, that we realised this was the medium by which they acquired the ability to produce an equally rich art on sheets of paper.

It is of some interest to discover that in the art of the desert nomads, and possibly in other Aboriginal groups, there is a hidden and unsuspected art in the sand drawings that was only revealed by the techniques of crayon drawing and finger painting. The rich symbolism of the drawings and the information they contained about the philosophy of the desert nomads would never have been revealed to us without the use of these homely European materials.[6]

Mountford went away with some 300 drawings (now in the collection of the South Australian Museum) by the men and women largely of the Pitjantjatjara people, as well as several hundred children's drawings (more figurative in nature depicting largely naturalistic landforms, fauna and people).

These crayon drawings, made in the 1940s, were the results of a meeting of Aboriginal imagery and Western materials. This was as far, however, as the 'experiment' went. It is fortunate that some thirty years later, at the Central Desert settlement of Papunya, circumstances, timing and personalities combined with more long-lasting results. For without this, the Papunya experience, too, could well have ended, as did the Mountford project and

other similar projects which occurred during the mid-twentieth century in various locations, as a one-off event remembered only as a small footnote in Aboriginal history.

Albert Namatjira

At the same time as Mountford's Ernabella experience, in the desert community of Hermannsburg, paintings by the man who was to become Australia's most famous Aboriginal artist of the first half of the twentieth century were starting to come to the public's attention. Albert Namatjira (1902–1959) was born at the Lutheran mission of Hermannsburg, 130 kilometres west of Alice Springs, in 1902. His early artistic skills were encouraged by the mission's pastor J. W. Albrecht. Albrecht, instrumental in the establishment of the mission at Haasts Bluff, is widely acknowledged for his unusually respectful and sympathetic attitudes towards Aboriginal lore and skills. It was he who initially encouraged Namatjira's artistic talents by suggesting he carve and decorate wall plaques for the mission church.

It was Melbourne artists Rex Battarbee and John Gardner, however, who visited the area during the early 1930s and introduced Namatjira to the style which made him famous. Demonstrating the artist's strong aptitude for the watercolour medium and a distinctive capturing of the high colouring of the desert landscape, Namatjira's paintings were an instant success when first exhibited in 1938. National and international fame followed, bringing great financial and other benefits to Namatjira and his extended family—along with the attendant problems of increased alcohol consumption and other health difficulties. (Namatjira died in tragic circumstances in 1959, having been jailed for bringing alcohol to his community. Accorded the honour of being made an Australian citizen, he was permitted alcohol; his relations and friends at his home, to whom he took alcohol, were not.) Namatjira's legacy was the creation of an entire school of younger watercolour painters in his style (called the Arrernte group of watercolourists), whose work continues today. As well, his influence as a role model and the clarity of his work had a large impact on subsequent generations of Aboriginal artists of very different styles and media, including the late Melbourne-based artist Lin Onus, the Central Desert painter Clifford Possum Tjapaltjarri and the Northern Territory artist Ginger Riley.

Ernabella—a school of acrylics develops

Shortly before Namatjira's death, another and quite different
artistic development was also taking place—again with the people
Mountford had visited in the 1940s, the Pitjantjatjara of
Ernabella, 400 kilometres east of Alice Springs. This time,
teachers and especially the art and craft adviser Winifred Hilliard,
appointed in 1954, encouraged the painting of traditional motifs
using brightly coloured acrylic paints. Perhaps because Hilliard
was a woman, and in contrast to Mountford who had favoured
the crayon designs of the men, this time most of the several
dozen painters were women. The paintings, a number of which
were reproduced photographically in limited edition posters and
postcards, were quite startling in their use of clear, confident,
blocked-in colours and swirling shapes.

Called *walka*, the designs are not like the drawings done in
Mountford's time, which interestingly resemble more closely the
earliest Papunya board paintings and seem more orientated
towards graphic design. Unable to place them in either an
'ethnographic' or contemporary Western art context, much of the
city-based art world viewed the *walka* with some suspicion
(although a fruitful fabric-making workshop has since blossomed
based on the designs, which some artists also incorporate into
paintings). Apart from anything else, their bold use of non–earth-
based colours made them simply ten or more years ahead of
their time.

The rise of Papunya art

After the mural painting was carried out at Papunya in 1971, the
power of the new medium enthused almost the entire community.
Soon numerous others, largely men, were painting on just about
any flat surface to hand—most often boards, but also packing
cases and occasionally corrugated iron sheets. Paints were first
crushed ochres, then, when available, postercolours, oils, house
paint and finally acrylics.

'Schoolteacher mob give me job, shool'em [teaching] all that
school kid mob [wood carving],' said leading painter Clifford
Possum Tjapaltjarri describing the start of the Papunya painting
movement to art adviser John Kean in Alice Springs in 1984.

After that Geoff Bardon been there! After that he been start for this
painting. Get them hardboard. Small one. We been do 'em inside

[Bardon's] house first. That was me and Tim Leura [Tjapaltjarri] and Kaapa [Tjampitjinpa]. We been working' there. And other mob been get job and we been get pay and sell'em board. I sell'em big one … Two men from America. We been get that job, all them Luritja side [group]. Right after that all them Pintupi mob been get job. We do 'em all on art board.[7]

For a few months, the painting developed in the community without significant outside awareness. In August 1971, however, Kaapa Tjampitjinpa won equal first prize at the Caltex Art Award in Alice Springs. By then, more than twenty artists (all male) were painting: Geoffrey Bardon estimates that in the first year and a half, at least 1000 works were painted.[8] By 1972, when Peter Fannin, the first designated art adviser, was appointed, the number of painters had doubled; during the 1980s, the numbers reached more than 200.

Although in the early years painting was prolific, selling the art and sustaining the movement were far from easy. As long-time Alice Springs resident Richard (Dick) Kimber, a community worker, teacher and writer who has had a close relationship with the Papunya painting movement from its inception, describes:

For ten years no one would buy the art. The first painting I saw was one of Kaapa's [Tjampitjinpa] and the instant impact on me was amazing. I immediately wrote to Bob Edwards [then curator of anthropology at the South Australian Museum, who became the first director of the Aboriginal Arts Board of the Australia Council]. If credit is due to anyone for keeping Papunya painting going at that stage it ought to go to Bob Edwards. Bob had had a love of Aboriginal art, especially rock paintings, for years, and he came out here and looked at the art and the community and organised funding for the administrator. Bob used to say that [as the art wasn't selling anywhere nearly as fast as it was produced] Papunya in those days was the most highly subsidised art in the country!

Peter Fannin's [the first designated art coordinator appointed to Papunya in 1973 following Geoffrey Bardon] family bought some, and other white workers at the community did, too, but generally up to about 1976 you couldn't give them away. There was always someone looking for things, but they didn't want to pay money for them. Art in Alice itself was very much focused towards the Namatjira style [of realist watercolours]. Everywhere you went down the main street there

were dozens of places selling Namatjira and Namatjira-style paintings. This other stuff looked too different to be taken seriously at first. And we tried writing to all the Sydney dealers of greatest repute and the curators all over and no one was interested in the new art.[9]

Most state art galleries and the then new National Gallery of Australia were reluctant to acquire works of such difference. The Museum and Art Gallery of the Northern Territory, through the interest of its then director Colin Jack Hinton and its Aboriginal art curator Margie West, was one of the few public galleries actually keen to buy the work. In consequence, its 4000-strong Aboriginal collection contains many key examples of early Papunya work.

In the Central Desert and Alice Springs, attention was patchy. Kaapa Tjampitjinpa's co-winning of the Caltex Art Award in 1971, says Dick Kimber, was a very early recognition of the significance of the new painting:

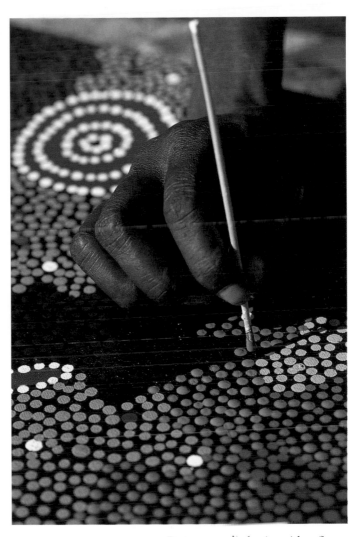

Dots are applied using either fine brushes or sticks, as this artist is doing, or with the ends of larger brushes to create different effects.

Then, there were a few newspaper articles about what was happening at Papunya and both the Australian Museum and Museum of Victoria bought some. Pat Hogan at the Stuart Art Centre—at the caravan park she and her husband owned—showed quite a few. She also had people in there painting and made sure they were painting with the finest brushes (or ends of brushes) she could supply so the works that came from that source were usually very good.

Then the late Andrew Crocker, an English barrister and quite a flamboyant character, arrived as art coordinator. He got on the phone and rang every wealthy person he could think of saying 'I think you ought to have a collection of this work.' He was the one who got Robert Holmes à Court interested. Robert Holmes à Court was one of the most high profile people in Australia and suddenly his collection from

Papunya was photographed in Vogue *and major newspapers. Suddenly art from Papunya was a highly desirable thing to be collecting.[10]*

Pivotal also was the support given through the Aboriginal Arts Board of the Australia Council. Established in 1973, the Aboriginal Arts Board's charter, says its inaugural (1973–1980) director Robert Edwards, was that Aboriginals should decide their own artistic future:

At the time, many repressive things were still going on—like kids not being taught their own language, white people deciding on housing and

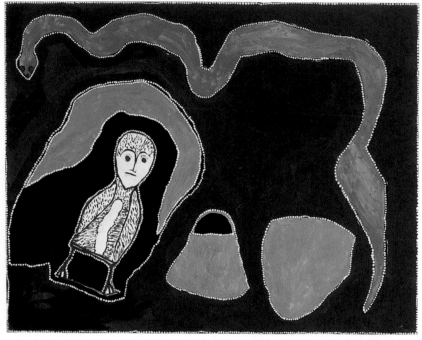

telling Aboriginals this was the way it had to be, and so on. The logic was quite simple: the government would start to put money into Aboriginal affairs, but many Aboriginals weren't at the time confident enough to make use of money to be really productive—mainly because everyone said their heritage was second rate, and they were believing it. There was also a lot of disillusionment on the part of older Aboriginals with the next generation who seemed headed into adopting a Western way of life. They would withhold stories because they didn't trust the younger generation.

Rover Thomas, *Nyuk Nyuk The Owl*. Rover Thomas's images of spirit figures such as the Owl are part of the evolving song–dance cycle of the Kimberley.

The setting up of the Aboriginal Arts Board was concurrent with other moves to enable Aboriginals control over their own heritage. Dick Roughsey, Billy Stockman [Tjapaltjarri] and Wandjuk Marika were on the original Board and what happened in terms of the marketing of the art was at their suggestion.[11]

Crucial in this, says Edwards, was the strong belief that the best way of helping the artists was to buy the art. He continues:

In non-Aboriginal art, grants are given out, and it buys artists time to develop ideas. This, said our Aboriginal representatives, would not work in an Aboriginal context. They said, 'If you give an Aboriginal money, he'll sit down and do nothing because traditionally art has always been a

*part of food and other ceremonies. We should rather buy the work.
Which we did. Right through Aboriginal Australia. We bought bark
paintings, burial poles, Western Desert art. We helped the establishment
of the Papunya Tula Artists Pty Ltd and other artists cooperatives,
supplied materials and bought vehicles. We set up a shop in Alice
Springs and one at the Argyle Arts Centre in Sydney. It was all aimed
at introducing the art to a wider audience.*[12]

The problem, says Edwards, was a major one.

*No one else wanted to buy the art. We had art coming out of our ears!
Papunya artists were in the first few years incredibly prolific and we
were building up quite a stockpile. Boards and canvases were stacked
several deep around all the office walls and it started to worry the
council and government auditors, who weren't so used to the concrete
effects of grants! What on earth were we going to do with it all? We
tried to give it to galleries and museums, and no one would take it.*

*For example, we offered the Art Gallery of South Australia the pick
of several hundred really wonderful early Western Desert paintings.
They simply wouldn't take them. Eventually, because I knew many of
the board members, I virtually forced them to take them. Now, of
course, they [the AGSA] acknowledge them as being amongst the most
important Aboriginal works in their collection! This was typical of much
gallery reaction.*

*Again, it was the Aboriginal board members who suggested a
solution—that we send the work overseas. In four years, we organised
sixteen international exhibitions, often in conjunction with large
benevolent cultural foundations [such as Rothman's and Peter
Stuyvesant]. There was the same problem: what to do with the art when
the shows finished? 'Leave it there,' said the Aboriginals, 'if you bring it
back [it will] kill the market.' So we donated it to museums on the
proviso that it would be on public show. This is why a number of
overseas galleries and museums often have much better collections of
early modern Aboriginal work than many in Australia.*

*In retrospect, this turned out to be one of the most subtle and brilliant
marketing exercises in Australian art—and it's never really been
acknowledged or credited as being that of the Aboriginals themselves. If
we'd given just money, it just would have killed it—it would have most
probably been an experiment that went nowhere.*

*Of course, it doesn't need that level of support these days as it has
become a much more wide open industry. But we set up the*

superstructure that in many ways enabled that to happen. We believed passionately in the possibilities of the art—a belief that has been well and truly justified.[13]

Success, however, did not come without cost. As the financial stakes and popularity of particular artists' work became more pronounced, so did jealousies and interpersonal frictions. Not even the establishment of Papunya Tula Artists Pty Ltd—an artists' cooperative set up by the artists themselves in order to circumvent some of the problems—was able to shield the movement from the intense pressures that arose as the art became a highly marketable commodity. Dealers flying in or travelling from various parts of Australia and the world offering large sums of cash on the spot became a common phenomenon.

As, in Aboriginal societies, all goods are shared—income derived by one family member is accessible to all—the pressures on those artists generating the most income was, and remains, intense. The success of Papunya's painting movement significantly changed its community structure. Material benefits—of such value in the white world—were for the first time within reach. Jealousies flared and issues of money and its distribution contributed to further divisions in the community.

That the painting continued in the face of considerable difficulties was attributable to the determination, skill and hard work of founding artists such as Clifford Possum Tjapaltjarri, Mick Namarari Tjapaltjarri, Turkey Tolson Tjapaltjarri and the late Tim Leura Tjapaltjarri and Kaapa Mbitjana Tjampitjinpa, along with a succession of dedicated art advisers—Geoffrey Bardon, Peter Fannin, John Kean, Janet Wilson, Dick Kimber, the late Andrew Crocker and, from 1982, Daphne Williams.

The art movement spreads in the desert

In sister Western and Central Desert communities—especially Yuendumu, Balgo Hills, Lajamanu and Utopia—people watched Papunya's 1970s and early 1980s artistic developments with interest, but no little reservation.

There were debates about whether images traditionally only meant to be seen by those initiated to a level of responsibility should be made available to a wider audience and whether the art should be sold at all. Reaction was strongest by the Pitjantjatjara of the Ernabella area, who in the early 1970s lodged a formal

complaint to the Aboriginal Arts Board about Pitjantjatjara images being viewed publicly.[11] In 1983, the debate was still continuing with Chair of the Lajamanu Community Council, Maurice Luther Jupurrurla, saying of the twelve-person constructed sand painting created at the exhibition D'une autre continent: l'Australie—le rève et le réel' at ARC/Musée d'Art Moderne de le Ville de Paris, 1983:

… We only want the world to accept and respect our culture. We only want recognition that we have a culture, and that we remain strong, as Warlpiri people in Australia. We just want to be recognised as part of the human race, with our own painting traditions which we maintain, as we always have. We will NEVER put this kind of painting onto canvas, or onto artboard, or onto any 'permanent' medium. The permanence of these designs is in our minds. We do not need museums of

Mick Namarari Tjapaltjarri, *Bush Tucker Story* (1972). Finely applied dots and lines give this painting a soft, lyrical quality characteristic of the first paintings from Papunya to use dots as a device to mask sensitive imagery.

RIGHT: Alec Mingelmanganu, *Wandjina* (1980). Mingelmanganu was one of the earliest of Western Australia's modern-day Kalumburu painters of the spirit being Wandjina, whose images appear on rock walls throughout the Kimberley. Mingelmanganu's aims were to continue the cultural practices and visual representations of his Woonambel traditions.

books to remind us of our traditions. We are forever renewing and re-creating those traditions in our ceremonies.[15]

Luther died in 1985 and about a year later Lajamanu elders decided that, properly used, painting for the purposes of selling could be a positive means of keeping the culture alive and painting also began at Lajamanu.

Gradually people in other communities—at Yuendumu, Balgo Hills and Utopia, as well as numerous smaller outstations and settlements, and individuals, started painting and making batik, sculpture and craft. The success of the new forms took hold in the outside world and, by the early 1990s, thousands of Western and Central Desert people had become regular painters or craftspeople, working either individually or through their community arts cooperative.

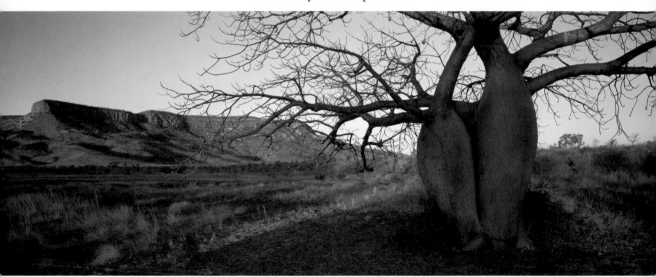

ABOVE: The oddly shaped boab trees, which hold water in their trunks to withstand periods of drought, are a feature of the Kimberley.

Developments in the Kimberley

Art developments in the adjoining Kimberley region followed that of the Central Desert. As in the Central and Western deserts, art on transportable objects, save for carved boab nut and decorated pearl shells as well as the sacred *tjurunga*, had not been seen until the start of the 1980s paintings movement. After European arrival in the 1880s, the Kimberley's Aboriginal population had suffered a similar displacement to that of the Central and Western Desert people. Here, however, the settlements which have since become major art-producing centres were not set up as those of other desert regions as government settlements, but rather were largely established by missionaries.

36

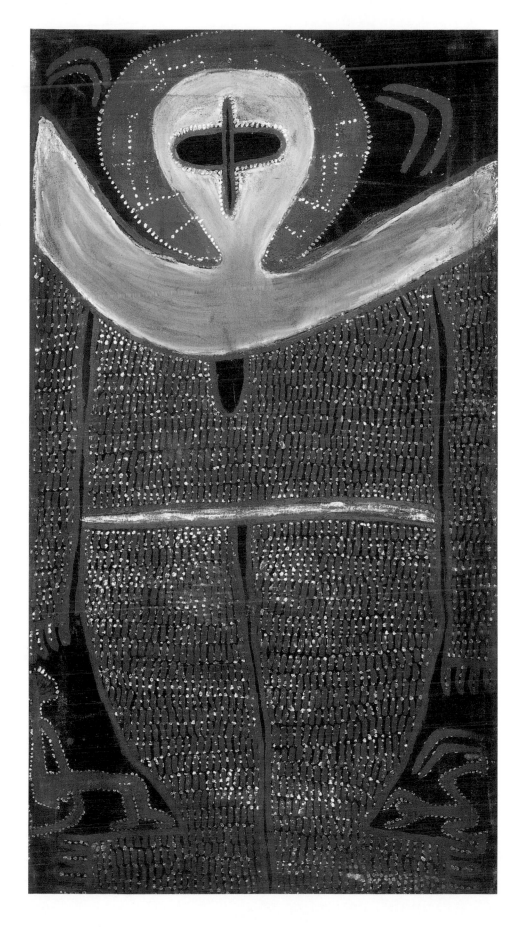

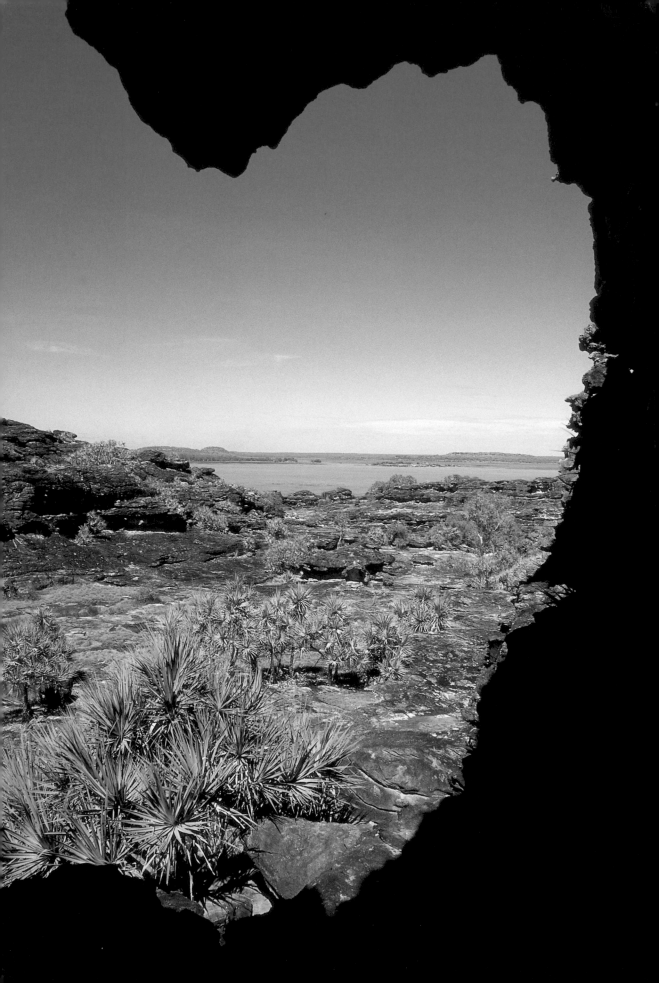

The first forms of modern Kimberley art were the boards produced by Warmun (Turkey Creek) people in the late 1970s. This was followed shortly after by modern-day paintings of 'Wandjina' produced by coastal Kimberley painters. In the mid-1980s, people of the Western Desert – Kimberley region of Balgo Hills, who have very strong family connections with the Central Desert community of Papunya, started painting in acrylic on canvas. At around the same time, a number of Fitzroy Crossing residents started painting in brightly coloured watercolour.

Arnhem Land—a land of continuity

The development of modern-day art in Arnhem Land differs markedly from that of the desert experience. In the coastal regions of Australia's Top End, image making has been produced for sale or barter for several hundred years. In the 1700s, painted barks, carvings and other transportable objects were traded with the Macassans and others who arrived every year to replenish supplies during the fishing season; during the late 1800s, white anthropologists traded flour and other goods for paintings. With the development of tourism during the 1900s, paintings on bark were made specifically to supply to tourists. It was at this time that the practice of attaching a split stick pole to the top and bottom of a bark became commonplace.

Most Arnhem Land missions also promoted the making of art and artefacts, although many Aboriginal people have said this was often with the aim of encouraging the Western notion of the work ethic rather than to allow the free practice of cultural traditions. Some of the barks and carvings made in this way were sold to the not-so-frequent visitors and others were collected by early ethnographers such as Baldwin Spencer, Charles Mountford and later Dr Stuart Scougall, who traded goods such as tobacco and flour for the paintings.

Collectors of barks such as the Perth-based anthropologists Ronald and Catherine Berndt, who also wrote copiously about bark painting and the art and artefacts of Arnhem Land and the far north in the 1950s and 1960s; Sydney-based Dorothy Bennett,

LEFT: The view through an Arnhem Land cave to the lush plains below offers a glimpse into this rich, wildlife-filled countryside.

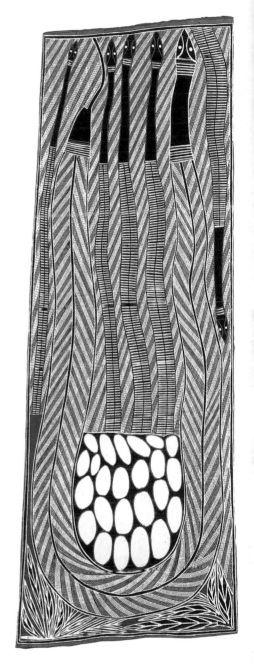

ABOVE: George Milpururru *Pythons with their Eggs* (1987). One of the most prolific artists of Central Arnhem Land, Milpururru was a member of the clan called Gurrumba Gurrumba. The black-headed python is one of his totems.

who accompanied Stuart Scougall on expeditions in the late 1950s; Karel Kupka, collecting for the National Museum of Arts, Paris; the Melbourne-based Jim Davidson and Sydney-based Sandra Holmes assisted the furthering of the work of many artists through their collections and representation to a wider audience. Many works thus collected became the nuclei for large collections in state museums, and, to a lesser extent, art galleries. In 1950, it was estimated there were more than 1000 barks in Australian public collections.[16]

It was, however, the abstract painter and then deputy director of the Art Gallery of New South Wales, Tony Tuckson, who inspired both the greatest interest and the hottest debates about the art of Arnhem Land in the 1950s and 1960s. Enamoured of the works of bark painters and Tiwi carvers of Melville Island, Tuckson readily accepted the 1959 gift of anthropologist Dr Stuart Scougall of a specially made set of Melville Island Tiwi burial poles, *Tutini*, travelling to Arnhem Land to witness their making (page 182). On their arrival in Sydney, the group of seventeen poles were placed in the gallery's foyer by Tuckson. Several newspapers and magazines decried the statement made by the gallery in displaying them in such a prominent position, including the *Bulletin*'s Douglas Stewart. In July 1995, he commented that they made for a 'somewhat bizarre display' and were inappropriate in an art context.[17] A number of leading modernist artists, however, including Sir Russell Drysdale, Sali Herman and Margaret Preston, came to the defence of the poles as works of art, becoming sufficiently inspired to use them as the basis for major paintings and other works of art.

Tuckson continued to work towards the acceptance of Aboriginal art in the fine art context. In 1964, he mounted a major exhibition, Australian Aboriginal Art. With assistance from the Berndts and Mountford, Tuckson was able to assemble a show comprised almost entirely of works from Arnhem Land. It toured for more than a year—the first major Aboriginal art exhibition to be conceived as art, rather than a museum event.

A year before this exhibition, some major bark painters from Yirrkala on the northeastern tip of Arnhem Land had produced the Yirrkala Bark Petition (page 41)—the first example of an art work making a powerful political and cultural statement.

Simultaneously, Yirrkala elders, fearful of the complete loss of their culture, also instigated a unique community project to

BARK PETITION

Various artists, *Bark Petition, Yirrkala* (1963). The Yirrkala Bark Petition was presented to the Parliament of Australia in 1963 on behalf of 500 people, to plead their case opposing mining on their land. Made on a stringybark board, clan designs and figurative representations of creation animals, with the people's claims written on a central panel, it was the first example of an artwork being used to represent people's connection to their land.

create encyclopedic bark paintings on an unprecedented scale. Originally displayed in the community church, these 'Church Panels', as they have become known, remain in the collection of the community's Buku Larrngay Mulka Arts Centre and are still considered one of the most important artworks in the development of Australian art.

During the 1970s and 1980s, the Arnhem Land missions and settlements such as Yirrkala, Maningrida, Ramingining, Oenpelli (Gunbalanya) and Elcho Island were returned to Aboriginal control. All of these, as well as a number of other centres and numerous individual artists, have, since the return of control to Aboriginal people, established community arts centres and taken the traditional forms of bark, carving and weaving into the realm of contemporary art.

Community arts centres and how the art is sold

Since public demand for Aboriginal art developed in the early 1980s, there has arisen a network of artists representatives, cooperatives, agents and dealers through which art reaches its ultimate destination, whether it be public gallery collections, exhibition or retail outlets. People in many communities, recognising the pressures they were likely to be subjected to when demand for their art became intense, followed the lead of Papunya painters who formed the first artists' cooperative. Papunya Tula Artists (*Papunya Tula* means a 'meeting place for all brothers and cousins') was established in 1972 and incorporated as a company in 1975. Twenty years later, some twenty to thirty cooperatives (many featured in this book) along similar lines had been established throughout the Central and Western deserts, Arnhem Land and the Kimberley. Some cooperatives also manage the communities' cultural centres in which both historical and contemporary works of significance are retained in the community in question—displayed to educate both younger community members and visitors about the history and culture of the area. The arts centre building itself is sometimes the focus for the making as well as the storage, display and sale of art. Here works are catalogued, priced, packaged and dispatched, exhibitions organised, records kept and materials stored.

The style of building the centres occupy varies widely. Some are open-sided, vast, tin sheds providing shelter from the beating sun and tropical rains; others are more sophisticated, with

architect-designed buildings and air-conditioned storage and display areas. Some were set up or double as women's centres where women can escape family and other pressures. Artists, both men and women, often paint in the arts centre, or more often just outside—on the verandah or paved area—or in and around their own homes either in the community itself or at an outstation.

A number of arts centres encourage visitors and have a display area with works hanging and stacked against the wall, stored in piles or rolls through which the visitor can look. Others prefer to operate at 'arm's length' and do not encourage large groups of visitors.

When a work comes in to the centre, the artist and the coordinator agree on its wholesale price. The artist is then likely to receive around 70 per cent of this immediately, the balance paid on sale of the work. Works are sold by almost all the art cooperatives and individual artists on a strictly 'pay-when-purchased' basis. A few leading galleries produce exhibitions with works supplied on a consignment basis (the most common practice for non-Aboriginal art transactions), but this tends to be the exception rather than the rule.

The coordinator is responsible for supplying artists with canvases and painting material, retrieving finished works from artists, establishing a wholesale price for the works and paying the artists. As well, he or she deals with commercial dealers, organises group exhibitions in both private and public galleries, and responds to the many requests for information. Coordinators also often become involved in other cultural aspects such as helping coordinate painting trips to important sites and facilitating the painting of large collaborative works.

The role of the art coordinator

The great majority of art coordinators employed by the artists cooperatives since the early 1970s have been non-Aboriginals or Aboriginal people from a different area. While, from an outside perspective, this may seem to run counter to an ideal of Aboriginal organisations employing Aboriginal people, it is in fact a system the communities themselves have chosen. Within Aboriginal groups, loyalty to family and the extended network of relatives is strong. To have someone from one group or family responsible for the often pressured business of dealing with money and payments, establishing the price of works and

deciding on which artists works are seen can be extremely fraught.

Former coordinator at the Arnhem Land community of Ramingining, now curator of indigenous art at the Museum of Australia in Canberra, Djon Mundine described:

… I mean the pressures are pretty hard on a white adviser living within the community and if you are a local person it may be too much. In many instances, I've seen it has been too much on that person as regards to pricing and favouring particular art groups within the community.[18]

In many cases also, art has flowered at a community because of a unique interchange between community members and outsiders who bring new artistic skills. The establishment of the school of batik-making at the Central Desert community of Ernabella in the 1970s, a similar enterprise at its sister community of Utopia, the Hermannsburg school of pottery and the fabric workshops of the Tiwi Islands of Bathurst and Melville are just some of the examples where outside craftspeople's input has led to a thriving art movement.

Less easy to quantify, but also important, are the effects of the personality and interpersonal skills of a coordinator, which often result in fine-quality works. One of the greatest threats to sustaining quality works, in evidence from the early Papunya days on, is the temptation to drop standards in order to keep up supply. Most of the communities face this pressure at some stage. And weighing up the different needs—of the necessity of selling works (arising from both outside pressures and from the artists and the community itself) while allowing the art some time to develop gracefully, and allow space for the artists to explore other non-selling aspects of their art and culture—is one of the most difficult balances for coordinators and the community to achieve.

As well as the formal cooperatives, many artists, whether linked to them or not, sell their art to individual agents or dealers who often act as middle-people, buying works from artists and selling them on to retail and other outlets. This system is unlike those operating in other areas of the contemporary Australian art market and has arisen for several reasons, including speed of supply and the fact that many leading artists live far from capital cities so dealers usually visit them rather than vice versa.

Persistent in much of the public mind about this aspect of

Aboriginal art is the notion that avaricious dealers routinely rip
Aboriginal artists off, paying well under a fair price for works
which they then sell for many times more. There is no doubt this
does occur and has been the subject of concern to various
regulatory bodies for many years. There also exist, however,
numerous examples of fair dealing and long-term relationships
between dealers and artists to great mutual benefit.

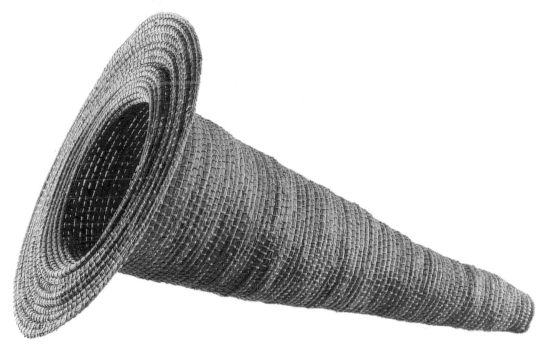

Introducing the art to a wider audience

Since the early 1980s, exhibitions have played a major role in
raising the profile of Aboriginal art and introducing it either in a
commercial or public gallery non-selling context to the world (see
A Buyer's Guide and Directory). Permanent displays of
Aboriginal art can also be found in most of Australia's public
collections. Particularly noteworthy are Canberra's National
Museum of Australia, Adelaide's Museum of South Australia and
Tandanya, Sydney's Yiribana Gallery at the Art Gallery of New
South Wales, Melbourne's Museum Victoria and the Ian Potter
Centre-NGV: Australian Art (opening mid 2002) and Darwin's
Museum and Art Gallery of the Northern Territory.

Australia's major indigenous art award, the National Aboriginal
and Torres Strait Islander Art Award, was started in 1983. With
its 150 to 200 exhibits, it continues to provide the most
comprehensive survey of the latest work of Aboriginal Australia.

Yvonne Koolmatrie, *Eel Trap*
(1997). One of the three women
artists to represent Australia at the
Venice Biennale in 1998,
Koolmatrie creates weavings which
make striking sculptural objects.

45

Also significant is the Canberra-based Heritage Commission's biennial Aboriginal Heritage Award in which artists are selected for not only their work's aesthetic qualities, but also its connection to place.

Latest developments

During the late 1980s and the 1990s, the appreciation of Aboriginal art broadened through the development of a strong school of urban-based Aboriginal artists, along with the increased inclusion of Aboriginal art in major survey and other exhibitions.

Australia has twice been represented by Aboriginal artists at the world's foremost contemporary art event, the Venice Biennale, with the 1991 displays of Rover Thomas and the urban-based Trevor Nickolls, and the 1997 exhibition of Emily Kame Kngwarreye, Yvonne Koolmatrie and Judy Watson.

The 1980s, especially leading up to Australia's bicentennial year in 1988 during which the rights of indigenous people were widely discussed, saw a growing interest in the work of urban-based Aboriginal artists. Artists such as Ian Abdulla, Gordon Bennett, Fiona Foley, Leah King Smith, Trevor Nickolls, Lin Onus, Judy Watson and numerous others offered either direct or more subtle evocations of what being Aboriginal meant. Sometimes confronting, sometimes poignant, their images speak clearly of recent Aboriginal history and add a further dimension to the work of land-based painters, sculptors, weavers and craftspeople.

The late 1980s and 1990s also saw a significant increase in the presence of indigenous people in management positions within Aboriginal art, including within Australia's major government funding body, the Australia Council; the major institutions; as freelance curators and in groups concerned with artists' rights and copyright issues. Aboriginal artists groups were also set up to oversee the rights of Aboriginal artists and arts centres in the northern region (the Association of Northern Kimberley Aboriginal Artists) and the central regions (DESART), as well as the National Indigenous Artists Association which represents indigenous artists on copyright and other issues of concern.

In the commercial sphere until the early 1990s, Aboriginal art tended to be shown in specialist galleries. While many collectors and other buyers responded to the art for many years, it appeared only briefly on the agenda of serious art criticism, due in large

part to its derivations being outside the bounds of the experience of many critics. This changed markedly in the 1990s when there was both a broadening of the critical base and the inclusion by leading non-specialist galleries of exhibitions by Aboriginal artists as part of their annual program.

In the 1990s, Aboriginal artists throughout the desert regions, the Kimberley and the Top End continue to provide the greatest number of paintings, carvings, sculptures, ceramics, fabric and other crafts for sale. The older, established communities have now been joined by new and exciting art-producing areas such as Queensland's Lockhart River and sometimes, as in the Warburton Ranges glass project, new media.

Also, during the 1990s, Aboriginal art entered the serious resale market with the Australian branch of Sotheby's auctions setting up a specialist department and undertaking increasingly high-profile and substantial specialist auctions of Aboriginal work.

During the 1990s the coming of newer generations into the older art-producing communities such as Balgo Hills, Papunya Tula (and its outstations Kintore and Kiwirrkura), Utopia, Warmun and Yirrkala saw the development of new styles and, sometimes, new media in these well established communities.

While many lament the passing of the 'golden days' of Aboriginal art of the late 1970s and early 1980s, when now famous painters were producing some of their finest works, with its wider acceptance and entry into the resale market, Aboriginal art at the end of the century could also be said to have entered a more sophisticated and exciting phase in its development. This is a phase in which the art of Aboriginal Australia can be assessed in a broad context—as a major, if not *the* major, force in contemporary Australian art.

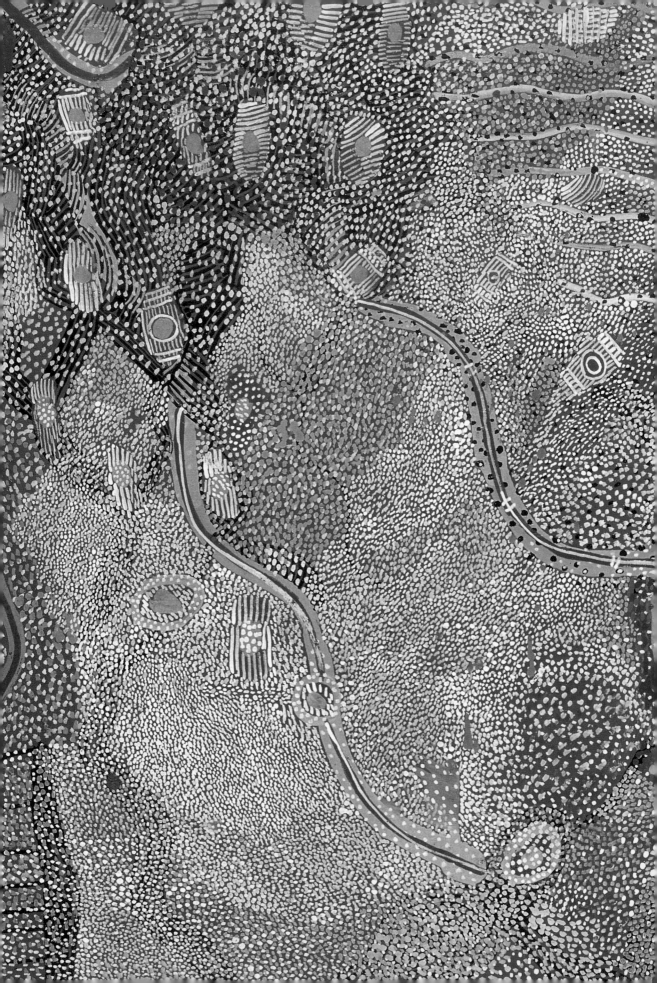

CENTRAL &
WESTERN
DESERT

I n Australia's centre, the red-sanded, rocky plains, broken by rolling outcrops of rounded or craggy hills, stretch into the blue-hazed distance. Within this vast scale, subtleties abound. Colours change with the progress of the day: from the early morning's clear light which so sharply defines shapes; to the silent, bleached flatness of the midday hours; to the soft purple-reds and sage greens of dusk. At night, temperatures plummet and the star-filled sky of the inky nights overwhelms with its sheer magnitude.

It was at Papunya, 230 kilometres northwest of Alice Springs, that the school of acrylic painting on canvas began in the 1970s. This has since become one of the most widely practised forms of painting for Central and Western Desert people. Over the next decade, it was followed by similar painting movements at other desert areas of Yuendumu, Utopia, Haasts Bluff, Ernabella, Hermannsburg (Ntaria) and Lajamanu.

As well as the main centres where painting predominates, thriving art and craft centres have developed in many other smaller communities. These make a variety of goods, including decorated beads, wood carvings, printed fabrics and pottery.

Indigenous heritage and European inroads

Until European exploration and settlement of Australia's desert regions from the early 1880s, the Warlpiri and Walmadjarri people of the north, the Kukaja and Pintupi of the west, the Pitjantjatjara and Luritja of the south and the Arrernte of the east had lived a traditional nomadic life. The cattle introduced by Europeans for the pastoral properties, which took over vast tracts of the land, soon degraded the fragile vegetation, often beyond regeneration.

Yet, until the mid-1900s, Aboriginal people could still maintain some connection to the land. Some worked as stockmen and women, others lived at the missionary communities of Ernabella and Hermannsburg, from where they could often travel. With the advent of government-established reserves at Haasts Bluff (1941), Yuendumu (1946), Lajamanu (1946) and Papunya (1961), however, such freedoms were curtailed. It was not until the 1970s—following agitation for Aboriginal land rights and the election of a Labor government which granted the first land rights to desert people—that restrictions on the settlements were eased. In the 1970s and 1980s, most of these government

LEFT: Mount Sonder West of Alice Springs shows the power of some of the marvellous landforms of the Central Desert region.

CENTRAL & WESTERN DESERT
Birthplace of a cultural revolution

PREVIOUS SPREAD: Detail from John Warangkula Tjupurrula, *Rain Dreaming* (1972). One of the finest examples of the rhapsodic quality created by the fine overlaying of dots by this master painter of the Papunya school of the 1970s.

communities were returned to Aboriginal control and people were free to move back to traditional lands to live in small outstation settlements.

From sand and body decoration to gallery walls
The main forms of traditional visual representations by desert people are sand and body painting made as part of ceremony.

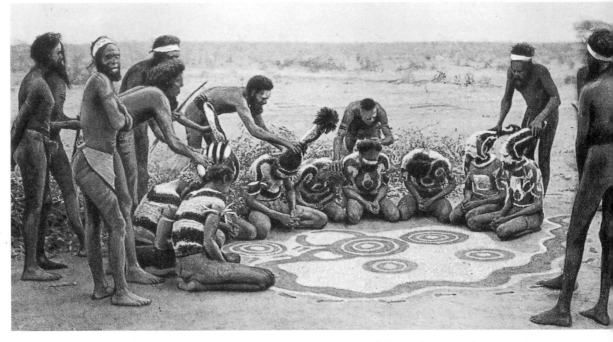

This historically significant photograph by ethnographers and explorers Baldwin Spencer and Frank Gillen, taken on an expedition through Central Australia in 1912, shows ground painting being made and ceremonial body paint applied by the men before a ceremony.

Weapons such as spears and clubs, utilitarian objects such as coolamons (women's carrying vessels) and the sacred wood or stone men's 'message boards', *tjurunga*, were also engraved for either decorative or ceremonial purposes. The small, usually oval-shaped *tjurunga* carry particular meaning, detailing the story of a man's life, his clan associations and major Dreamings. Of great significance to both the individual and the group, for safety's sake these were often stored en masse in a special keeping place for retrieval during times of ceremony.

Body decorations are also an important part of ceremonial practice and made from ochres ground to a paste with water then applied in striped or circular designs to the face and torso. Leading Utopia painter, Kathleen Petyarre, describes how women's body painting forms an integral part of ceremonial life:

The old women used to paint the ceremonial designs on their breasts, first with their fingers, and on their chests, and then with a brush called

a tyepale, *made from a stick. They painted their thighs with white paint. They painted with red and white ochres. Then they danced, showing their legs. The old women danced with a ceremonial stick in the earth.*

The spirits of the country gave women's ceremonies to the old woman. The woman sings, then she gives that ceremony to the others, to make it strong. The old woman is the boss because the spirits of the country have given her the ceremony. So all the women get together and sing.

The old women sing these ceremonies if people are sick; they sing to heal young girls, or children. If a child is sick in the stomach, they sing. The old women are also holding their country as they dance. The old women dance with that in mind. They teach the younger women and give them the knowledge, to their granddaughters, so then all the grandmothers and granddaughters continue the tradition.[1]

The modern acrylic paintings of many Central and Western Desert artists are based on these designs. Circles may indicate waterholes, a campsite or fire; lines may denote lightning, watercourses or ancestral paths; a 'u' shape usually indicates a sitting place or breasts; arcs may be boomerangs; short lines may be diggings sticks or spears. Realistic animal tracks and footprints are also often included.

The dots, which in various forms have become the most characteristic element of desert art, represent many things—stars, sparks, burnt ground, clouds. The dense, fine layering of dots seen in many Central and Western Desert paintings was developed as an artistic style in the mid-1970s by Papunya master painters, including John Warangkula Tjupurrula, Yala Yala Gibbs Tjungurrayi, Mick Namarari Tjapaltjarri and others. These artists developed the technique largely to mask the more direct symbolism and stories whose representation on early board was considered inappropriate for general viewing.

With an estimated 2000-plus Aboriginal artists and craftspeople making art in the Central, Western and Eastern deserts, styles of their images vary widely. While there are numerous painters living in and around Alice Springs whose work is individualistic, paintings from the communities are often identifiable by their stylistic similarity. These include the brilliant coloration and dense patterns of interwoven dots of the Warlpiri painters of Yuendumu; the ochre-based colours favoured by Papunya painters and the raw, free, thickly applied and often

rainbow, cloud, cliff or sandhill

rain

Fire, smoke, water or blood

waterhole waterhole

running water

clouds, boomerangs or windbreaks

star

a spiralling line can mean water, a rainbow, a snake, lightning, a string, a cliff or native-bee honey storage

man

two men sitting

concentric circles can mean a camp site, a stone, a well, a rock hole, a breast, fire, a hole or fruit

this grouping usually means four women sitting

sitting-down place

footprints

travelling sign, with the concentric circles representing a resting place

Some symbols used in Central and Western Desert paintings.

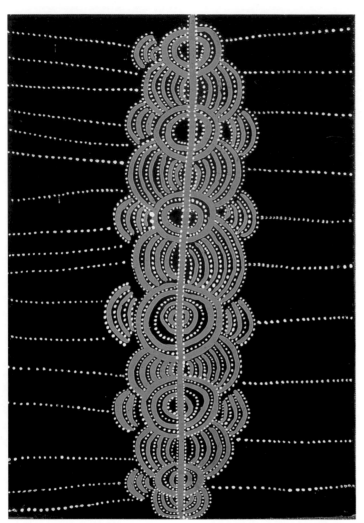

Mick Namarari Tjapaltjarri, *Bush Tucker Story* (1971–72). This early Papunya painting demonstrates the clearly defined elements and direct storytelling imagery of the first acrylic works from the new school of desert painting.

monochromatic colours of the painters of Lajamanu. The work of others, notably the late Emily Kame Kngwarreye, who is credited with being stylistically one of the boldest of Aboriginal painters, is noted for a sense of ongoing exploration and development.

Where to see and buy the art

Central and Western Desert acrylic or 'dot' painting is the most widely represented form of modern Aboriginal art. Australia's major state galleries (with the exception of Tasmania), Australia's National Gallery in Canberra, and the Museum and Art Gallery of the Northern Territory contain substantial collections of post-1971 Central and Western Desert art— shown in varying degrees of space on permanent display. The National Gallery of Victoria's new gallery of Australian art at Federation Square (to be opened mid 2002) has a large ground floor section devoted to the showing of Aboriginal art. The Art Gallery of New South Wales has a permanent gallery, Yiribana, devoted to Aboriginal art and housing both the permanent collection and changing exhibitions. The Art Gallery of South Australia has an important collection of 1970s Papunya board paintings and has built on these to form a major Central Desert collection. The Art Gallery of Western Australia also has a major collection of largely post-1980s Aboriginal art, while the Queensland Art Gallery is adding continually to its collection.

The National Gallery in Canberra has a good representative collection of Central Desert art, added to in 1998 by the purchase of the Peter Fannin collection of works from the early 1970s. In Darwin, the Museum and Art Gallery of the Northern Territory was the first public gallery actively to collect the then new form of Aboriginal art during the 1970s, and has collected it

continuously ever since. The National Museum of Australia's Gallery of the First Australians has a comprehensive display, as does Museum Victoria and the Museum of South Australia.

Commercially, the choice of art from this area is vast, ranging in price from about $50 to tens of thousands of dollars. This is particularly notable since Aboriginal art has entered the secondary art market largely through the activities of Sotheby's auctions and some major dealers during the mid-1990s. Here, works by early Papunya artists and other famous Aboriginal artists such as Emily Kngwarreye and Rover Thomas have leapt in price by tens of thousands of dollars within a few years, and now fairly routinely fetch prices ranging from $90 000 to more than $200 000.

Alice Springs's Todd Mall and surrounding streets contains the greatest number of Aboriginal galleries in a concentrated area, with art available ranging from the inexpensive tourist buy to some high-quality works. Galleries of particular note here are the Papunya Tula shop, Aboriginal Desert Art Gallery and Gondwana Galleries.

In Darwin, Framed Gallery and Karen Brown Gallery are two of the main outlets for Central and Western Desert art. Brisbane's Fire-Works Gallery represents many Central and Western Desert artists. In Perth, Dianne Mossenson's Indigenart shows the work of Central and Western Desert artists, often in exhibitions featuring younger

artists or new projects and community ventures. In Sydney, well-established specialist Aboriginal galleries carrying a full range of Central and Western Desert art include the Hogarth, Coo-ee, Desart, and Jinta galleries, while Utopia Art specialises in art from that area. In Adelaide, Gallery Australis shows some Central and Western Desert work, as does DACOU Aboriginal

This selection of individually designed batiks in brightly coloured cotton typifies the range and quality of fabric printing from the Ernabella school of batik making.

Ronnie Tjampitjinpa *Untitled* (1971–1972). An early example of one of the Central Desert's most famous artist, this striking work features the sense of movement which distinguishes this artist's later work.

Gallery and Tony Bond—Art Dealer. Melbourne's Gallery Gabrielle Pizzi was one of the first to show the work of Papunya and other early Central Desert artists while focusing also on works of urban and Arnhem Land artists. Other Melbourne galleries showing this work are Hank Ebes's Aboriginal Gallery of Dreamings, Alison Kelly Gallery, Vivien Anderson Gallery, and Aboriginal Art Galleries of Australia—the latter being the Melbourne branch of the Alice Springs gallery Aboriginal Desert Art Gallery.

In recent years, leading non-specialist galleries have started to hold regular exhibitions of Aboriginal art. Those showing works from the Central and Western Desert include Melbourne's Niagara, William Mora galleries, Lauraine Diggins and Sutton galleries.

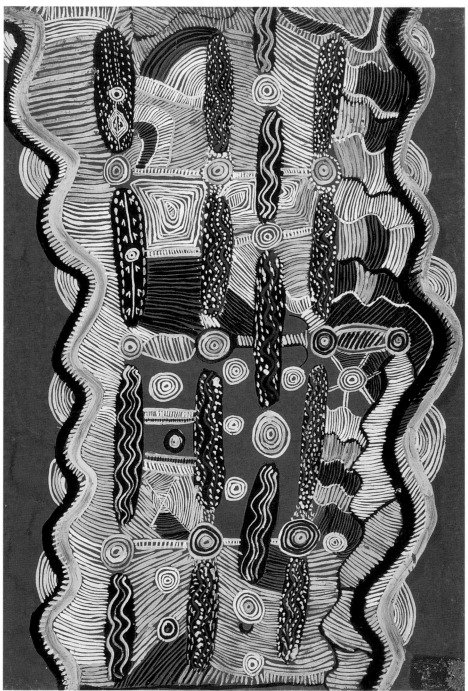

Recommended reading

General texts on art of the desert regions. For publication details see Recommended Reading page 233 *Aboriginal Art*, Wally Caruana, 1993; *Aboriginal Artists of the Western Desert: A Biographical Dictionary*, Vivien Johnson, 1994; *Aratjara: Art of the First Australians*, exhibition catalogue, 1993; *Art of the First Australians*, Aboriginal Arts Board of the Australia Council; *Australian Aboriginal Paintings*, Jennifer Isaacs, 1989; *Dreamings*, ed. P. Sutton, The Asia Society Galleries, New York, 1988; *Dreamings of the Desert*, Art Gallery of South Australia; *Mythscapes: Aboriginal Art of the Desert*, National Gallery of Victoria; *Nangara: The Australian Aboriginal Art Exhibition*, Ebes Collection, 1996; *Tjukurrpa: Desert Dreamings*, Art Gallery of Western Australia, 1993; *Oxford Companion to Aboriginal Art and culture*, eds Neale & Kleinert, 2000; *Papunya Tula: Genesis and Genius*, Art Gallery of New South Wales, 2000; *Visual arts and crafts sources directory*, ATSIC, 2000; *Aboriginal Art*, Howard Morphy, 1998.

Turkey Tolson Tjupurrula, *Straightening Spears at Ilyingaungau* (1990). This striking painting represents the spears used by Tolson's ancestors at Ilyingaungau, a rocky outcrop west of Alice Springs, during a fight for their territory with a neighbouring tribe.

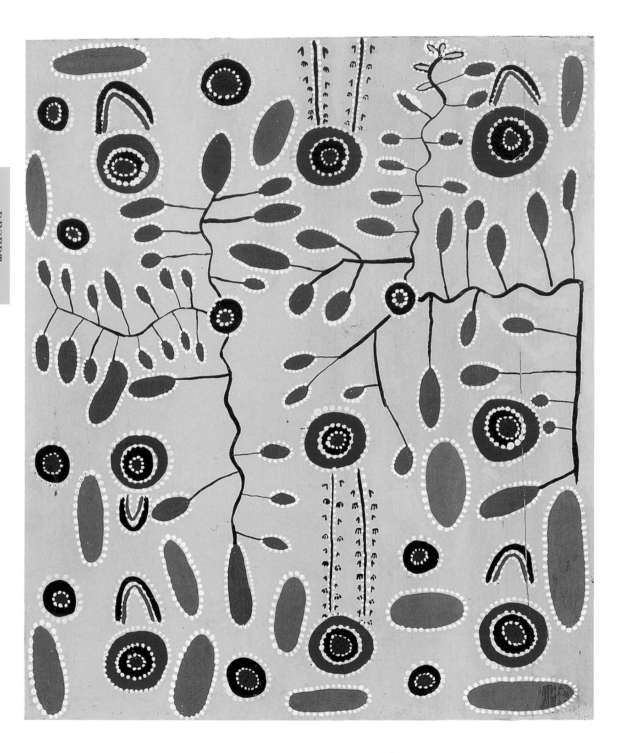

I t was quite a moment as we all watched … the first hieroglyph being put on the wall lovingly and beautifully with a marvellous painting technique. Some of the men went across and touched the wall even before the paint had dried. Then the little children came across and stood beside the old painting men and Kaapa [Kaapa Mbitjana Tjampitjinpa—one of the most significant early painters] and we all stood back and watched the start of the honey ant mural as it was finally to appear. This was the beginning of the Western Desert painting movement, when led by Kaapa, the Aboriginal men saw themselves in their own image before their very eyes, on a European building. Something strange and marvellous was set in motion.'[1]

PAPUNYA

Something 'strange and marvellous set in motion'

The Honey Ant mural which teacher Geoffrey Bardon had encouraged the painting of on the walls of the schoolhouse at Papunya in 1971 was, as he says, the start of the whole Central and Western Desert art movement. Today, however, there is little to remind the visitor that such significant events in the development of Australian art had taken place. The famous mural has long since been painted over and the painting room, the centre for flourishing activity in the 1970s, no longer exists.

Some 250 kilometres west of Alice Springs, Papunya was the last of the Aboriginal reserves to be set up by the federal government, in 1960. Today, the modest buildings linked by stone-filled dusty 'streets' are shaded in desultory fashion by the occasional large eucalypt. Flat desert stretches on each side, broken only by a rocky outcrop or small hill. Small, prefabricated houses line the streets—their concrete open verandahs, the most popular living areas, spread with bedding and cooking utensils. Larger public buildings—the school and medical centre—service the community's several hundred members.

During the late 1970s and 1980s, with the return of the area to Aboriginal control, many Papunya residents moved out to smaller communities. A Pintupi community of around 300 people was established at Kintore, next to the border with Western Australia, in 1981; Kiwirrkura, 250 kilometres further west in Western Australia itself, was established in 1983. Many of today's artists live at these communities, with around twenty to thirty artists at Papunya itself, and many also spending time in Alice Springs.

Papunya Tula Artists Pty Ltd, the cooperative established by the artists in 1971 to manage their work, remains the formal outlet for the paintings of Papunya artists. Operating from a shop

LEFT: Billy Stockman Tjapaltjarri's *Wild Potato (Yala) Dreaming* (1971) was one of the second group of paintings by eleven Papunya artists to be sold at Alice Springs's Stuart Art Centre in 1972.

in Alice Springs's Todd Mall, the cooperative has forty-five shareholders and services the needs of 250 artists.

The evolving art of Papunya

The style of Papunya art, whose development is explained in detail in the Introduction (page 51), has grown and changed over the years. The first Papunya paintings in 1972 followed in the same style—and with the same intent to record stories—as the murals on the school buildings. Symbols and designs as seen in Billy Stockman Tjapaltjarri's 1971 *Wild Potato (Yala) Dreaming*, (page 59) are codified over a plain red-brown, black or yellow background. Shapes are simple and few. Arcs, concentric circles and 'U' shapes predominate, sometimes outlined or linked by large dots. Sacred landscape elements are also depicted through the stylised symbols and sometimes figurative renditions of objects such as painted spears, boomerangs, shields and axes are used. Colours are restricted to those resembling those of the rocks and earth—white, yellow, red and black.

Traditionally, many of these images were intended only to be viewed by a select entitled few, or made in sand as part of a ceremony, after which they were destroyed. Translating them onto a permanent medium caused an immediate dilemma. On the one hand, re-creating the images on more permanent materials meant that they were being recorded for posterity and as learning tools for youngsters, as well as being the means by which the non-Aboriginal population could learn something of Aboriginal culture. On the other, these images being seen by people outside the select few, even those who had no idea of their significance (the vast majority of viewers—and certainly almost all non-Aboriginals), was a serious transgression of Aboriginal law.

How to keep painting without revealing the sacred–secret images? One answer was to reproduce only those images of a secular nature—ones which related important Dreaming stories and events, but not restricted to viewing only by an initiated group. Then an innovative stylistic solution was found. Dots seen in the sand paintings and other visual representations mainly as outlines or large decorative elements were reduced in size and painted as overlays to obscure the stylised symbols. The symbols were thus all but hidden from view to all except those initiated who understood exactly what it was at which they were looking. Instigators of this 'dot' style—which has since, in one form or

another, become the predominant style of Central and Western Desert art—included the late Anatjari Tjakamarra (c. 1930–1992), Kaapa Mbitjana Tjampitjinpa (c. 1920–1989), Clifford Possum Tjapaltjarri and John Warungkula Tjupurrula. Warangkula's paintings, such as the 1973 *Rain Dreaming* (page 50), are particularly fine examples of the emerging style and, aesthetically, works of enormous beauty and often great radiance.

Gradually, as others took up the new style, the dots became not just the masking device by which elements were concealed, but also the basis of the work itself.

Colours of the earth

In the Papunya Tula art movement's first years (1972–73), the palette was restricted to ochre colours. From about 1973, during the time Peter Fannin was art adviser, for a time the colours broadened to include blues, greens, purples and pinks.

Shortly after, however, the artists decided to revert to their original concept of mainly using the four basic colours—yellow, white, red and black—of the naturally found ochre and charcoal. Although the acrylics used are not natural materials, since the mid-1970s, the palette of the Papunya artists has largely, but not always, been restricted to these colours, which are mixed to produce an amazing variety of hues.

Stylistic formality and beyond

Stylistically, Papunya art remains—with a few individual exceptions— quite formal. Artists such as Clifford Possum have, in essence, stayed within the bounds of a highly distinctive, consistently recognisable style—as in the *Honey Ant Dreaming story* of 1983 (pages 20–21). One of the younger of the original 'Bardon painting men' and the last to join, Possum had been a skilled woodcarver, originally employed at Papunya to teach children carving.

Others, including Turkey Tolson Tjupurrula, Maggie Poulson and Mick Namarari Tjapaltjarri, made progressive stylistic changes. Another of the original 'Bardon painting men', the late Mick Namarari, in particular, displayed in his work a sense of visual exploration.

Various stages his work moved through included the sparse and highly symbolised early 1970s paintings, the veiled effects of dotted overlays during the mid-1970s and the broad, painted

In 1980, Geoffrey Bardon returned to Papunya for a visit: '… I sometimes thought … that an older Australia was passing away forever, that our own symmetries had been set aside and made helpless, and that a new visualisation and idea of the continent had come forth … It is hard to be clear about an entire continent wondrously re-perceived by the brutally rejected and sick, and poor. Yet this is what occurred. This was the gift that time gave, and I know this, in my heart, for I was there.'[2]

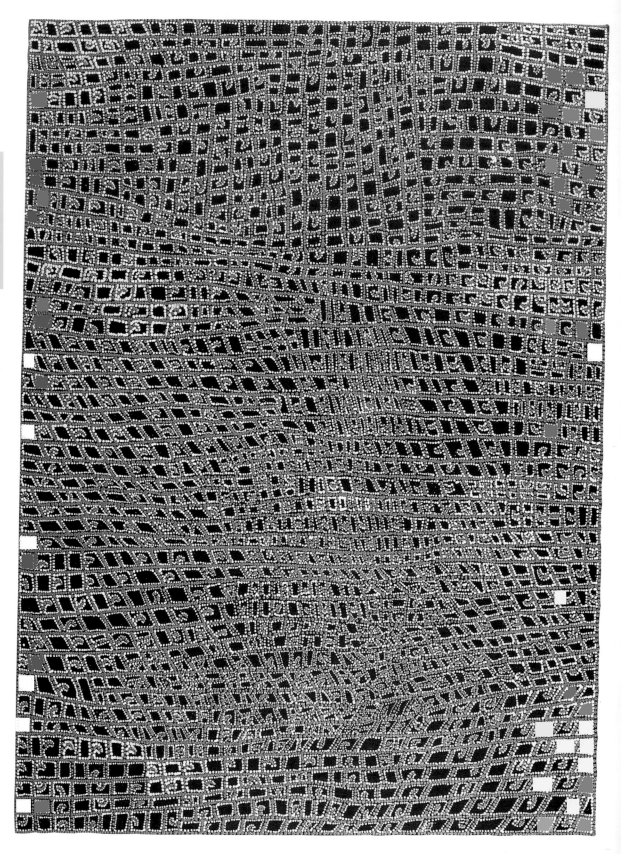

bands and interlinking geometric squares of his 1990s *Tingari* story paintings.

Along with the continuing work of the original painters, during the 1980s a new generation of painters evolved. Michael Jagamara Nelson started painting in 1983 and, in 1988, designed the mosaic for the forecourt of the new Parliament House in Canberra. His paintings such as *Five Stories* (left) have been exhibited many times in solo and group shows in leading commercial and public galleries, as have been those of Dini Campbell, Ronnie Tjampitjinpa and Freddie Ward Tjungarrayi. These painters, based at the small settlement at Kintore since the outstation was established in the 1980s, have produced numerous distinctive paintings such as the 1985 *Tingari Men at Pilintjinya* (page 78) by Simon Tjakamarra (c. 1946–1990). The concentric circles or roundels symbolise a series of sacred–secret sites, interlinked by a series of networked lines.

LEFT: Dorothy Napangardi, *Mina Mina Women's Dreaming*, (1998). One of Napangardi's distinctively detailed works which relates to the Mina Mina site near China Well in the Tanami Desert.

Some Papunya artists
Jagamara, Malcolm Moloney; Napangati, Pansy; Nelson, Michael Jagamara; Nungurrayi, Gabriella Possum; Sandy, William; Syddick, Linda Junkata Napaltjarri; Tjakamarra, Anatjari; Tjakamarra, Freddy West; Tjakamarra, John; Tjakamarra, Long Jack; Tjakamarra, Simon; Tjampitinpa, Anatjari; Tjampitjinpa, Dini Campbell; Tjampitjinpa, Dini Nolan; Tjampitjinpa, Kaapa Mbitjana; Tjampitjinpa, Maxi; Tjampitjinpa, Old Walter; Tjampitjinpa, Ronnie; Tjangala, Major Riley; Tjangala, Uta Uta; Tjapaltjarri, Billy Stockman; Tjapaltjarri, Clifford Possum; Tjapaltjarri, Charle Egalie; Tjapaltjarri, Mick Namarari; Tjapaltjarri, Tim Leura; Tjapangarti, Timmy Payungka; Tjungurrayi, Charlie Tarawa; Tjungurrayi, George; Tjungurrayi, Shorty Lungkarda; Tjungurrayi, Two Bob; Tjungurrayi, Yala Yala Gibbs; Tjupurrula, John Warangkula.

Where to see and buy the art
From the early 1980s, artists such as Clifford Possum Tjapaltjarri, Michael Jagamara Nelson and Turkey Tolson Tjupurrula have had work selected for major contemporary art exhibitions. These included the Art Gallery of New South Wales's Perspecta (from 1981); the São Paulo Biennale and several important major international touring exhibitions. In 1988, Clifford Possum was given a solo exhibition in 1988 at London's Institute of

RIGHT: Michael Jagamara Nelson, *Lightning* (1998). A new development in the work of this well known Central Desert artist, this striking work was one of a series of paintings created in Brisbane in 1998 and demonstrates the capacity for many Aboriginal artists to evolve new styles.

Contemporary Art. During the 1980s, major Papunya works were also commissioned for airport lounges (the Alice Springs airport displays a major Clifford Possum as an excellent introduction for visitors), corporate collections and foyers, and public institutions. They also featured in exhibitions such as the National Gallery of Victoria's 1989 exhibition Mythscapes: Aboriginal Art of the Desert (the catalogue of which remains an excellent survey of art from this area).

As noted in 'Central and Western Desert: birthplace of a cultural revolution', most major state and Australia's national gallery contain many examples of Papunya and other Central Desert art. One notable Papunya work in a public collection, however, is the late Tim Leura Tjapaltjarri and his younger brother Clifford Possum Tjapaltjarri's *Napperby Spirit Dreaming*, held in the collection of the National Gallery of Victoria. Made in 1980, the 7-metre long painting details the major Dreamings of the brothers' Anmatyerre country near Napperby Station. The Art Gallery of South Australia also has a particularly fine collection of early Papunya boards.

The Papunya Tula Artists' Cooperative, based in Alice Springs's Todd Street, is the main wholesaling outlet for Papunya works and also sells direct to the public. Others of the numerous Todd Mall galleries selling the work of Papunya artists include Michael Hollow's Aboriginal Desert Art, Gallery Gondwana and another Papunya community-established gallery, Warumpi.

In Sydney, Utopia Art and Hogarth Galleries stock Papunya art and hold exhibitions of individual artist's work. In Melbourne, Gallery Gabrielle Pizzi was the first to display Papunya art and continues to represent it. William Mora Galleries holds occasional exhibitions of the work of major Papunya artists, as does Alison Kelly Gallery, while the Aboriginal Gallery of Dreamings and Aboriginal Art Galleries of Australia have a wide variety of stock. Brisbane's Fire-Works Gallery represents artists from this region, as does Adelaide's Gallery Australis, Perth's Indigenart, Darwin's Framed Gallery and Aboriginal Fine Arts Gallery, and Canberra's Chapman Gallery.

Since the mid-1990s, a strong secondary sale market for the earliest Papunya works has developed as a result of Sotheby's regular auctions of Aboriginal-only works from 1996 onwards.

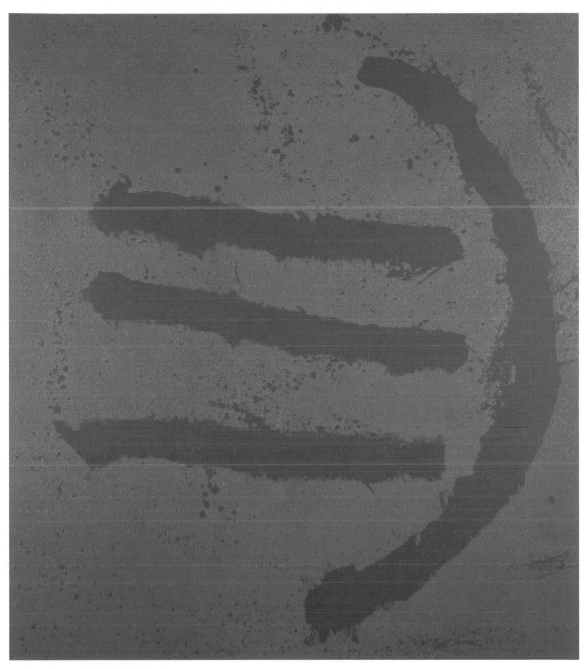

Recommended reading

For publication details see Recommended Reading page 233. All books listed as recommended reading in the introduction to this section and *Papunya Tula: Art of the Western Desert*, Geoffrey Bardon, 1991; *The Art of Clifford Possum Tjapaltjarri*, Vivien Johnson, 1994 (reprinted 1996); *Michael Jagamara Nelson*, Vivien Johnson, 1997; *Papunya Tula: Genesis and Genius*, AGNSW, 2000.

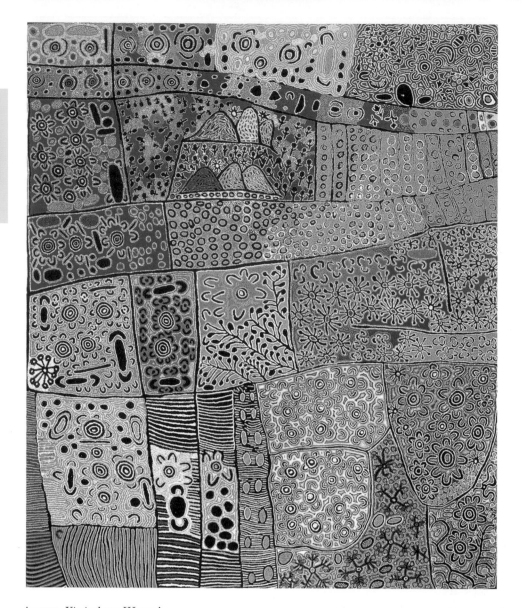

ABOVE: *Kiwirrkura Women's Painting* (1999). This detailed painting was painted by 18 Kintore/Kiwirrkura women and depicts designs relating to the rockhole site of Marrapinta.

RIGHT: Charlie Tarawa Tjungurrayi, *An audience with the Queen* (1989). Painted after the artist had been introduced to Her Majesty Queen Elizabeth II. The lines on the border show the fence around the meeting place which is manned by guards.

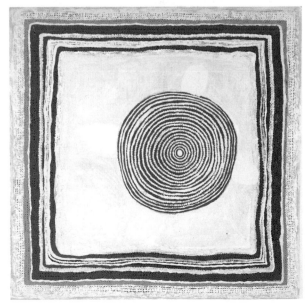

Kintore was established as an outstation of Papunya in 1981. Later a further settlement was established at Kiwirrkura, further north-west. Many of the well known 'Bardon men' painters who started painting with teacher Geoffrey Bardon in the Papunya community in the early 1970s later moved back to their Pintupi homelands which surround Kintore. Other important painters based at Kintore, who started painting after this include the brothers Walala and Warlimpirrnga Tjapaltjarri, who were amongst the last central desert indigenous people to 'walk out' of the desert into a European organised community in 1984. Their largely black and white or brown and white clearly delineated paintings often depict the Tingari story (see page 78).

In 1994 a women's painting project was held between the women of the Haasts Bluff area who hold strong familial ties with the Kintore women and later exhibited in Sydney's Utopia gallery. A jointly painted canvas by the Kintore women was produced as well as numerous individual works. Since, the women of Kintore, who are often related to the well known male painters, have been producing exciting freely-textured works that have received high acclaim.

Although the influence of the women's more experienced male relatives can be seen, their work has also evolved its own highly distinctive style. The acrylic paint is often thickly applied, the designs free and the colours varied. Often the colours are soft pastel orange-pinks, or ochre-reds against a white background; sometimes quite bold blues, oranges, purples and golds predominate.

Subjects include Tingari Women's cycles which relate the stories of the women who accompanied the men on their traditional journeys throughout the desert.

KINTORE & KIWIRRKURA
An art movement extends

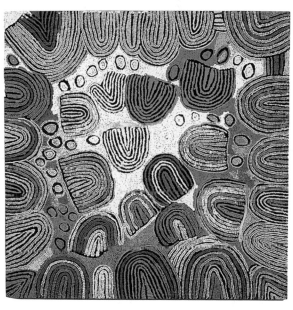

ABOVE: Naata Nungurrayi, *Untitled*, 2000. This subtly coloured work by one of Kintore's leading women painters shows the fine balance of women's designs which typifies the later styles of women painters from this area.

Some Kintore and Kiwirrkura artists
Nampitjinpa, Kayi Kayi; Nampitjinpa Inyuwa; Nampitjinpa, Nyurapayia; Nampitjinpa, Yuyua; Napanangka, Makinti; Napangati, Denise Reid; Napangati, Florrie Watson; Napurrula, Ningurayi; Nungurrayi, Naata; Nungurrayi, Nancy; Tjapaltjarri, Walala; Tjungurrayi, Charlie.

See Papunya for where to see the art and recommended reading.

Clifford Possum Tjapaltjarri,
Untitled (Bushfire Dreaming)
(c. 1986).

CLIFFORD POSSUM TJAPALTJARRI

b. 1932, Napperby Station, NT. Language group: Anmatyerre.

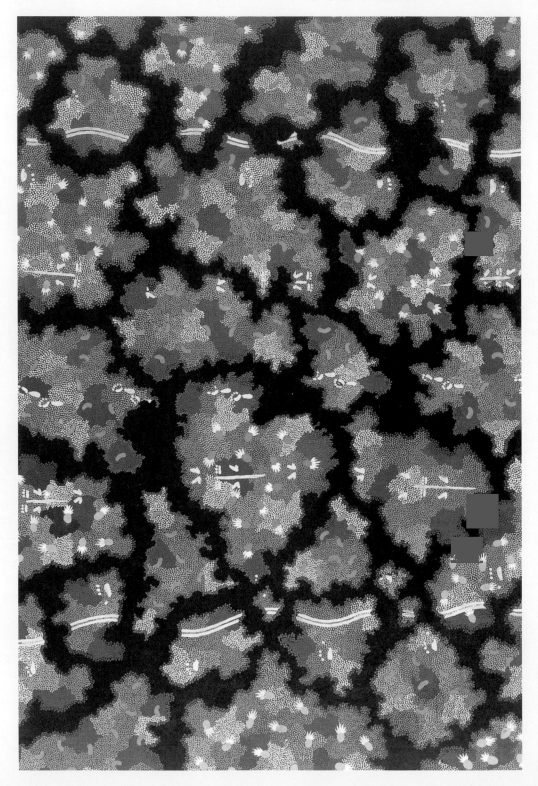

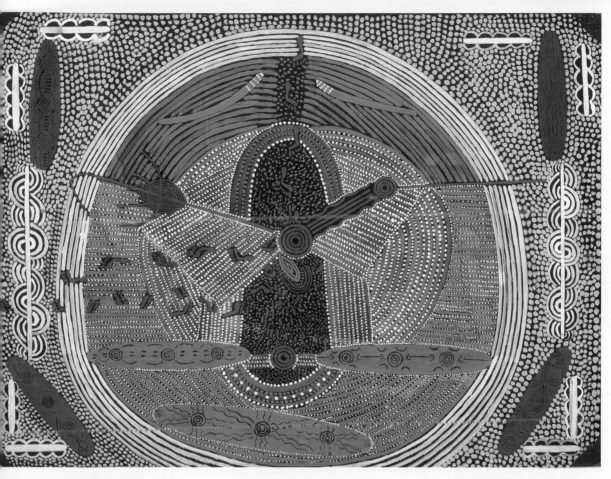

One of the youngest and last to join the 'painting men' at Papunya in the early 1970s—although his painting of traditional stories had started even before this—Clifford Possum has become one of the most well known of the many Western Desert artists. As a young man, Possum worked as a stockman on cattle stations around the Central and Western Desert areas, becoming also a skilled wood carver. As a child, he observed the famous Hermannsburg painter Albert Namatjira depicting their country in Western-style, realistic watercolours.

According to his biographer Dr Vivien Johnson, Clifford Possum's work is differentiated from many of the early Papunya painters by the artist's ability to perceive a parallel between the maps of Europeans and traditional Western Desert sand painting maps of country. 'Only Possum', she writes, 'went on to … develop the potential of scaling up the mapping enterprise to produce a series of 'deeds of title' to his home country, whose monumental size, complexity and sheer visual impact proclaim their cultural authority.'[1]

Seen in numerous important solo and group exhibitions from 1977, Possum's painting attracted both local and international attention, with works being collected by most major national public and private collections.

Clifford Possum Tjapaltjarri, *Love Story* (1972). The second painting Clifford Possum painted at Papunya, this lyrical work depicts the ceremonies performed by Possum's ancestral relative Lilipiliti Tjungurrayi to entice a Napangati woman to his campsite, including spinning hairstring, during which he 'talks his thoughts to the wind', the hair blown away as Lilipiliti is distracted by the woman's approach.

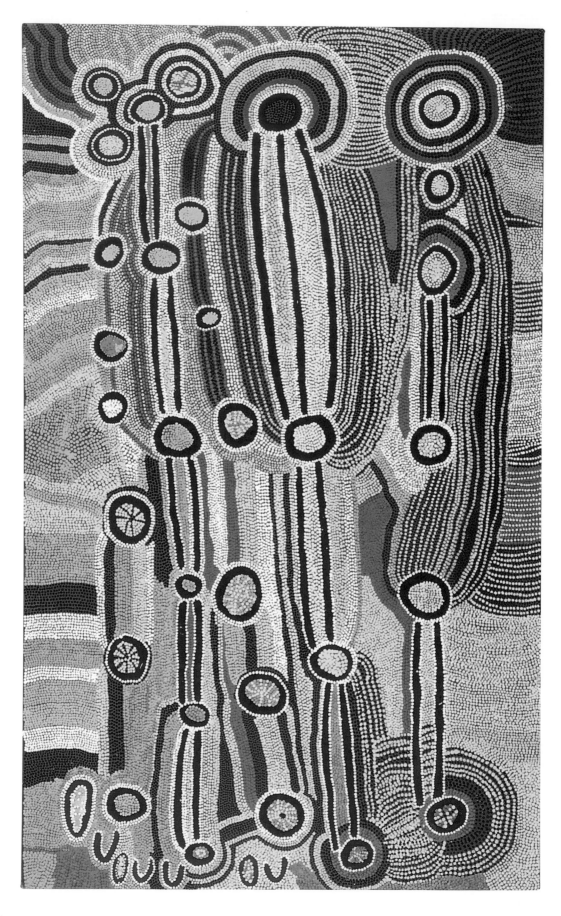

ry to limit Warlpiri colours and you're in trouble... look we've got these colours all around us everywhere. Japaljarri [Paddy Stewart Japaljarri, one of the senior painters] pointed at the sky and said 'Look, blue' and then to a plastic bag stuck on the wire fence. 'Red's there. These are the colours of our world, you know.'[1]

Yuendumu art has, from its outset in the mid-1980s, been notable for its use of bright colours and intricate patterns.

Three hundred kilometres northwest of Alice Springs, Yuendumu was established in 1946 and handed over to its community of around 800 Warlpiri people in 1978. Like most of the settlements established in the 1940s to 1960s under the government assimilation policy, the main Yuendumu settlement comprises a mixture of buildings, linked by winding dirt streets. The outside walls of the community's arts centre, Warlukurlangu Arts, are completely covered by brilliantly coloured Dreaming story murals. Inside, an air of casual efficiency prevails. Painting is generally done away from the centre, which has become the arts administrative and display heart. Some paintings are stretched and hung on walls; others are in piles or rolled in a storage area, and are brought out for viewing.

Women's body painting: an art movement is born

Yuendumu's modern painting movement started some ten years after that at Papunya, 100 kilometres to the south. It came about following the distribution of art materials by anthropologists Francoise Dussart and Meredith Morris as a continuation of their research and recording of women's body painting designs. The new materials were enthusiastically greeted by the women, a group of about thirty of whom undertook to paint and sell enough decorated coolamons, beads and small boards to raise money to buy a four-wheel drive vehicle.

The project was a success and, shortly after, the community asked several of the male elders to paint Dreaming stories on the school's doors in order to pass them on to the children and younger members of the community.

The first exhibition of Yuendumu paintings was held in 1985 at Sydney's Hogarth Galleries. As the show's press release indicates, the paintings stood out from much other desert art as they were 'less contrived, freer and less stylised than other desert paintings ... the effect ... more contemporary, even post-modernist, in the

LEFT: Maggie Napangardi Watson, *Jinti-parnta Jukurrpa (Native Truffle Dreaming)* (1992). This story is part of the women's Dreaming belonging to the painter's people. She relates stories of the journeys the women took collecting food such as the edible fungus or truffle, *Jinti-parnta*. Found after the rains, it creates cracks in the earth's crust as it forces its way upwards.

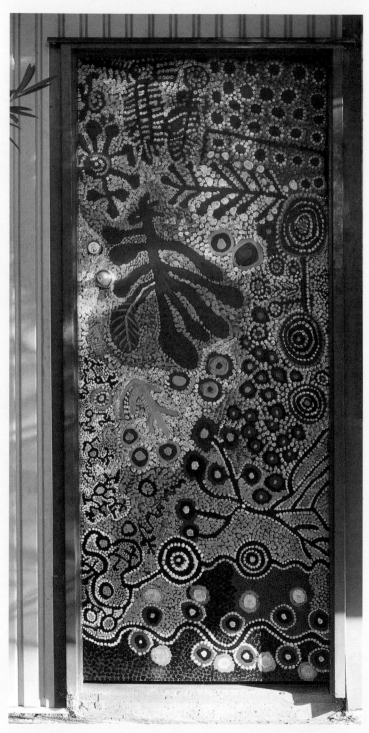

Paddy Japaljarri Stewart, *Puurdakurlu Manu Wnalijikirli (Yam and Bush Tomato)*, Door 7 (1984). Relating to a place west of Yuendumu, the painting describes the importance of these fruit and vegetables to the Dreamtime ancestors, as well as to the older people in the days when the fruit was more abundant.

YUENDUMU DOORS

We want our children to learn about and know our Law, our Dreamings. That is why we painted these Dreamtime stories.
PADDY JAPALJARRI STEWART.[2]

In 1984, at the suggestion of school headmaster Terry Davis, forty-two doors of the Yuendumu school were painted. Davis wanted the school to look 'less European' and to have Warlpiri stories passed on to the younger generation. Painters were senior men Paddy Jupurrula Nelson, Paddy Japaljarri Stewart, Paddy Japaljarri Sims and Roy Jupurrula. Recorded on the doors are the important stories and events in the Dreamtime life of the lands and people around Yuendumu. As Eric Michaels describes, they 'stand midway between canvases exported for European audiences and their sources which are in ceremonial groundpaintings oriented to specific geographical sites'.[3]

Over the years, their purpose served the doors stayed in situ until bought by the South Australian Museum in 1995. The museum had the doors restored, keeping some of the graffiti with which they became covered intact. The doors are now featured in a major display in the museum—a tribute to a significant event in the history of modern Aboriginal art.

striking application of colour'. The sale at the exhibition of a large night sky painting to the National Gallery of Australia for $3000 and other smaller works enabled the establishment of the artists' cooperative Warlukurlangu Artists Association (*Warlukurlangu* means 'Fire Dreaming') . The following year, an exhibition in Perth was a huge financial and public success, sealing Yuendumu's presence as a major centre for art.

In 1989, six Yuendumu artists were invited to exhibit a large 10-metre x 4-metre ground painting *Yarla* as part of the exhibition Magiciens de la Terre at the Pompidou Centre, Paris. Made entirely from natural materials, including ochre, charcoal, hair and string, the painting created international interest in both the Yuendumu community and Australian Aboriginal art in general.

Since then, more than sixty exhibitions of Yuendumu work have been held in major galleries in Australian capital cities and overseas, with Yuendumu artists participating in more than 1000 other group exhibitions. Major commissions have included an external mural by six Warlpiri women artists for the South Australian Museum in 1988; a 7-metre x 3-metre painting worked on by forty-two artists for the Aratjara touring exhibition; fourteen paintings for the National Gallery of Australia (1992) and, in 1995, a set of thematically linked works featuring a number of Dreamings which formed the foundation of a new collection featured in a major Pacific Arts Exhibition at St Louis Museum in the United States.

On its establishment in 1986, Warlukurlangu Artists Association had ninety members; ten years later, it represented 150 artists, with enthusiasm for painting still vibrant.

Paddy Japaljarri Sims, *Kunajarrayi Jukurrpa (Mount Nicker Dreaming)* (1986). This painting by one of the senior artists typifies the mosaic-like intricacy of some of the most memorable Yuendumu paintings. It relates the stories of the witchetty grub, budgerigar and women's Dreamings passing through the painter's ancestral lands.

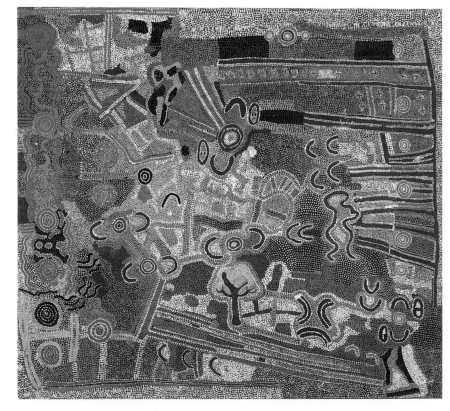

'We generally can't keep up with the demand for canvas and paint, and if we could, the market couldn't absorb all the work produced,' said former art coordinator Christine Lennard in 1995. 'It is also far from an elitist movement. The kids can come and get boards and paints, and the old people encourage them to participate, so new talent is being nurtured.'[4]

A riot of colour

Unlike those of their sister community Papunya, who decided to restrict their palette to ochre-like colours, Yuendumu painters have always used bright acrylics of many hues.

Jukurrpa, the Dreaming lore on which the painting is based, pervades all aspects of life. It is fundamental to lifestyle, codes of behaviour, respect for the land, the law, relationships within the tribe, the ritual and ceremony, hunting and food gathering.

Also unlike its sister community of Papunya, the majority of whose painters have been men, easily more than half of Warlukurlangu's artists are women. Until the early 1980s, most anthropologists working with Aboriginal communities were men, with women anthropologists such as the WA-based Catherine Berndt usually taking field trips accompanied by male colleagues. During the 1980s, however, a women-only focus at Yuendumu evolved with the interest shown in women's ceremonies and body designs by Dussart and Morris. Many of Warlukurlangu's art coordinators have also been women. And it was the women painters who chose the name 'Warlukurlangu' itself.

'The first responsibility Dreaming of the women who worked with Francoise Dussart was Warlukurlangu—Fire Dreaming,' says Lennard. 'So they called themselves "Warlukurlangu". When it came to naming the organisation, the women said, "We started it and we're naming it." And that was the end to it.'[5]

Collaboration in the community

The strong sense of cohesion in the Yuendumu painting community has been evident in the largely steady stream of good-quality works and competent organisation underpinned by the regular undertaking of some large cooperative projects. These often have to do with locating specific sites belonging to different Dreamings.

Groups of sometimes up to forty people go on the journeys, up to three of which are made each year. Back at the community,

some large collaborative paintings are produced, sometimes with as many as fifteen people working on the one canvas.

The large 1993 collaborative work *Ngarlu Jukurrrpa (Sugarleaf Dreaming)* (below), painted by various artists, tells the story of the pink-flower bearing sugarleaf bush whose Dreaming country is east of Yuendumu. Here, the story goes, Lintipilinti, a Dreamtime Jungurrayi man, fell in love with a taboo Napangardi

Various artists, *Ngarlu Jukurrpa* (1993). Large, intricate and wonderfully rhythmic, this complex work relates the Ngarla

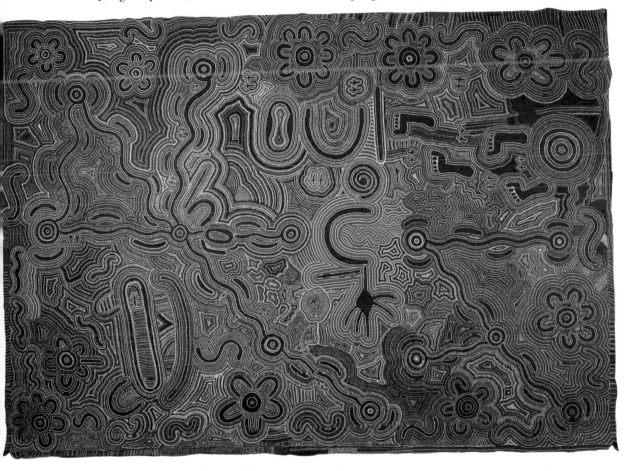

woman (his classificatory mother-in-law). Singing magic love songs which were conveyed to Napangardi by a small bird, Litipilinti's love magic was so strong she started dreaming of him and was drawn to the waterhole where he was camped, where they met and made love. The Ancestral Spirits were so angered by the pair's wrongdoing, they turned the couple into stone.

Such stories are often painted with the assistance of a large part of the community, including many who are not painters. Thus the paintings' creation is both an absorbing communal activity and a means of relating stories and laws to a younger generation.

(Sugarleaf) Dreaming and the tale of the Jungurrayi man, Lintipilinti, and his taboo love affair with his classificatory mother-in-law, a Napangardi woman.

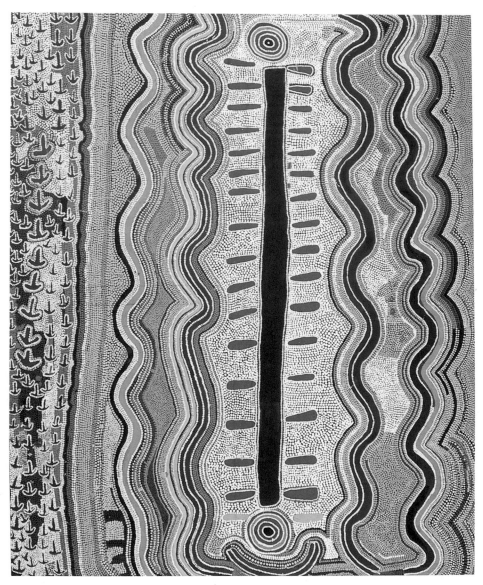

Yuendumu's early paintings, says Christine Lennard, were particularly vibrant, 'the designs raw and explosive, executed with large, almost messy brush strokes with a freedom unlike the meticulous, minimalist work of Papunya Tula artists'. Later works developed a more precise quality, while losing nothing of their vibrant coloration. Paddy Japaljarri Sims's 1989 *Kunajarrayi Jukurrpa (Mount Nicker Dreaming)* (page 73) shows the denser and more brilliant coloration, smaller dotting and mosaic-like pattern that has characterised Yuendumu painting since the late 1980s.

Darby Jampitjinpa Ross, *Ngapa Manu Yankirri Jukurrpa (Water and Emu Dreaming)* (1989). This large work relates the story of the rains, the clouds that created them and the path of the floods that arose over the lands, bringing an abundance of bush tucker as they subsided.

Women's and men's painting may also differ in some design and content, although both use concentric circles. Women's paintings such as Maggie Napangardi Watson's *Junti-Parnta Jukurrpa (Native Truffle Dreaming)* (page 70) often depict aspects of nurture, birth and death. This painting typifies the larger dotting and more classic colours of early Yuendumu painting—the women of the Nakamarra and Napurrula subsections are responsible for digging for sweet potatoes. Men's paintings such as Darby Jampitjinpa Ross's 1989 *Ngapa Manu Yankirri Jukurrpa (Water and Emu Dreaming)* (left) may focus on lines of site or ceremonial journey.

Some Yuendumu artists

Brown, Sheila Napaljarri; Carroll, Paddy Tjungarrayi; Daniels,
Dolly Nampijinpa; Egan, Jeannie Nungarrayi; Granites, Judy
Nampijinpa; Granites, Rex Daniel Japanangka; Jupurrula, Ray;
Napangardi, Eunice; Napangardi, Molly; Nelson, Lorna
Napurrula; Nelson, Paddy Jupurrula; Poulson, Clarise
Nampijinpa; Poulson, Maggie Japangardi; Poulson, Peggy
Napurrula; Rice, Thomas Jangala; Ross, Darby Jampitjinpa; Sims,
Bessie; Sims, Paddy Japaljarri; Spencer, Larry Jungarrayi; Stewart,
Paddy Japaljarri; Walker, Liddy Napanangka; Watson, Lawrence;
Watson, Maggie Napangardi.

Where to see and buy the art

Of special interest among the Australian public galleries' holdings
of Yuendumu art is that of the Art Gallery of Western Australia,
which has a fine collection of both individual and large
collaborative works from the late 1980s onwards.

 The Warlukurlangu Artists Association at Yuendumu is largely
a wholesale outlet, although some groups and dedicated collectors
may make arrangements to visit by contacting the arts centre,
whose staff can arrange approvals and permits from the
community council.

 Perhaps surprisingly, the Alice Springs galleries and shops
contain little Yuendumu art, although Gallery Gondwana is often
the exception. In Melbourne, Sutton Galleries, Fitzroy, often
holds exhibitions of Yuendumu artists, as does Gallery Gabrielle
Pizzi. Sydney's Hogarth Galleries has shown the work of
Yuendumu artists since their first commercial exhibition there in
1985. Coo-ee Galleries also represents their work.

Recommended reading

For publication details see Recommended Reading page 233.
All general texts as listed in introduction to desert section
and *Kuruwarri: Yuendumu Doors*, Aboriginal Studies Press,
Canberra, 1992.

TINGARI

BELOW: Simon Tjakamarra, *Tingari Men at Pilintijinya* (1985). The Tingari's journeys are related in this painting referring to the artist's lands, west of Kintore,

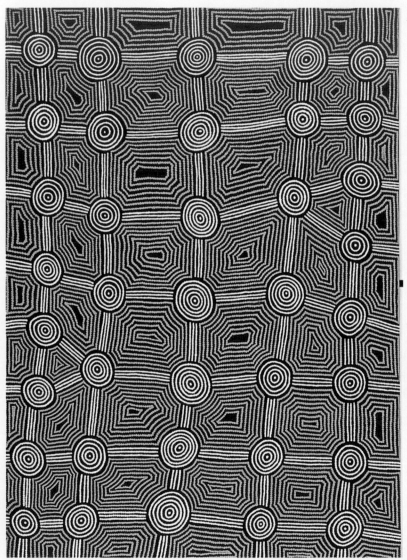

The group of ancestral spirit beings known as the Tingari brought law and culture to the people of the Western Desert. Their journeys, important sites and activities cover a huge area stretching from Pintupi country around the Papunya region 250 kilometres west of Alice Springs southwest to the Great Sandy and Tanami deserts around Balgo Hills,

through interlinked concentric circles denoting ceremonial camping sites—places in which important events have taken place, imbuing them with spiritual power.

and their depictions are numerous in Western Desert art.

Tingari stories, as seen in many Pintupi paintings such as Papunya artist's Simon Tjakamarra's 1985 *Tingari Men at Pilintjinya*, are abstracted, linear depictions of journeys and sacred–secret sites and events.

Donkeyman Lee Tjupurrula is a Kukatja painter from Balgo Hills. His *Tingari Dreaming at Walla Walla* (1989) shows a number of special Tingari sites linked through dotted lines denoting Tingari journeys. Walmajarri–Wangkajunka painter Jarinyanu David Downs's *Moses belting the rock in the desert* (1989) (page 136) links Christian and Aboriginal myths, a conjunction seen in Downs's work and in that of a number of other Aboriginal painters brought up in a Christian model.

As National Gallery of Australia indigenous art curator Wally

BELOW: Donkeyman Lee Tjupurrula, *Tingari Dreaming at Walla Walla* (1989). The work depicts, in linear style, a succession of sites and the abundance of the land as creeks come into flood.

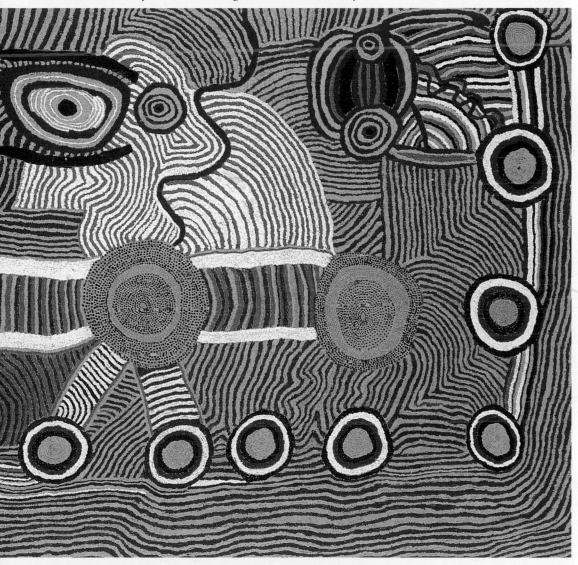

Caruana describes, religious beliefs concerning the Tingari provide ready models for Bible stories 'because of the Tingari's importance and the concepts for metamorphosis they incorporate'. Downs's work, Caruana says, 'follows the pictorial convention of desert painting in depicting travel aross the land in relation to events at specific sites'.[6]

The Eastern Desert community of Utopia, 230 kilometres northeast of Alice Springs, was not, as were many of the other major central desert art-producing communities, established as either a government settlement or mission station. Rather, the 1800–square-kilometre property was a pastoral station started by European settlers in the 1920s. Until its return to Aboriginal control in 1979, the area's Anmatyerre and Alyawarre population of several hundred had worked as stockmen and women, and in other domestic and farming jobs at Utopia and neighbouring pastoral stations. The hope that this sparse and fragile vegetation would support a thriving cattle industry seems to have been an over-optimistic one. The German settlers who gave it its name seem not, however, to have intended irony—the name chosen apparently in anticipation of a bountiful life after they found some rabbits 'so tame they could be caught by hand' nearby.[1]

Utopia resident and painter Barbara Weir is an Anmatyerre–European woman who, as one of the 'stolen generation', had been removed from the community as a child only to return in her late teens. She says that while *parrente* (lizards) and some edible plants are still reasonably abundant, especially after the rains, her older relatives still talk longingly of the days of plenty before the impact of the cattle when native grasses and wildlife abounded. 'It's what we think of when we paint—this land, our stories, the food we could make by grinding seeds, making flour, picking fruit.'[2]

Batik to canvas—the evolution of desert art

Utopia's modern-day art movement started in 1977 when a batik-making fabric workshop evolved as a corollary to a women's adult education literacy course set up several years earlier by teachers Toly Sawenko and Jenny Green. As an extension of sewing and woodblock printing classes, Green suggested to the twenty to thirty women who attended classes every day that they may like to learn the traditional Indonesian form of batik making such as that practised in other desert Aboriginal communities—namely Ernabella and Fregon—since the early 1970s. Fregon fabric artist Nyankula brought her skills, along with 'roving craftsperson' Suzy Bryce and coordinator Julia Murray, to classes attended first by about twenty-five women. Batiks developed from the original utilitarian clothing fabrics into more adventurous designs on silk created as works of art and shown in exhibitions from the early

UTOPIA
Diversity in the desert

LEFT: Emily Kame Kngwarreye, *Alhalkere* (1996). The famous octogenarian artist completed this vibrant canvas, in a style completely unlike any of her other batiks and paintings, just two weeks before she died in September 1996.

1980s. These often depicted free representations of seeds, grasses, flowers, berries, yams and other plants integral to women's ceremonies. While some men learned batik making, the numbers of women involved from the start made the enterprise fairly much 'women's business'.[3]

By 1988, the Utopia Women's Batik Group had grown to more than eighty members and become a well-established group. In

that year, Rodney Gooch, the Central Aboriginal Artists Media Association (CAAMA) coordinator took over as its organiser, suggesting to the women that they tell their own stories through producing one batik each. Eighty-eight women responded, each contributing a panel to the large work. Called *A Picture Story*, the whole work was acquired by the Robert Holmes à Court Collection and became the opening exhibition of Tandanya, Adelaide's Aboriginal art and culture centre in 1989.

Yet, as a contemporary art medium, fabric making was proving difficult to promote, especially given the far greater public success of the Papunya painting movement, which was by then firmly established. Did the artists want to try their hand at canvas? 'Absolutely,' says Gooch,[4] and another community project was undertaken with one hundred canvases being handed out over the hot summer months of 1988–89. Eighty-one

Ally Kemarre, *Untitled* (1989). One of the twenty or so regular batik makers from Utopia, Ally Kemarre's softly shaded batik is typical of the unusual and fine batiks made as pieces of art at this thriving school, which began in the 1980s.

canvases were collected several months later. Some of the artists translated their batik images into acrylics, but others experimented with the freedom the new medium offered producing strikingly different paintings. Emily Kame Kngwarreye, whose batiks had been noticed for their unfettered free imagery, produced a work that, says Gooch, was instantly exciting. 'As soon as I saw it just shone out at you and I knew it would be the star of the show.'[5] Other works contained a similar

power and, shown in Sydney's S. H. Ervin gallery in mid-1989, the Summer Project exhibition attracted instant attention. The exhibition launched Utopia art and Emily Kngwarreye into a new era of artistic growth and public acclaim.

Soon output was prodigious, with demand for the work constant. At its peak in 1989–90, says Gooch, the turnover for Utopia art was more than $1 million. Demand for Emily Kngwarreye's paintings, in particular, grew steadily. And although Kngwarreye was only one of several hundred painters, carvers and batik makers who have contributed to Utopia's status as an enduringly vibrant art-making community, it was largely due to her success that Utopia was placed on the art map. Yet, as with other 'big name' artists, success for Kngwarreye and her community did not come without its price—seen in pressure on the artists to produce constantly to satisfy an ever growing market. Due to a change in policy direction, the Alice Springs–based Central Australian Aboriginal Media Association (CAAMA) relinquished its managerial role in 1991 and since then Utopia's 200-plus painters, batik makers and woodcarvers have largely made their own arrangements for the sale and exhibition of their work. Also, according to Rodney Gooch, who continues to play an integral part in the development of Utopia art, within two years CAAMA's role as provider of canvas, sales organiser and exhibition coordinator was superseded by the artists' preference for individual arrangements with the dozens of local, interstate and international dealers regularly visiting the community.

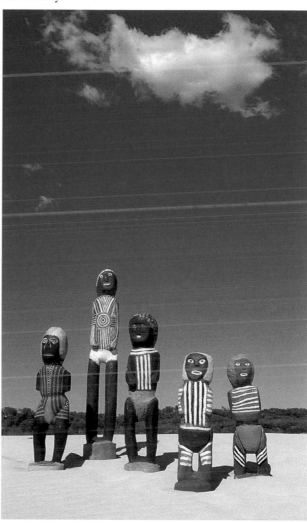

A group of carved sculptures of Dreamtime figures and local animals made by people of the Utopia region.

That Utopia artists have largely not felt the necessity to work through a cooperative such as those at Papunya, Yuendumu and other leading art-producing centres since the mid-1970s creation of a pivotally important women's batik-making workshop is due to a variety of factors. The huge area the community covers, with people living in groups adjacent to soakage bores, mitigates

BELOW: Billy Petyarre, *Dog* (1996). Many Utopia painters and batik makers are also prolific wood carvers, making and decorating sculptures of ancestral figures, as well as birds and animals such as seen in this appealing figurine.

against easy access to a central communal area; instrumental, also, is the history of the development of the Utopia community itself—which is unlike those of the government-established communities—and its modern-day art movement.

Individual expression and worldwide success

Although Kngwarreye was the most stylistically adventurous of

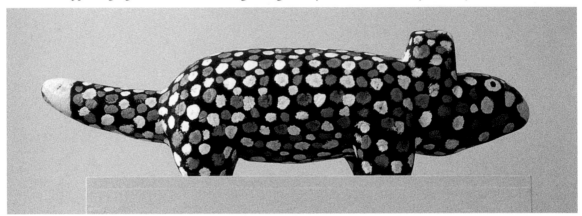

Utopia artists, other artists from this community such as sisters Ada, Nancy, Kathleen and especially Gloria Petyarre (right) show a similar enthusiasm for experimentation. Images based on flora and fauna similar to those seen in the early batik-making days also continue to resonate in both paintings and batiks.

RIGHT: Gloria Tamerre Petyarre, *Untitled (Leaves)* (1995). One of the senior painters and batik makers of Utopia, Gloria Petyarre's works are often characterised by a strong, clear element of design.

Utopia men's painting is also strong and notable for a more formal quality based on ceremonial design.

Works on paper have also been a part of Utopia's oeuvre, with artists participating in woodblock and silk-screening workshops both in the community and in other centres. As well, many people—both men and women—have continued their long-practised carving skills (boomerangs, clapping sticks, spears and coolamons) to produce a wide variety of imaginative figurative wooden sculptures. Since the mid-1990s, these have become quite a feature of art from Utopia. Favourite subjects include animals, such as in Billy Petyarre's *Dog* (above), or characters in traditional stories such as the law enforcer or 'bogey man' spirit *kwertatye*.

Following Kngwarreye's death in 1996 there was some quieting of interest in Utopia art, but soon the work of a younger generation of artists as well as new styles by existing artists again brought this community to the forefront of attention.

A community arts centre, Urapuntja, was established in 1999. It organises exhibitions and manages the art of over 100 Utopia

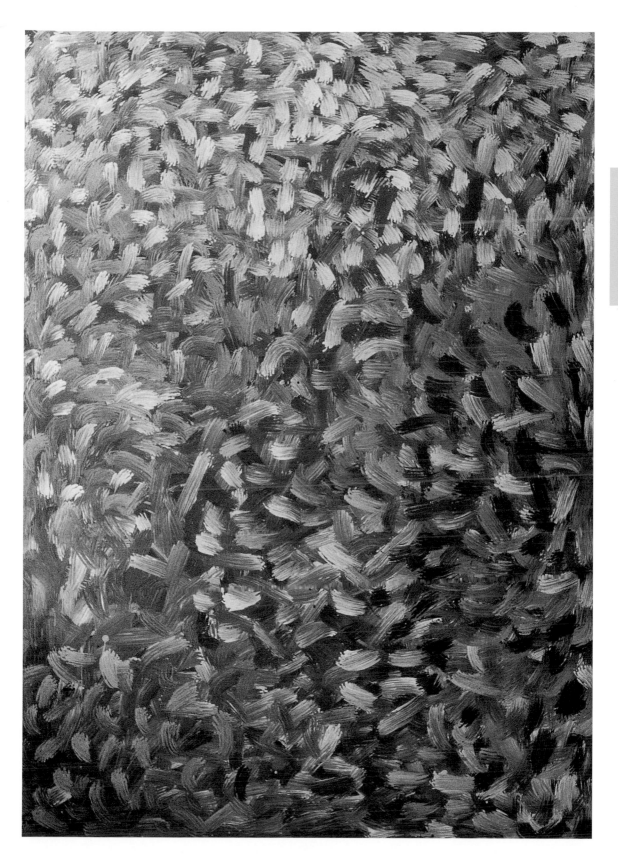

RIGHT: Minnie Pwerle, *Bush Melon* (2000). The vibrant colour and free brush strokes have attracted much attention for this senior Utopia artist since she started painting in 1999.

artists. Extraordinary has been the work of Minnie Pwerle, mother of Utopia-Adelaide artist Barbara Weir, who started painting in 1999 while in her late 70s. Her paintings, such as *Bush Melon* (page 87), show enormous freedom and use of colour. Barbara Weir's images such as her *Grass Seed Dreaming* (page 87) are similarly compelling, as are the paintings of some younger artists such as Lily Sandover Kngwarreye and Angelina Pwerle.

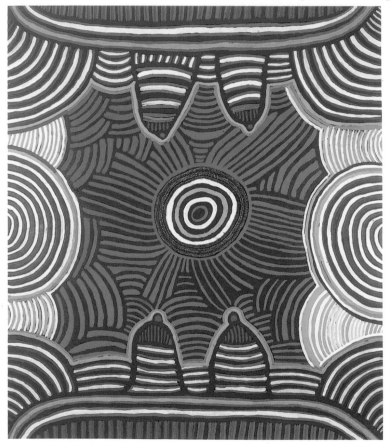

ABOVE: Ada Bird Petyarre, *Awelye for the Mountain Devil Lizard* (1994). This painting by a senior artist is based on traditional women's body design.

RIGHT: Barbara Weir, *Grass Seed Dreaming* (2001). Grasses were an important traditional food source for indigenous people before lands became degraded by overgrazing.

Some Utopia artists

Bird, Lyndsay Mpetyane; Kemare, Ally; Kngwarreye, Emily Kame; Kngwarreye, Lily Sandover; Petyarre, Ada Bird; Petyarre, Gloria; Petyarre, Kathleen; Pwerle, Angelina; Pwerle, Louis; Pwerle, Minnie; Weir, Barbara.

Where to see and buy the art

The work of Emily Kame Kngwarreye and a number of other Utopia painters is well represented in Australian public galleries. Alice Springs's Aboriginal Desert Gallery, Desart and Gallery Gondwana, carry stocks of Utopia art as does Darwin's Framed Gallery.

Sydney's Utopia Art was established in 1990 to show artists of this area, as was Adelaide's DACOU (Desert Arts Centre of Utopia) Gallery in 1995. In Melbourne Gallery Gabrielle Pizzi and Flinders Lane Gallery hold regular Utopia exhibitions while galleries that stock a wide range of Utopia artists include Aboriginal Art Galleries of Australia, Aboriginal Gallery of Dreamings and Alison Kelly Gallery. Melbourne's Lauraine Diggins shows Gloria Petyarre and Niagara Galleries shows Angelina Pwerle.

In Sydney, Desart, Gallery Savah, Hogarth Galleries and Utopia Art carry a wide range of Utopia art as does Fire-Works in Brisbane. Gallerie Australis in Adelaide represents the work of

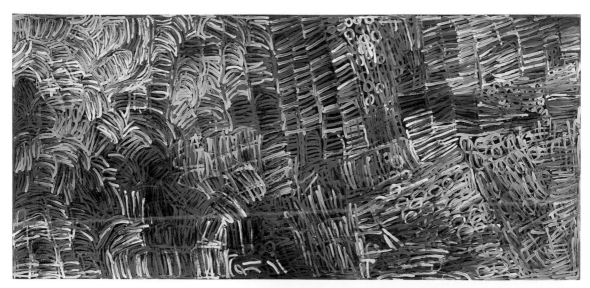

Kathleen Petyarre as does Melbourne's
Alcaston House and Sydney's Coo-ee
Gallery.

Recommended reading

All general texts as listed in the
introduction to the Desert section and
*The Art of Utopia: A new direction in
Contemporary Aboriginal Art*, Michael
Boulter, 1991; *Emily Kame Kngwarreye:
Alhalkere, paintings from Utopia*, Margo
Neale, ed. 1998; *Emily Kngwarreye
Paintings*, D. Holt, T. Smith and NGV,
1998; *Utopia—a picture story, The Holmes
à Court Collection*, A. Brody, 1990.

EMILY KAME KNGWARREYE

b. c. 1910, Utopia, NT. Language group: Anmatyerre. d. 2/9/96, Alice Springs, NT.

DESERT

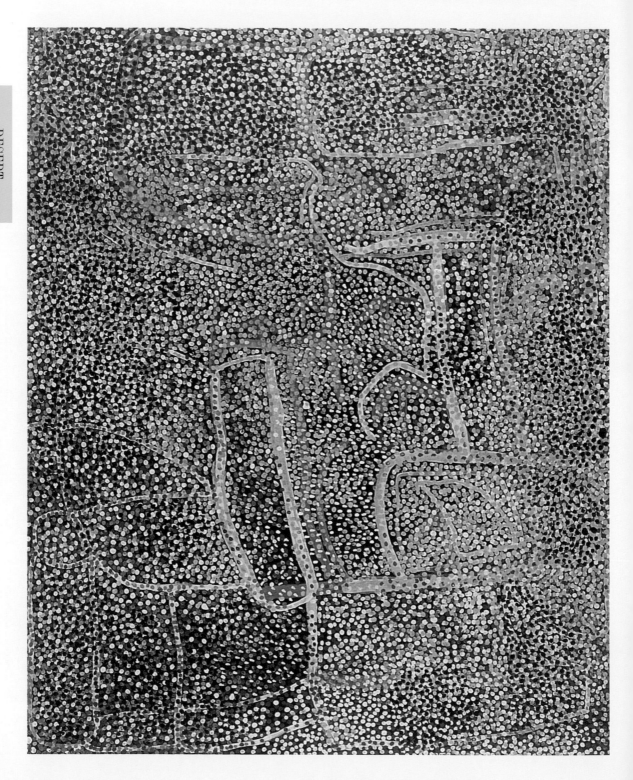

Whole lot, that's whole lot, Awelye [my Dreaming], Arlatyeye [pencil yam],
Arkerrthe [mountain devil lizard], Ntange [grass seed], Tingu [a Dreamtime
pup], Ankerre [emu], Intekwe [a favourite food of emus, a small plant],
Atnwerle [green bean] and Kame [yam seed]. That's what I paint, whole lot.[6]

This was Utopia painter Emily Kame Kngwarreye's most definitive
statement of her work. When she died in 1996, aged in her late eighties,
this desert Aboriginal painter had achieved fame of almost mythic
proportions. Within a few short years, the woman who painted her first
work on canvas at the age of around eighty had become an artistic
superstar. Lauded for their stylistic diversity and superb coloration, her
works were hailed as contemporary masterpieces likened to the paintings
of international art stars de Kooning, Sol Le Witt, Bridget Riley and
even Claude Monet.

That this acclaim was set against a background of a daily life spent
entirely on her land, at Utopia, and in conditions Westerners would
largely regard as primitive, further fuelled the mystique. As did her
prodigious output—a lifetime's work of 3000–4000 paintings telescoped
into just eight years.

Stylistically, Kngwarreye's paintings were very different, being far
freer in comparison to the more formal, regulated, clearly defined,
patterned designs of her desert-based contemporaries. The paintings
which first drew her work to attention were what became known as her
'dump-dump' dot style—as in *My Country* (1991)—a style she would
employ throughout her painting life. Painting with vigour and using the
full bristles of a large brush (not unlike the action of pounding a clove of
garlic in a mortar and pestle), she would build layers of brilliant colours.

In the *Wild Yam Dreaming* pictures as on the front jacket, which
emerged several years later, layers of crisscrossed lines evoke the roots
stretching deep into the soil. The horizontal (sometimes seen also
vertically), broadly brushed browns and blacks against a white
background are stylised translations of women's body painting painted
on the torso and face in ochres before many ceremonies.

In 1992, she received a federal government Creative Artists
Fellowship and, in 1997, Kngwarreye was one of three Aboriginal artists
to represent Australia at the Venice Biennale. Just two weeks before she
died, she produced a startling new series of twenty-two works (page 80).
With their broadly brushed areas of luminous, almost fluorescent
colours, these paintings demonstrate the immense vibrancy of
Kngwarreye's work and its sheer physical power—with an ability to
penetrate the very soul of the landscape.

BELOW: Emily Kame Kngwarreye,
Untitled batik (1988). Loose and
free in style, Kngwarreye's batiks
were distinctive, as were her later
paintings, for their strong
individuality.

LEFT: Emily Kame Kngwarreye,
Alalgura (Alhalkere)—My Country
(1991). Included in the major
touring Emily Kame Kngwarreye
retrospective exhibition organised
by the Queensland Art Gallery in
1997–98, this lyrical work was
painted at the property Delmore
Downs for its owners and one of
Kngwarreye's major dealers, Don
and Janet Holt. Through the thick
dotting, 'tracking lines' of the roots
of plants can be seen under the
surface of Kngwarreye's only
subject matter—her country.

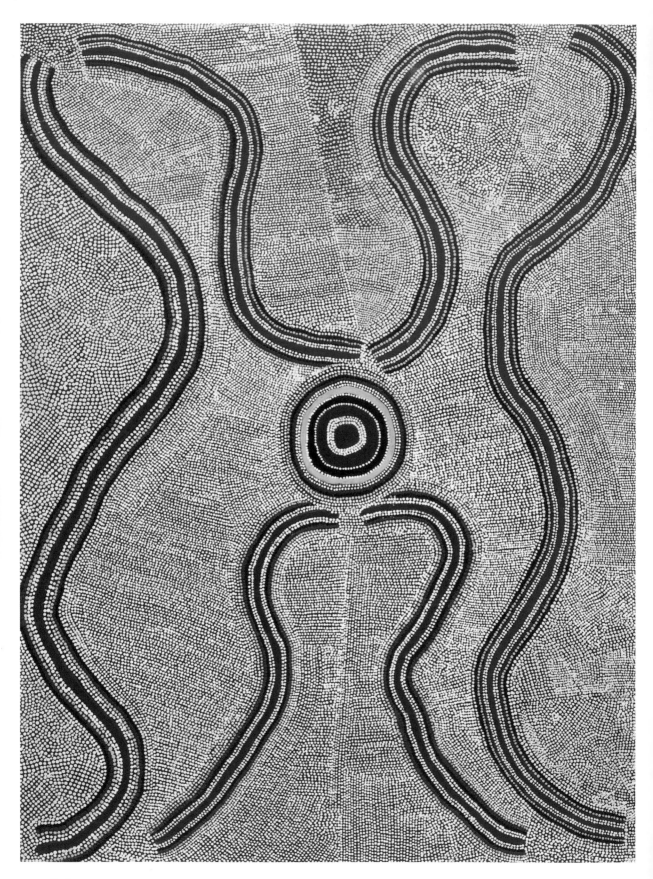

On the traditional lands of the Gurindji people, Lajamanu (originally called Hooker Creek) was established in 1946, when twenty-five Warlpiri people were trucked in from Yuendumu some 400 kilometres to the south. In 1951, another 150 Warlpiri were similarly removed from Yuendumu. Shortly after, the entire community walked back to Yuendumu. This happened again in 1958 and 1968. The dislocation from their land, separation from relatives and adoption of European ways being completely unacceptable to the Warlpiri, it was only when the first children were born at Lajamanu that they felt able to settle in the new environment.[1]

Around 750 people now live at Lajamanu which, from its inauspicious start, has developed a strong community identity and has also spawned a lively painting movement.

Unlike many other communities of a more rambling, spread-out nature, Lajamanu has a single, broad 'main street' off which are situated the central community building, store and school.

A painting movement is born

Lajamanu's painting movement started in the mid-1980s—and then only after considerable debate within the community as to the acceptability of painting for sale. Originally, some elders of the community had been highly critical of Papunya and other Central Desert people's translation of traditional stories and images to permanent materials (see Introduction). A change of community policy in 1985, however, after the death of the then chair of the community Maurice Luther Jupurrula, who had been a main opponent of the new painting movement, led to the start of painting about a year later.

An adult education class for painters was conducted, and, as in other communities, the response to the new possibilities was huge. Soon more than 100 people were painting and Lajamanu quickly became a major painting-producing centre.

Works were sold through galleries in Katherine and Darwin; some short-term funding for an art coordinator was approved by the federal government and, in 1987, a major exhibition of Lajamanu work was held at Gallery Gabrielle Pizzi in Melbourne. Yet a formal artists' cooperative such as those found in some other desert communities have been erratic at Lajamanu. The community's requests for funding have largely been refused by the government, apparently on the grounds that funding had

LAJAMANU

Richly textured paintings from a land of adversity

ABOVE: Murals such as this one on a Lajamanu building are often seen on the external walls of buildings at art-producing communities— they are typically added to and repainted continually.

LEFT: Abie Jangala, *Falcon Dreaming* (1987). Abie Jangala's paintings are noted for their striking, dense white dotting over a base colour and simple, bold design. This major work relates the story of a creation being falcon carrying a snake in its beak while on a desert journey.

already been established for Warlpiri artists through that granted to the artists of Yuendumu.[2] Art production therefore has been rather sporadic and dependent almost entirely on the relationship between individual dealers and artists.

Freedom and textural richness

Lajamanu art has a less constrained, freer quality typified by large iconographic images and boldly simple colours. Thickly applied overlays of dots and larger forms characterise much of the work, notable also for its largely restricted palette. While not formally limited, as Papunya artists have chosen, to the earth colours of red, black, brown and white, these colours originally frequently predominated in Lajamanu art. The interwoven, multicoloured dotted areas common in other Central Desert art are absent, with backgrounds being far more spacious and spare. Figurative elements such as hand and footprints, and emu tracks are not as readily used, with emphasis being on the more symbolic images of circles, curves and lines. Compositions are bold and a strong graphic element is present.

Abie Jangala's classic paintings, especially the 1987 *Falcon Dreaming* (page 90), demonstrate to great effect the power of simple, sparse imagery against a densely dotted ground. Lorna Napurrula Fencer's bold colouration, such as that on the opposite page, show this artist's particular style as well as the newer expressionism of Lajamanu artists.

Some Lajamanu artists

Blacksmith, Peter Japanangka; Fencer, Lorna Napurrula; Gibson, Paddy Japaljarri; Hargraves, Lily Nungarrayi; Jangala, Abie; Lawson, Louisa Napaljarri; Lawson, Ronnie Jakamarra; Nanpijinpa, Liddy Miller; Nungarrayi, Elizabeth Ross; Nungarrayi, Lily Hargraves; Robertson, Jimmy Jampijinpa; Tasman, Rosie Napurrula.

Where to see and buy the art

Lajamanu art is well represented in the National Gallery of Victoria, the Art Gallery of South Australia and various other state public galleries.

Although there have been, from time to time, formal structures for art-making set up in the community due to lack of permanent funding and structure, the Lajamanu arts centre (Warnayaka Art

Centre) operates largely as a wholesale outlet. Lajamanu's remoteness makes individual visits extremely expensive, save for those by dedicated art tour groups, and arduous if driving. Permits for visits to the Lajamanu community must be obtained first by contacting Warnayaka Arts.

Darwin's Karen Brown Gallery has had a long-time association

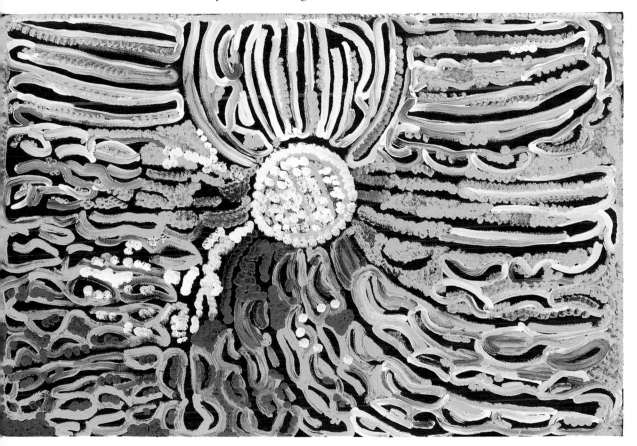

with Lajamanu artists and regularly represents much of their work. In Melbourne, Lajamanu art can be seen at Alcaston Gallery and Alison Kelly Gallery. Sydney's Hogarth Galleries and Coo-ee Gallery also represent Lajamanu artists.

Recommended reading

For publication details see Recommended Reading page 233. All general texts as listed in the introduction to the Desert section and *Tribal Elders: Symbolic Dreamings from the Australian Aboriginal Warlpiri tribe*, Japaljarri, 1998.

ABOVE: Lorna Fencer Napurrula, *Bush Potato* (2000). The thickly applied paints and free expressionist nature make Lorna Fencer Napurrula's art representative of the newer styles being practised by Lajamanu artists.

Ernabella, 440 kilometres west of Alice Springs, was established as a missionary station by the Presbyterian Church in 1880. Since the 1970s, it has become known for its colourful batiks, made largely by the women of the community.

In 1940, the Pitjantatjara people of Ernabella participated in an interesting artistic experiment in conjunction with ethnographer Charles Mountford (see Introduction, page 26). Later, in the 1950s and 1960s, the women of Ernabella were the first Central Desert people to use acrylic paints with images linked to traditional iconography. When a craft centre was established in 1948, the craft teacher, Ron Trudinger, encouraged the children to paint in whatever form they chose. Abstract, swirling designs emerged. When she arrived in 1954, craft adviser Winifred Hilliard further encouraged the painting of these works by the women of the community, who by this time had also started painting. She encouraged the women to experiment with a variety of materials such as pastels, watercolours and ink, and later brightly coloured acrylic paints.

The resulting paintings, developing in sophistication each year, were stylised representations—called *walka*—of desert vegetation and body painting, characterised by large swirling blocks of often highly coloured, arabesque designs. Reproduced in postcard and poster form, and promoted by some city poster agencies, this new style—the first extensive example of the use of Western materials with non-figurative Western imagery—attracted a good deal of attention. As noted in the Introduction, the paintings were not a great success in the art world. The women, however, continued to paint *walka* designs with limited commercial success, during the 1960s and 1970s.

ERNABELLA
Land of the Pitjantatjara, home of colourful batiks

LEFT: Angkuna Kulyuru, batik on silk. The colours and designs of today's striking batiks from Ernabella's batik-making workshop derive from the colours of the desert. These designs originated in the 1960s, but are combined with traditional iconography.

Batiks and beyond: contemporary art at Ernabella

With the employment of a new craft coordinator in 1972, the craft of batik making was introduced. This medium suited the *walka* designs well and provided the basis of what was to become a thriving commercial fabric business. Colours of Ernabella fabrics are often bright, reflecting, as the painters describe, the colours of the earth interspersed with greens, blues, violets, pinks, reds and other brilliant hues also seen in the desert flora of wildflowers, grasses and seeds.

Until the late 1980s, no one was painting Western Desert dot–style paintings at Ernabella—largely because, as with the

Warlpiri people of Lajamanu, many Pitjantjatjara people strongly resisted the notion that traditional designs, whether secret or not, be on public view.[1]

Since about 1988, however, this view has softened considerably, with Ernabella painters such as Tjulkiwa Atira-Atira relating their own Dreaming stories using a combination of Western Desert style with the design elements of the *walka*. In 1996, a ceramics workshop utilising the skills of ceramics practitioners from Adelaide's Jam Factory was also introduced at Ernabella, producing pottery decorated with designs similar to that of the fabrics.

Some Ernabella artists
Atira-Atira, Michael; Atira-Atira, Tjulkiwa; Atira-Atira, Yilpi; Baker, Nyukana; Carroll, Alison; Williams, Vera Mbitjana.

Where to see and buy the art
The *walka* design paintings are in the collections of a number of major public institutions, including the Powerhouse Museum, the

Alison Carroll, *Earthenware dish*, 1997. An example of the new pottery being produced at this Central Desert community.

Museum of Australia, the National Gallery of Melbourne, the Art Gallery of South Australia and the Museum and Art Gallery of the Northern Territory.

As there is no formal accommodation, requests to visit Ernabella are treated on an individual basis and encouraged only for those deemed as 'giving something back' to the community or who have a serious reason for wanting to visit. Permits are

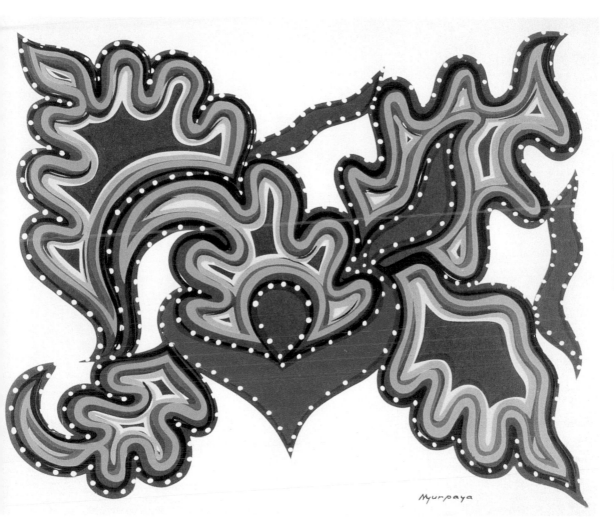

essential and can be arranged by the community's art coordinator.

Ernabella fabrics and, where available, pots can be bought from Indigenart, Perth; Peter Bellas, Brisbane; Framed and Raintree galleries, Darwin; Coo-ee and Rainbow Serpent galleries, Sydney; Sutton Galleries, Melbourne; Original Dreamtime and Gondwana galleries, Alice Springs; Gallery Australis and the Jam Factory, Adelaide.

Recommended reading

For publication details see Recommended Reading page 233. General texts as noted in the introduction to the Desert section and the catalogue of the Ernabella retrospective exhibition, *Warka-Irititja Munu Kuwari Kutu: Work from the Past and Present—A Celebration of 50 Years of Ernabella Arts*, held at Adelaide's Tandanya Aboriginal Cultural Centre in August 1998.

Nyupaya, *Walka* (1970s). An example of the brilliantly coloured paisley-like designs developed at Ernabella in the 1960s.

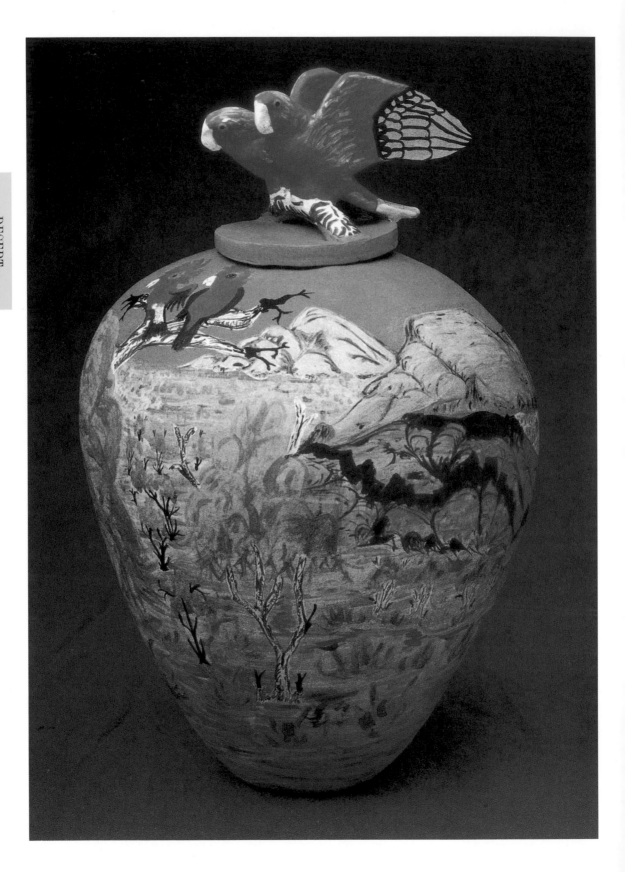

Since the 1990s, Hermannsburg (Ntaria), 130 kilometres west of Alice Springs, has become known for its colourful and innovative pottery. Yet although the distinctive pots by Hermmansburg's Arrernte residents have become synonymous with its modern artistic development, as the Museum and Art Gallery of the Northern Territory curator of Aboriginal art, Margie West, describes, artistic activity at Hermannsburg— established as a Lutheran Mission in 1877—is both longstanding and multifaceted.

[Their] artistic history ... is perhaps one of the most interesting and complex of any Central Australian group ... With the establishment of Hermannsurg as a Lutheran mission ... the Arrernte were taught a range of introduced skills over the years, including leatherwork, embroidery and designing with pokerwork.[1]

Western-style figuration and early pottery

The teaching of Western-style figurative drawing at school also established a receptiveness to the work of visiting artists. This culminated in the emergence of watercolourist Albert Namatjira (1902–1959), who became one of Australia's most famous artists. His luminous views of the MacDonnell Ranges and other central desert views attracted international attention and Namatjira left a legacy of watercolour painting in his style which remains today in the work of his relations and other Arrernte people.

In the 1960s, an early pottery school was established by mission employee, V. A. Jaensch, who had been impressed with a display of pottery in Adelaide. After making contact with the Adelaide Potters' Club, Jaensch returned to Hermannsburg where he sought out suitable clays—involving the community in the new project. A kiln was built, the old blacksmith's shop converted to a pottery workshop and production started in May 1963.

Objects were hand-modelled and included emus, kangaroos, camels, birds and human figures. In style, they were reminiscent of the pottery which similarly featured Australian flora and fauna made during the 1930s and 1940s by a number of artist–potters such as Merric Boyd. The figurines were sold in the community craft shed along with other tourist curios. The nascent pottery movement had lapsed by 1964, however, possibly due to the fluctuating population.[2]

LEFT: Beryl Ngale Entata, *Hentye (Pink Galahs)* (1995). The body of this vibrantly decorated pot features scenes of the desert, while the colourful galahs form the handle of its lid.

99

A unique modern art form

The experience was not forgotten by at least one influential
community member. The late Aboriginal pastor Ungwanaka
never forgot the enjoyment he experienced working with clay as a
young man in the 1960s. When discussions were held with the
Aboriginal and Torres Strait Islander Commission in 1990 about
possible enterprise development at Hermannsburg, he suggested
that a pottery workshop be established. In late 1990, largely due
to his efforts, the Northern Territory Open College of TAFE
provided the infrastructure to set up a pottery program,
appointing American-born potter Naomi Sharp as coordinator.

A fertile pottery workshop has since developed, with
Hermannsburg pots being seen in exhibition and for sale in
leading outlets and galleries, and evolving into the production of
bas-relief ceramic murals for public buildings.

Naomi Sharp brought her observations of the pots made in

other parts of the world—especially those of the North American Pueblo Indians—to her new role. A simple, rounded shape was decided upon as the most conducive to the effect the potters wanted to achieve. Individualism is expressed in the widely differing decorations on the lids and body of the pots. Lids often comprise a sculptured figurine of an animal or aspect of a plant (seeds, leaves or fruit), with the underglaze of the pot itself usually decorated with both paintings and bas-relief designs. Around fourteen potters, mostly women, have remained with the project consistently—although numbers have been as high as forty on occasion.

In 1991, four of the potters worked on a month-long collaborative project to produce a 24-tiled mural for an internal wall of the Alice Springs Department of Education and Employment. Depicting one of the many traditional Dreaming stories, the 160-centimetre long, brightly coloured work, *Twins*

Various artists, *The Cycle of Life— Amphibians and Reptiles from the Hermannsburg Area* (1994). Mural for the Taronga Park Zoo Amphibian and Reptile House, Sydney. Fourteen artists worked on this large bas-relief mural, created as an extension of their pottery school and celebrating the reptiles typical to their area now housed in Sydney's famous zoo.

101

Dreaming from Palm Valley, is largely figurative and comprises both flat and bas-relief elements, painted and kiln-dried—as are the pots. By 1996, around eleven such murals had been commissioned and completed, the largest being the 114-centimetre x 314-centimetre *Cycle of Life: Amphibians and reptiles from the Hermannsburg area* for Sydney's Taronga Park Zoo's Amphibian and Reptile House.

Some Hermannsburg artists

Hudson, Noreen; Inkamala, Gwen Mpetyane; Namatjira, Albert; Pareroultja, Otto; Rontji, Virginia; Rubuntja, Wenton; Ungwanaka, Rachel; Watson, Maggie.

Where to see and buy the pots

In 1996, the Museum and Art Gallery of the Northern Territory held a major touring retrospective, Hermannsburg Potters, the catalogue of which is well worthwhile obtaining for a complete history of the pottery. The Museum and Art Gallery of the Northern Territory also has a signficant collection of the pots, while the murals may be seen on public display in the relevant buildings mentioned above.

Victoria's Shepparton Art Gallery, the Museum of Victoria and the National Gallery of Victoria all have representative collections of the pots.

Coordinator Naomi Sharp says that only visitors with 'appropriate interest' such as other potters or professionals in the arts are generally welcomed to the community—by appointment only. Hermannsburg itself, however, where the pots are on display and sale at the Historic Centre, is open to all, with no permits required for visitors.

Pots are available for sale at Alcaston Gallery, Melbourne;

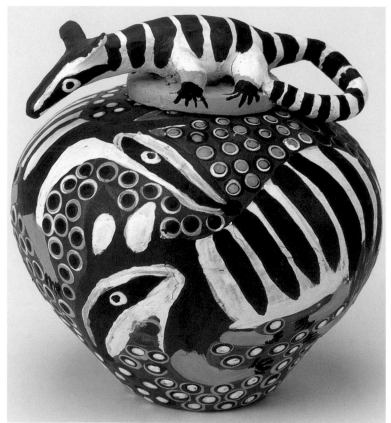

Gwen Mpetyane Inkamala, *Tyelpe (Quoll)* (1996). One of the twenty or so largely women potters from Hermannsburg, Arrernte woman Gwen Inkamala concentrates on depicting geckos, honey ants, lizards, parrots, wild onions, and echidnas and other fauna such as this small marsupial quoll. Her pots are moulded and decorated in the style for which this vibrant pottery school has become famous since it started in 1991.

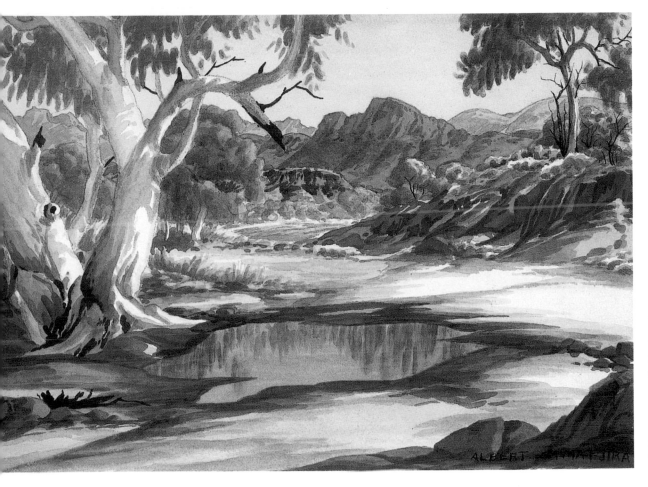

Hogarth Galleries, Sydney; Indigenart, Perth and Mbantau Gallery, Alice Springs.

Recommended reading

For publication details see Recommended Reading page 233. All general texts as listed in the introduction to the Desert section as well as *Albert Namatjira: The Life and Work of an Australian Painter*, ed. N. Amadio, 1986; *Hermannsburg Potters*, eds West and Keane, 1996; *Modern Australian Aboriginal Art*, Rex Battarbee, 1951; *Namatjira: Wanderer between Two Worlds*, Batty, 1963; *The Encyclopedia of Australian Art*, Alan and Susan McCulloch, 1994; *The Heritage of Namatjira*, eds Hardy & Megaw, 1992.

Albert Namatjira, *Anthewerre* (c. 1955). The most famous Aboriginal artist of the mid-twentieth century, Albert Namatjira painted luminous scenes such as this from the desert countries surrounding his Hermannsburg home. Namatjira introduced the colours and variety of the country to a new group of city dwellers both within Australia and internationally.

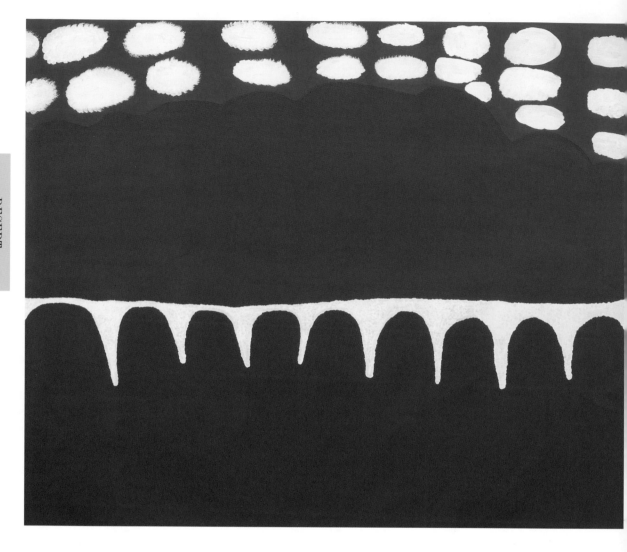

Long Tom Tjapanangka,
Ulampawarru (1996). Long Tom's
large, bold planes of colour and
sharp observation of the elements
of his country have made his
paintings as memorable as they are
identifiable.

The painting movement at Haasts Bluff, 230 kilometres west of Alice Springs, has evolved since the early 1990s. The Ikuntji Women's Centre was established in 1992 and became a focal point for community concerns. With the appointment of art coordinator Marina Strocchi in 1992, it also became the hub of a small but thriving painting movement. About fifteen of the community paint regularly and their work has attracted attention in solo and group exhibitions in capital cities since late 1993.

In her book *Ikuntji: Paintings from Haasts Bluff 1992–94*, Marina Strocchi describes how the centre was 'sung open' in April 1993. 'Since then,' she says, 'many activities have taken place at the centre—which is also frequented by children and men. Painting has been the most popular. Some artists in their sixties have only just started painting. Others have set up studios in their own homes and paint daily.'[1]

The Haasts Bluff area is home to the Western Arrernte, Pitjantjatjara and Pintupi people, and was named after a little known New Zealand geologist by an early European explorer. Situated between two mountain ranges, the settlement itself was established in 1946 after a Lutheran missionary team led by Father Albrecht from Hermannsburg Mission, 100 kilometres to the southeast, started distributing rations in the vicinity.

A new painting movement from desert family links

The Haasts Bluff community, which numbers between 80 and 160 people, grew from a one-room, corrugated iron hut delivered from Alice Springs in 1946. A working cattle station was developed shortly after, but by 1959 many people from the area had been relocated to Papunya, 40 kilometres to the north, which had a more reliable water supply. During the 1970s, when Aboriginal people were allowed to move from the government settlements more freely, many Haasts Bluff people moved back to their own country. With so much crossover and so many family ties between people of the Haasts Bluff and Papunya communities, painting at Haasts Bluff following the emergence of the Papunya painting movement was, as Alice Springs resident and Papunya art worker Dick Kimber recalls, 'almost instantaneous'.

During the 1970s, Kimber relates he would undertake regular trips to Papunya and Haasts Bluff, and around various outstations, distributing boards, canvases and paints, picking them up a fortnight later and paying for sales.[2] With the death of

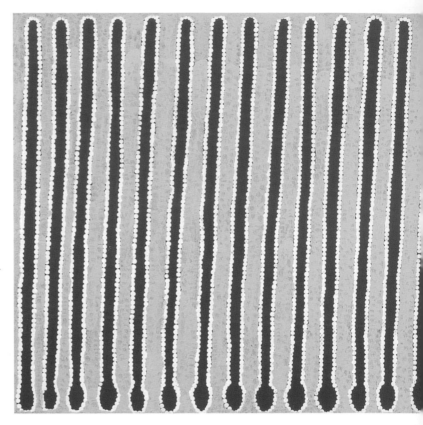

leading painters Barney Raggatt Tjupurrula and Timmy Tjungarrayi Jugadai, and the establishment of even further flung outstations, painting at Haasts Bluff declined during the 1980s, but has again begun to flourish in the small community.

Individuation and freedom

The latest paintings of Haasts Bluff artists are notable for their variety of styles and often strong coloration. Long Tom Tjapanangka's paintings have developed, as in *Ulampawarru and Irantjii* (page 104), a striking mix of figurative and abstracted landforms, flora and fauna, and this won him the National Aboriginal and Torres Strait Islander Art Award in 1999. Mitjili Napurrula's 'spear' paintings, as in *Kulata Tjuta's spears from Uwalki (the artist's country south of Kintore)* (above), have a similar clarity of colour, as well as defined linear patterning.

Some Haasts Bluff artists

Daniels, Barney Tjungarrayi; Dixon, Anne Nungarrayi; Jack, Gideon Tjupurrula; Jugadai, Daisy Napaltjarri; Nangala, Narputta; Napaltjarri, Tjungupi; Napanangka, Eunice; Napurrula, Militji; Tjapanangka, Long Tom.

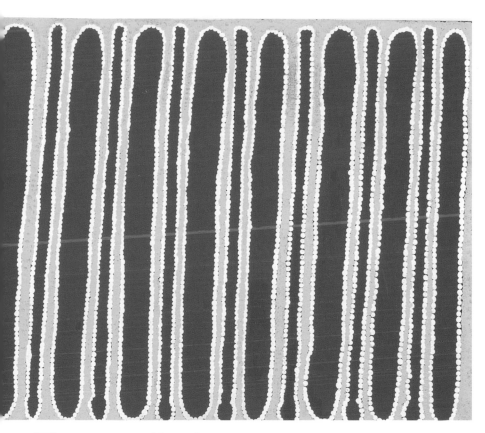

Where to see and buy the art

Paintings by Haasts Bluff artists are in many public state gallery collections, including those of the Art Gallery of South Australia, the National Gallery of Australia and the Queensland Art Gallery, as well as the Flinders University and Darwin Supreme Court collections.

Visits to the arts centre are possible for those who are serious, or potentially serious, purchasers of work. Permits are arranged on behalf of the community by the Central Land Council in Alice Springs.

Major galleries representing Haasts Bluff art are Desert Designs, Fremantle; Dusseldorf Gallery, Perth; Gallerie Australis, Adelaide; Hogarth Galleries, Sydney; Gallery Gabrielle Pizzi, Melbourne; and Niagara Galleries, Melbourne.

Recommended reading

For publication details see Recommended Reading page 233. General texts as listed in the introduction to the desert section and *Ikuntji: Paintings from Haasts Bluff 1992–94*, Marina Strocchi, 1994.

Mitjili Napurrula, *Kulata Tjuta's Spears from Uwalki (the artist's country south of Kintore)* (1996). Militji Napurrula has become a well-known Haasts Bluff painter for distinctive paintings such as this, one of a continuing series based on her father's homeland area of Uwalki, south of Haasts Bluff near the Kintore Ranges.

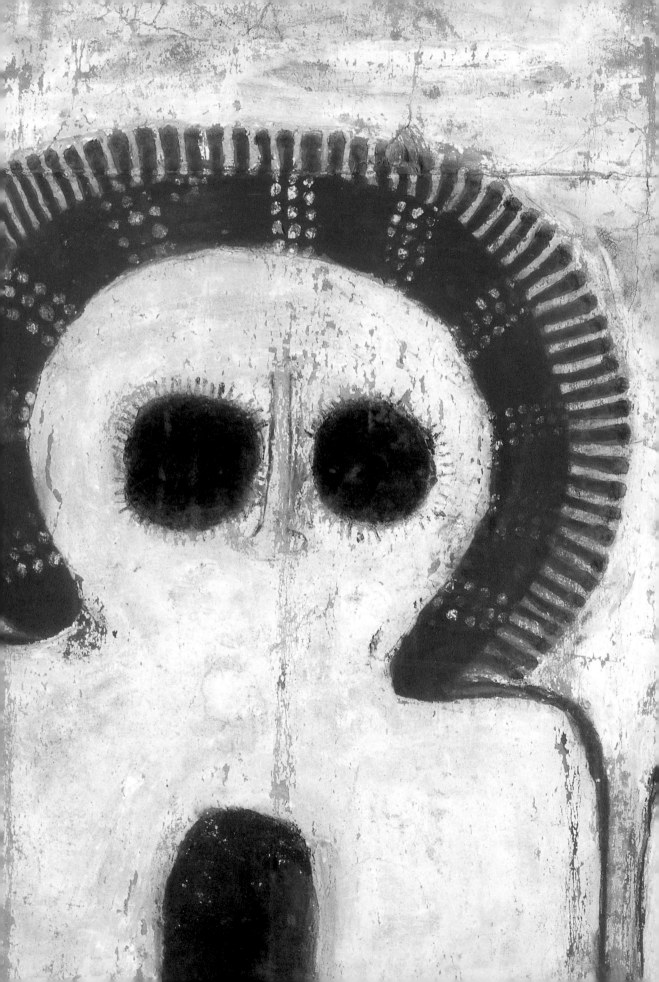

THE KIMBERLEY

A dramatic land
of colourful contrasts

Bordered by the Indian Ocean to the north and west, and covering 422 000 square kilometres, Western Australia's Kimberley region is one of the most widely varied and dramatic locations in Australia. Wide sweeps of sandy coast broken by craggy, red rock outcrops and crystal clear waters line the northwest coastal regions—some of the most isolated beaches in the world. Along the flat rocky plateaux of the King Leopold and Durack ranges, millions of tonnes of water are disgorged into the sea annually during the dramatic wet season (November to March), through vast sweeping rivers and waterfalls. To the south are the several thousand square kilometres of the Great Sandy and Tanami deserts—spinifex-covered and once fertile life-supporting grounds. Inland, the wide Fitzroy River, its annual swell and fall carving huge towering cliffs, winds from Derby to the central Kimberley.

Colours in the Kimberley are a mix of subtlety and drama. At Cape Leveque, 200 kilometres north of the tourist town of Broome, the brilliant red coastal cliffs combine with basalt ocean rocks to form fine sand with a pinkish tinge. Further south, in the Great Sandy Desert, the low, sloping sun's rays at dawn and dusk turn desert spinifex into hues of mauve and lavender.

At the Kimberley's northernmost tip, a channel of the Joseph Bonaparte Gulf leads down to the exporting, farming and industrial centre of Wyndham. In the southeast is Kununurra, just west of the Northern Territory border—a bustling tourist and trade town also developing a healthy vegetable and fruit industry. The dome-shaped Bungle Bungles, 140 kilometres to the south, dominate the landscape. Relief from the burning mid-day heat in the Bungle Bungles can be found in the cool, black depths of its crevices and caves. Further south again is the small settlement of Balgo Hills—one of the most remote communities in the world—and, to the west, the Kimberley's southernmost point is just below the small settlement of La Grange. Both distances and differences in the Kimberley are huge. During the 1980s, the area started developing as a major tourist destination with light plane and four-wheel drive camping trips abounding at a volume found in few other places in the country.

Displacement and fragmentation

The history of the Kimberley's Pama-Nyungan, Bunuban, Jarragan, Nyulnylan and Worrorran people is delineated sharply

THE KIMBERLEY

A dramatic land of colourful contrasts

LEFT: The wide plains of the Kimberley offer a timeless experience for the visitor.

PREVIOUS SPREAD: Detail from Charlie Numbulmoore, *Wandjina* (1970). Taken from the cave paintings of one of the rock shelters on Numbulmoore's ancestral Kimberley lands and repainted on bark, these stark, simple Wandjina—their head dresses decorated to resemble clouds and rain—are powerful renditions of these ancient creation ancestors.

by the first European contact and the encroaching white domination of the country.[1]

Throughout the Kimberley, the early years of white settlement in the mid-1800s included many instances of massacres and black–white conflicts. A number of Kimberley artists, including the late Rover Thomas and his relative, the late Queenie McKenzie, have related some of these events in memorable paintings. Queenie McKenzie, who lived at the community of Warmun (Turkey Creek) near the Bungle Bungles, was born around 1920. In 1997, she told how, as a young girl living on a Kimberley cattle station, a 'big mob' of her people had been killed by whites in retribution for killing a bullock. 'We were running everywhere, up hills, hiding behind rocks,' she said. 'They were shooting—didn't matter who they got—men, women, us children.'[2]

Warmun artists the late Queenie McKenzie, Jack Britten, Hector Jandany and Henry Wambini at Warmum in 1991.

A Kukatja woman living at Balgo Hills, Tjama Napanangka, who was born around the same time as Queenie, described how her grandfather was shot dead in front of her and her family after throwing a boomerang which narrowly missed a white stockman (actually aimed at an Aboriginal stockman who had run away with his wife). The stockman shot her grandfather, then told Tjama and her siblings to bring firewood, which he threw on the body, doused with kerosene and lit—ordering the women and children not to cry as their grandfather's body burnt before their eyes.[3]

Such chilling personal accounts occur throughout Kimberley history, as well as instances of poisoned flour and waterholes, ethnocide on missions, and the rounding up and chaining of enslaved Aboriginal stockmen who wandered off stations. There were, however, other occasions when, despite the dispossession of their lands, indigenous people developed far more harmonious interdependent relationships based on mutual trust and respect with European pastoralists.

Until the mid-1900s, many Kimberley Aboriginals worked as stockmen and women and in a variety of other jobs on pastoral

stations, often for minimal wages, but with the opportunity to travel to some degree. With the advent of the government Pastoral Award in 1969, however, aimed at ensuring equal wages for black and white, most Aboriginal people found themselves further removed from even these adopted homes when they were thrown off the stations.[4] Most gravitated to towns such as Fitzroy Crossing or Kununurra. At Turkey Creek, the eastern Kimberley

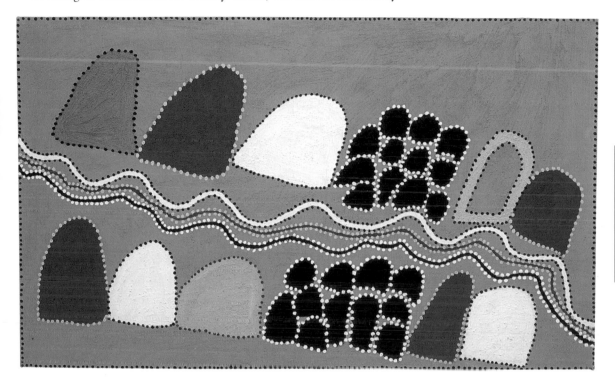

Gija people pressed the government to assist them with the establishment of an Aboriginal community (Warmun). Others gravitated to mission stations such as those of the Western Desert's Balgo Hills and the northern coast's Lombadina.

It was in this climate that the modern Kimberley art movement began in the late 1970s, when people, first at Warmun and then Balgo, started to reconnect with their cultural heritage through their art.

Art as a joyous resurgence of traditional values

Modern social history is reflected strongly in much Kimberley art, which is generated from four major painting areas—all very different in style and media. The first of the major Kimberley painting movements was that of the ochre painters of Warmun (Turkey Creek) south of Kununurra. This movement developed

Madigan Thomas, *Untitled* (1997). The clear definition of silhouetted shapes and use of natural ochres ground to a fine paste seen in this work by younger Warmun painter Madigan Thomas characterise the style of painting that has made the art of this area of the Kimberley so distinctive.

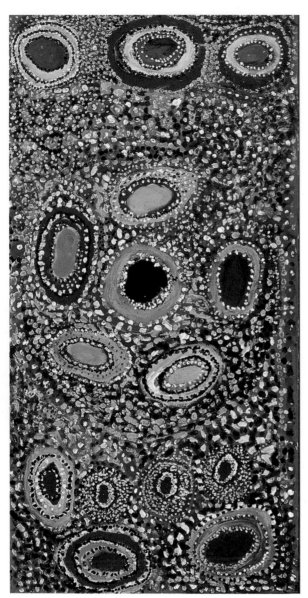

Milliga Napaltjarri, *Purrunga* (1991). Interleaving patterns and bright yellows burst from the canvas of this major Balgo Hills artist with exuberance. Her vibrant abstracted patterns overlie a dark ground and resemble the springing of new growth after rains or the fruiting of plants.

from the late 1970s when painted ceremonial boards were commissioned by a city-based art adviser. The style of painters such as the late Paddy Jaminji, Rover Thomas and Queenie McKenzie, Hector Jandanay, Jack Britten and others is identifiable for its thickly applied ochre—in which a surprising variety of hues can be achieved—and silhouetted forms usually outlined with white dots.

To the northwest, painters living at the coastal towns of Derby and Kalumburu continue to represent the Wandjina—mouthless ancestral beings which bring the rain and control the fertility of the land. These have been painted on rock walls in white and red ochres for at least 3000 years, retouched constantly by artists permitted under traditional lore to do so, before their modern portrayal on bark and later canvas and paper.

In contrast to the more confined colours of the Warmun painters and Wandjina artists, the art of the Kimberley desert community of Balgo Hills, on the edges of the Tanami and Great Sandy deserts, is a riot of colour. Strongly linked through family association with the Western Desert people of Papunya and Yuendumu, Balgo artists started acrylic painting in the mid-1980s. Their paintings, however, do not resemble those of Papunya and Yuendumu communities, being less based on an overall dotting technique and more on large fluid blocks of colour and weaving patterns.

The Kimberley's fourth major art-producing area is that of the central town of Fitzroy Crossing on the Fitzroy River. Since the early 1980s when it started in conjunction with adult literacy classes, the painting movement at Fitzroy Crossing has developed great vitality.

The brightly coloured, freely constructed watercolour paintings which portray figurative elements such as trees, mountain ranges, animals and plants, as well as abstracted planar forms, often show great clarity and individuality.

As demand for Kimberley art developed during the 1980s, artist-run cooperatives were established, as they had been in the Central Desert areas, with many painters also selling their art privately.

Where to see and buy the art

As Kimberley art of the transportable kind (as opposed to the numerous rock painting sites) is a relatively new phenomenon, historical collections of Kimberley art are rare. The Kimberley has no tradition such as that of Arnhem Land's bark painting or the Central Desert's stone and other artefacts. The Museum and Art Gallery of the Northern Territory does, however, have a good collection of decorated pearl shell. The Western Australian Museum and several other museums contain some important early Wandjina barks, with the Western Australian Museum also displaying a re-creation of a typical desert and cave environment of the Kimberley, created by senior Aboriginal people. The National Gallery of Victoria's Images of Power exhibition in 1995 provided the most comprehensive display of modern Kimberley art. This gallery also retains a good collection of art of this region, as does the Art Gallery of Western Australia and the Museum and Art Gallery of the Northern Territory.

A Western Desert Balgo Hills artist bends in concentration over her colourful painting of country.

Galleries dealing particularly in art of the Kimberley are more specialised than those stocking Central Desert art, and are referred to in the relevant chapters.

Recommended reading

For publication details see Recommended Reading page 233.
Aboriginal Art, Wally Caruana, 1993; *Oxford Companion to Aboriginal Art & Culture*, eds Kleinert & Neale, 2000; *Aboriginal Art*, H. Morphy, 1998; *Aratjara: Art of the First Australians* 1993; *Art from the Great Sandy Desert*, Art Gallery of Western Australia, 1986; *Australian Rock Art: A New Synthesis*, Robert Layton, 1996; *Australia's Greatest Rock Art*, Graham Walsh, 1988; *Dreamings*, ed. P. Sutton, 1993; *Footprints Across Our Land*, Magabala Books, Broome; *Images of Power*, ed. J. Ryan, National Gallery of Victoria, 1995; *Patterns of Life: The Story of the Aboriginal People of Western Australia*, Western Australian Museum, 1980.

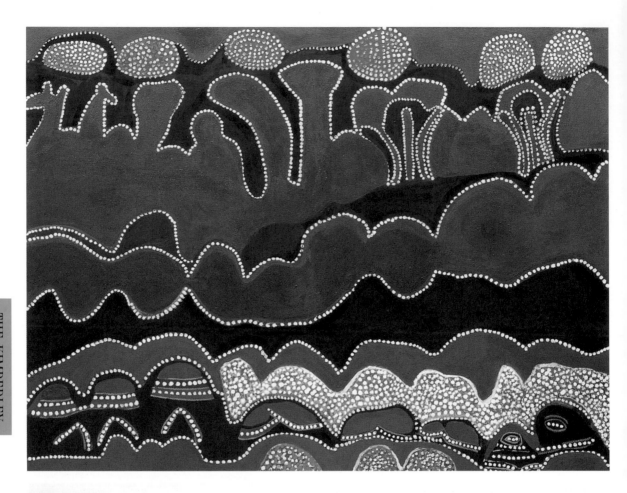

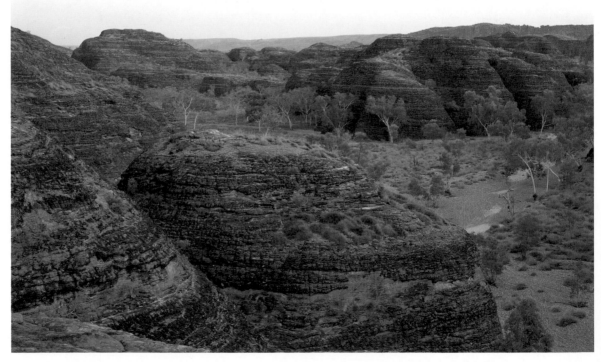

Situated close to the Bungle Bungle Ranges (the Aboriginal name of which is Purnululu), the small outback town of Turkey Creek has become a meeting point for four-wheel drive excursions to the Bungles and beyond. The Warmun Aboriginal community opposite the Turkey Creek store and café is home to the Gija people, whose traditional lands surround the township of Halls Creek, about 100 kilometres to the southwest. A number of the most well known Kimberley artists, including Rover Thomas and Queenie McKenzie, live or lived at the community. Others such as Hector Jandany are based at the even smaller Frog Hollow community, some 30 kilometres distant.

Warmun art has been distributed since 1985 through the Waringarri Arts Centre at Kununurra, established by the community of the same name to service all Kimberley artists.

WARMUN
A land of rugged contrast

Modern-day dreaming

Paintings on board and canvas for sale developed at Warmun as an extension of a modern-day song and dance cycle, the krill krill. In 1974, an old woman, spiritually related to Rover Thomas, died while being transported by plane from Turkey Creek to Perth following a car accident. About a month after her death, during a break in a ceremony in which he was participating, Thomas was visited by her spirit.

The spirit, he described, gave him a series of songs and stories relating to her death and many other events to do with a vast tract of the country. These included Dreaming stories such as that of the Rainbow Serpent and those relating to the formation of various landscape features and forces of nature such as the creation of the dramatic Wolf Crater and Cyclone Tracy which hit Darwin and surrounding coastal areas in 1974. Thomas was the stories' 'Dreamer'—the conduit through which these stories were told. After several years of him telling the stories, they evolved into a narrative song/dance ceremony. Called Krill Krill (Gurirr Gurirr), the ceremony was performed by members of the Warmun community. An integral element was the painting of boards carried by dancers in the ceremony. For several years, the boards were not painted by Thomas, but by his uncle Paddy Jaminji, from stories told to Jaminji by Thomas.

Perth-based art consultant Mary Macha, then manager and field officer for the Western Australian government's Aboriginal Arts and Crafts outlet and a frequent visitor to the Warmun area,

ABOVE LEFT: Jack Britten, *Purnululu (The Bunge Bungle Ranges)* (1996). Britten's dark shapes outlined in soft white dots and parallel layers of images have made his paintings highly memorable. This rendition is of his country, which encompasses the Bungle Bungle Ranges—called Purnululu by his Gija people.

BELOW LEFT: The Bungle Bungle Ranges, or Purnululu, are important sacred hunting and living sites and form the basis for many modern-day paintings by Warmun artists.

says that she 'nearly fainted with joy' on seeing one of these boards for the first time:

Paddy [Jaminji] showed it to me, then the group took it touring with them while they performed the ceremony all over the Kimberley and the Northern Territory—bouncing around on the back of the truck for well over a year. More paintings were added and, of course, they suffered somewhat in their travels. Snails were squashed on them, the dogs walked over them, they had things spilt on them and they were covered in dust. But were they powerful!

Eventually Paddy said I could buy them and they painted others. This happened three times over about three years. But no one would buy the first collection. Eventually Lord McAlpine [a major collector of Aboriginal art, for whom Macha was art consultant] bought the first and third collections. Now they are in the Australian Museum, Sydney. Professor Ronald Berndt bought the second for the University of Western Australia.

Macha was also a witness to Rover Thomas's first paintings.

He came out of a crowd of people when I was at Warmun one day and said 'I'm the one with the Dreaming—and I want to start painting.' His first paintings were powerful and quite unique.[1]

Seen first in group exhibitions in Perth, Thomas's work almost immediately attracted attention. With its large planes of black, brown and yellow defined by large white or black dots, it was startlingly different to the multi-hued acrylic-painted Central and Western desert paintings at the time regarded as the predominant form of 'new' Aboriginal art.

As in other areas, once started, painting at Warmun rapidly took hold. Unlike many communities whose art developed in conjunction with an art adviser, however, Warmun painters have remained completely independent, choosing to work always in natural ochres first on board, then canvas. Thickly applied, the ochres give the painting surface a unique, highly textural quality.

The melding of textures and natural ochres

Warmun artists such as George Mung Mung, Rover Thomas and Jack Britten pioneered the large country maps which 'look beneath the skin' of the land to its structure. Hills rise dome-like

in cross-section outlined in white dots, as in Jack Britten's *Untitled Landscape*, whereas the works of Rover Thomas, as the paintings on page 124 and 125 demonstrate, take a more planar perspective.

The spirit figure Manginta, as in Rover Thomas and Paddy Jaminji's 1983 painting (above), was amongst the first images to be translated from ceremonial board to paintings designed to

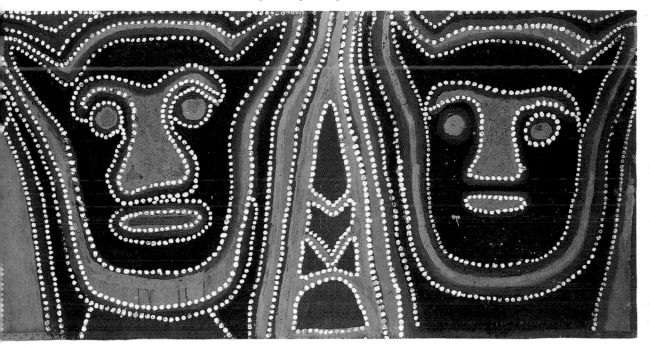

leave the community. They and other ancestral figures continue to be painted, as well as works of country such as Patrick Mung Mung's *Ngarrgooroon Country* (Bream Gorge) on page 120.

Warmun art is also characterised by its inclusion of narrative of modern events. Rover Thomas's *Cyclone Tracy* (page 125) is one of the most well known examples of this, and both Thomas and his relation Queenie McKenzie based many paintings on the massacres they or their immediate forebears witnessed. Warmun also has a particularly strong community group involved in teaching painting to a younger generation, with an active formal art program starting with primary school children.

Since 1999 a new community owned arts centre at Warmun has led to the development of the work of a younger generation of Warmun artists. Housed in a 1950s one-time post office, elevated on three-metre high concrete stumps, the building enables artists to work in the breeze of a shaded ground area. Since the establishment of the arts centre, there has been a

Paddy Jaminji and Rover Thomas, *The Spirits Jimpi and Manginta* (1983). Jimpi and Manginta are the two devils who accompany the spirit of Thomas's female relative whose death sparked the Kimberley Krill Krill song–dance cycle in the early 1970s. Her spirit, accompanied first by one devil then another, moves through the desert to Darwin, where she sees that the town has been destroyed by the Rainbow Serpent known in Western terms as Cyclone Tracy.

119

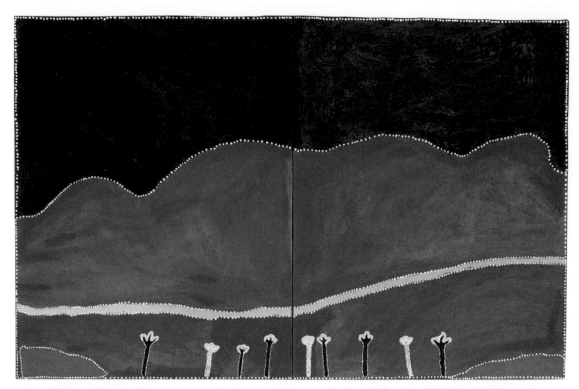

Above: Patrick Mung Mung, *Ngarrgooroon Country* (Bream Gorge) (2001). The second generation of Warmun artists such as senior artist Patrick Mung Mung, whose late father was one of the founder's of modern-day painting for this part of the Kimberley, shows new styles while maintaining the use of ochres.

flowering of art in the community, with around 50 artists painting regularly. More senior artists have evolved new styles and a whole new generation of younger painters is developing. These include Charlene Carrington, Katie Cox, Nancy Nodea and Phyllis Thomas, who are joining more senior artists such as Shirley Purdie, Gordon Barney, Patrick Mung Mung, Betty Carrington, Lena Nyadbi and Madigan Thomas. Most noticeable about these new paintings is the experimentation with different shadings of ochres, whether they be the simple horizontal or vertical block monochromatic shades as in Lena Nyadbi's *Jimbala Ngarrangkarni* (Spearhead Dreaming) (page 122) or interwoven shapes as in Patrick Mung Mung's *Ngarrgoorroon Country* (Bream Gorge). Other artists demonstrate the huge variety of possibilities with natural pigment which includes shades of blue-grey, charcoal, yellow, green and pink. Texture too is used to great effect—from the heavily applied opaque to pale washes. The results offer a huge variety of individual interpretations of landscape, story and daily life in widely divergent images.

Some Warmun artists
Barney, Gordon; Britten, Jack; Carrington, Betty; Cox, Katie; Jaminji, Paddy; Jandany, Hector; Juli, Mabel; McKenzie, Queenie;

Mung Mung, George; Mung Mung, Patrick; Mungari, Beerabee;
Nyadbi, Lena; Patrick, Peggy; Purdie, Shirley; Thomas,
Madigan; Thoman, Rover; Timms, Freddy; Wambini, Henry.

Where to see and buy the art

Most of Australia's major public collections have holdings of
Warmun artists' work. Of special note are those in the National
Gallery of Victoria, and the National Gallery of Australia, which
has a comprehensive collection of Rover Thomas's work,
including the 2001 record-breaking auction sale painting (see
Introduction).

The Warmun Arts Centre is a retail as well as wholesale outlet
where latest works can be seen. Another Kimberley outlet is

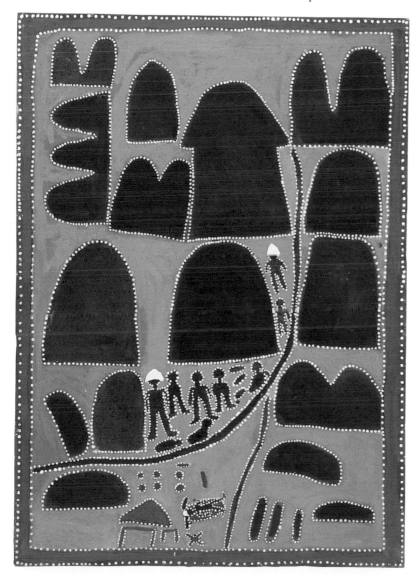

Queenie McKenzie, *Three
massacres and the Rover Thomas
story* (1996). As a child,
Warmun artist Queenie
McKenzie witnessed at least
one massacre of her Gija
people by white pastoralists. In
this painting, she related these
incidents, as well as another
where she saved the life of her
classificatory nephew, Rover
Thomas, by sewing on his
scalp after a horse had stood on
his head while the two were
stock mustering in a remote
area.

ABOVE: Lena Nyadbi, *Jimbala Ngarrankgkani* (Spearhead Dreaming) (2001). This senior Warmun artist often depicts the spearhead design used in women's ceremonial body painting in her striking two-part paintings.

RIGHT: Alan Griffiths, *Boornooloobun Cave* (2001). Lines of figures dance and move across the surface of Red Rock artist Griffiths' work, reminiscent of the ceremonial dances the artist performs holding large colourful woven ceremonial boards.

Broome's Short Street Gallery. Warmun exhibitions are regularly held at Melbourne's Gabrielle Pizzi and Niagara Galleries, Sydney's Hogarth Galleries, Brisbane's Fire-Works Gallery, and South Australia's Tineriba Tribal Gallery. Freddie Timms, an artist from the Warmun area, is represented by Sydney's Watters Gallery while Melbourne's Kimberley Gallery shows the work of other artists linked to the Warmun community.

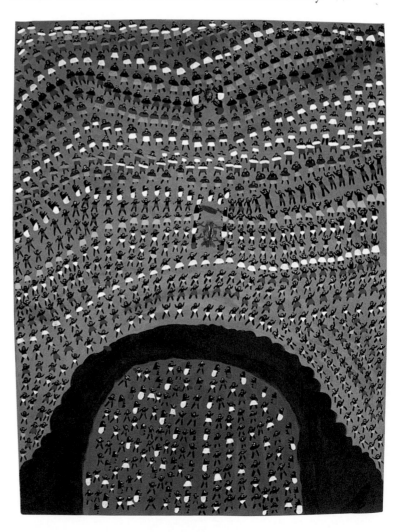

In the Kimberley's hub town of Kununurra, former Waringarri Arts Centre coordinator Kevin Kelly and wife Jenny Kelly run a private Aboriginal arts dealership and gallery. Kevin Kelly had previously had close association with leading Kimberley artists including Rover Thomas and Queenie McKenzie and is now the executor of their estates. The establishment of Red Rock has lead to some new work in ochre by artists of this area. Established in 1997, Red Rock represents around 15 artists—each with very different styles. Some are Walmajarri people, such as Nancy Noonju and George Wallaby, who were born near Billiluna, south of Balgo Hills, but now live in a community on the outskirts of Kununurra. Others live in the town itself while Ned and Maggie Johns live at the famed Gurindji-owned station, Wave Hill. Western desert Wangkajungka artist Billy Thomas, whose lands are around Billiluna, visits Kununurra frequently.

Though all these artists use ochre, their styles are very different. A finely dotted linear style characterises paintings by Ned Johns; George Wallaby's patterns are both formal in placement and boldly outlined; Alan Griffiths' paintings comprise horizontal layers of small outlined figures performing ceremonial dances; Billy Thomas overlays his paints thickly with swirls of white, brown and black ochre.

Some Red Rock artists

Gordon, Nellie; Griffiths, Alan; Johns, Ned; Johns, Maggie; Karadada, Roslyn; Lewis, Joe; Noonju, Nancy; Packsaddle, Ruby; Thomas, Billy; Wallaby, George.

Where to see and buy the art

Red Rock's main outlet is its own Victoria Highway showroom in Kununurra. Its artists are represented by Melbourne dealer Seva Frangos, who organises with Red Rock exhibitions for its artists around Australia.

Recommended Reading

General texts as listed in the Kimberley introduction, especially *Images of Power*, J. Ryan, 1993; *Roads Cross: The Paintings of Rover Thomas*, NGA 1994, page 4.

RED ROCK AT KUNUNURRA
Variety of ochres in a new centre

ABOVE: Billy Thomas, *Sandhills in the Great Sandy Desert* (2001). With their strongly textural surface and clear iconography, Billy Thomas's paintings reflect the multi-layers of the earth from which he collects his ochres.

ROVER THOMAS

Rover Thomas, *Ruby Plains Killing* (1990). The more chilling because often described in matter-of-fact, non-judgmental manner by their survivors or descendants, massacres such as the undated one at Ruby Creek, south of Halls Creek, became the subject of many of Thomas's paintings. In this instance, two or four men are killed by the station owner and manager in retribution for killing a bullock for food.

b. 1926, Gunawaggi (Well 33), Canning Stock Route, WA. Language group: Wangkajunka/Kukatja. Skin group: Julama. d. Warmun (Turkey Creek), 11 April 1998.

Rover Thomas left Australian art a twofold legacy. In taking the viewer 'inside the skin' of the land while relating stories of its people and place, he offered a unique interpretation of the landscape. Through his uncompromising sparse planar perspectives, Thomas along with the late Emily Kame Kngwarreye, was a major force in taking Aboriginal art out of an ethnographic category and placing it firmly at the forefront of international contemporary art.

In 1990, less than seven years after he had taken up painting at the age of sixty, the East Kimberley stockman-turned-painter was one of two Aboriginal painters to represent Australia at the Venice Biennale.

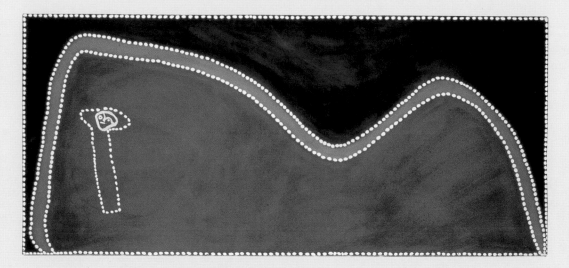

The most initially striking characteristic of Thomas's paintings, along with their highly textured ochre surfaces, is their minimal imagery and sense of space. With their large planes and restricted palette in which black often predominates, on the purely visual level, Thomas's paintings work as highly resolved abstracts.

Yet at their base is another, deeper layer—that of both a sense of place and usually a story about that place and its people. Among the most notable of Thomas's social documentary works are those telling of the massacres, poisoning and destruction of his Aboriginal forebears. One such example is a 1990 series based on the chillingly pre-planned Bedford Plains killings less than seventy years before. All the more

powerful because of their almost lyrical abstraction, Thomas's paintings of this event are accompanied by his own word poems.

Thomas did not, however, only document the horrific sides of life. To those who knew him well, he was a man with a wicked sense of humour, a warm, engaging personality and a keen sense of the whimsical and absurd. All of this was relayed in paintings—as were his journeys throughout many other parts of the country, as well as his own Kimberley lands.

Thomas was born at Gunawaggi (Well 33), a tiny community on Western Australia's Canning Stock Route, in 1926. During World War II, he lived at Bililuna, Western Australia, near the then mission station community of Balgo Hills, where he was initiated into traditional law. He spent many years as a stockman traversing vast tracts of the Kimberley and Northern Territory.

Rover Thomas, *Cyclone Tracy* (1995). One of Thomas's most famous groups of works, relating to the Krill Krill ceremony and the effects of the cyclone—believed by many Aboriginal people to be the Rainbow Serpent's work—on Darwin and surrounding country.

To Thomas, events of the present were as significant as those of the past. His painting career indeed stemmed from the constantly evolving modern-day Krill Krill song/dance cycle. Unusual also in Thomas's work was that, unlike many Aboriginal painters, he depicted country other than that of his Wangkajunka-Kukatja people.

'Thomas X-rays the topography,' wrote National Gallery of Victoria Aboriginal art curator Judith Ryan in her 1993 catalogue essay of the Images of Power exhibition of Aboriginal art of the Kimberley, 'seeing through to its skeleton and enabling it to be read as a conceptual map. His work echoes the flat, sparse expanses of desert terrain … As an artist Thomas is not locked inside language patterns or ritual structures of the Western Desert: he looks beyond them to another world of reality and enjoys the freedom to depict this expansively …'[2]

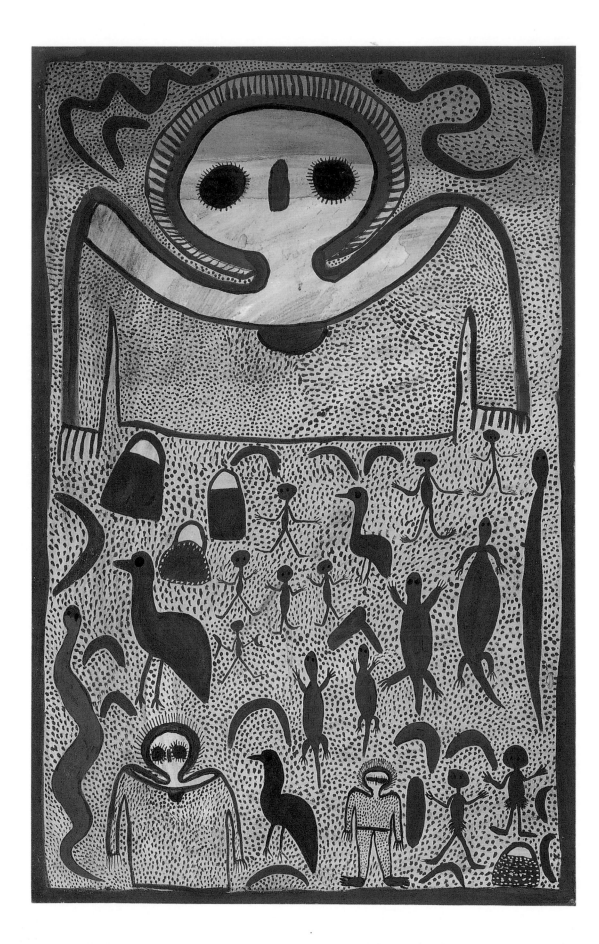

Kalumburu, 1000 kilometres north of Broome, is a former missionary settlement established in 1907. Here, several families—including the Karedadas and Jangarras—paint traditional images of the Wandjina on bark, canvas and paper.

The painting of Wandjina images on bark and board started around 1930 as a result of the encouragement of anthropologists who collected examples for Australian and international museums. The Wandjina were, as anthropologist A. P. Elkin observed in 1951, the 'heroes' of the Dreaming era who, at the end of their travels and exploits, 'died' and became paintings: that is, they left their shades on rock walls. Elkin continues:

They are usually depicted with eyes and nose and no mouth. To retouch a painted Wandjina causes rain, and to paint or retouch figures of animals, birds, reptile and plants in Wandjina gallery ensures the increase of the particular species in due season. The painting or the retouching is the ritual; it is a sacramental act through which life is mediated to nature and to man.

Each … group has it gallery or galleries, knows the myth of the gallery's Wandjina and is responsible for the painting ritual there. The species represented in it are the clan's totems.[1]

Spirit beings in the modern context

The modern art movement started in the early 1970s when painters such as Charlie Numbulmoore, George Jomeri, Sam Woolgoodgja and Cocky Wutjunga started painting Wandjina such as that illustrated on page 108–109.[2] Interest was further sparked when a Wandjina of the late Kalumburu resident Alec Mingelmanganu exhibited in the 1975 Derby Boab Art Week, under the title of *Austral Gothic*. Other members of the Kalumburu community followed suit and their works were exhibited at Aboriginal Traditional Arts in Perth a year later. Some of the bark paintings in this exhibition used the mouth-spray and hand-stencil techniques derived from rock art, with the works attached to hooped cane frames or stick straighteners.

Since, artists such as Ingatia and Waigan Jangarra, Rosie and Louis Karedada, Lily and Jack Karedada and David Mowarjli have painted Wandjina on bark, board, canvas and paper using natural ochres, as do the painters of Warmun. As with these Warmun artists, the Kalumburu painters are also serviced by the Kununurra-based Waringarri Arts Centre.

KALUMBURU
Land of the powerful Wandjina

LEFT: Lily Karedada, *Wandjina* (1990). One of the most prolific of contemporary Wandjina painters, Lily Karedada paints representations of these distinctive spirit figures on bark and canvas.

FAR RIGHT: Bobyin Nongah, *Kungmanggur Story (Spider and Snakes)* (pre-1963). This historic bark was collected by American amateur anthropologist Louis A. Allen in the nearby town of Port Keats in the early 1960s. It depicts the ancestor snake Kunmanggurr, who came out of the sacred waterhole to create the first people. The spider at left is said to have special significance in mortuary rites, as its web is believed to catch the spirit of the deceased if it attempts to wander before the rites are completed.

RIGHT: Artist unknown, *Untitled Spirit Figures* (1960). These ancient figures have rarely been seen in paintings since the late 1960s.

FAR RIGHT: Artist unknown, *Group of carved pearl shells surrounding a glass spear point* (c. 1940s–1950s). These rare carvings were made for ceremonial as well as decorative purposes. The glass spear point is made from clear glass with a finely serrated outer edge.

Some Kalumburu artists
Bobyin Nongah; Jangarra family; Karedada family; Mingelmanganu, Alec; Mowljarlji David; Numbulmoore, Charlie; Wheera, Jack; Wutjunga, Cocky.

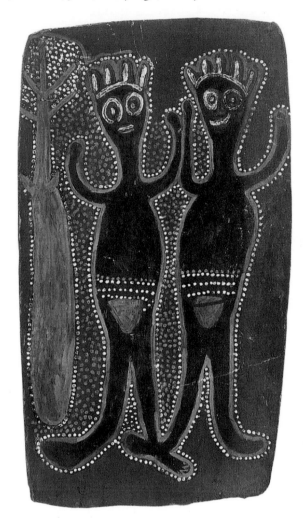

Where to see and buy the art
The Western Australian Museum has some important early Wandjina paintings, as does the National Gallery of Victoria.

Commercially, they are largely available through the Waringarri Arts Centre at Kununurra in Western Australia; Kimberley Art in Melbourne; and the Coo-ee and Hogarth galleries in Sydney.

Recommended reading
For publication details see Recommended Reading page 233. See general texts as in the Kimberley Introduction page 115.

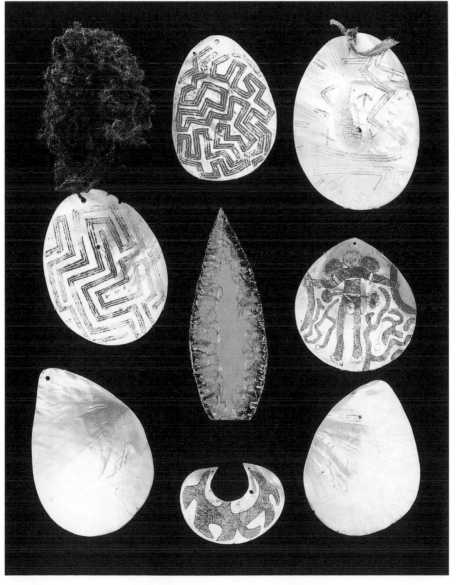

129

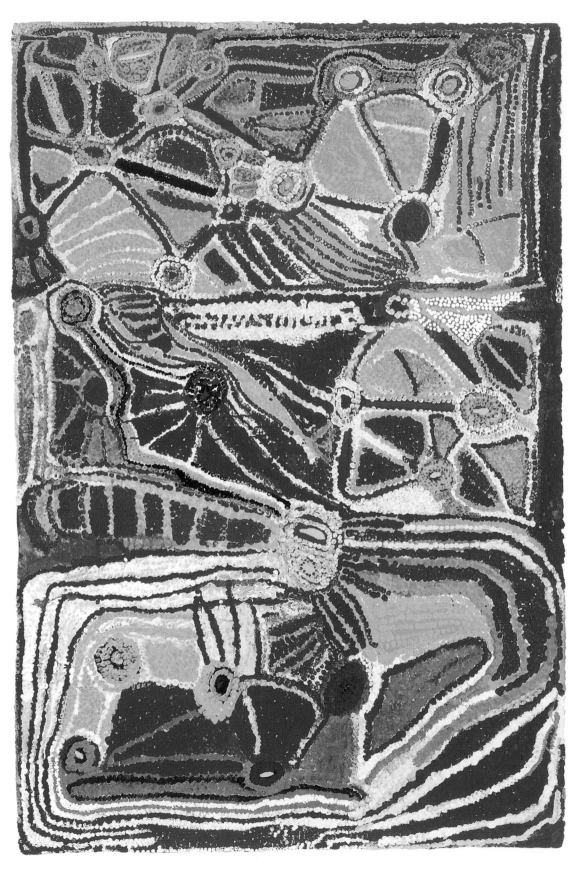

Deep in the Western Desert, Balgo is one of the most isolated of Australia's desert settlements. Three hundred kilometres from the nearest town, Halls Creek, the Balgo community occupies 1420 hectares of the 2.125-million–hectare Balwinna Aboriginal Reserve. A community of some 300 to 500 people, it has seven different language and family groups, predominant of which is Kukatja. Other major groups include Walmajarri, Warlpiri, Pintupi and Jaru.

Around the small, spread-out settlement stretch the spinifex-covered sandhills and plains of the Great Sandy and Tanami deserts. In the Wet, the community is frequently cut off for several months; in the Dry, the earth is baked hard. Temperatures regularly reach 40 degrees plus, although in the 'winter' (the Dry), a comfortable mid-20s is the norm, with nights often falling below zero. An easterly wind (Balgo means 'dirty wind') often persists, whipping up the sand around settlement buildings. The landscape, however, has aspects of extreme beauty—not least being the sheer space, clarity of light and, away from the community itself, the almost unbroken silence of the desert. Several kilometres from the settlement, the vivid orange-red of a rocky outcrop contrasts with the deep blue of an equally intensely hued sky. At sunset, the failing light fades the sage-green of the spinifex lining the rocky walls and plains of a vast amphitheatre-like escarpment to a soft purple-grey.

Like most desert Aboriginal communities, dirt tracks meander round the houses. The slight slope on which the community is sited divides Balgo into a 'top' and 'bottom' camp, with the artist-run Warlayirti Arts Centre located midway.

Established as a Catholic mission in 1939, Balgo became an Aboriginal-controlled community in 1981. Most of the older members of the community had left their tribal life of largely land-based existence and 'walked in' from the bush in adulthood. Their influence on the painting movement of the 1980s was instrumental to its development.

BALGO

Sage greens, soft purples and brilliant hues: the art of isolation

ABOVE: The spinifex-covered Tanami Desert turns sage green and soft violet at dusk.

LEFT: Eubena Nampitjin, *Untitled* (1992). Eubena is one of the senior Balgo artists. Her paintings, in which red, yellow and pink often predominate, have a vibrant, free quality.

Bai Bai Napangati, *Hair String Dreaming at Yimurr* (1992). This painting relates the travels of an old man in the artist's father's country who, while one day spinning hair into a sacred belt, was disturbed by a group of women and took cover inside a cave.

At Balgo, the Catholic church, in contrast to many missions on other stations, had a more interrelated and sympathetic relationship with the Aboriginal population. Here, children were not removed from their families and the use of traditional language and custom was encouraged. The modern settlement, however, reflects many of the problems common to Aboriginal settlements since the enforcement of a sedentary lifestyle— erratically maintained houses, alcohol and other drug problems, youth boredom, bad diet, and, in some cases, malnutrition and a variety of other health problems. Traditionally, the 'Balgo mob' are known and somewhat feared for their aggression. Fights both within the community, often caused by the number of different family groups, and outside during travel to ceremonies or sporting occasions are all too common.

Yet, despite these negative aspects, the feeling of the community as a whole is warm and friendly, with individuals constantly striving to make life more cohesive and attempting to ban alcohol and drugs.

Law and culture

Balgo art derives from its law and culture—called *Julururu*—
which incorporates events since the advent of the white man with
those of the Dreamtime, making for a constantly evolving, living
culture. There had been some tentative moves towards
establishing an art and craft movement in the late 1950s when
some soapstone carvings of figures, birds, animals were made, and
again during the 1970s when, encouraged by mission staff and
interested outsiders (including Professor Ronald Berndt and art
consultant Mary Macha from Perth), there was some painting on
small composition boards. It was after the establishment of an
Adult Education Centre in 1981 and a bilingual Catholic school
in 1983, however, that painting emerged in earnest.

Riotous colour and free expression

The Balgo community has strong Pintupi links through the
Western Desert. As well, several leading Pintupi Papunya artists
had relatives at Balgo and visited during the late 1970s. When

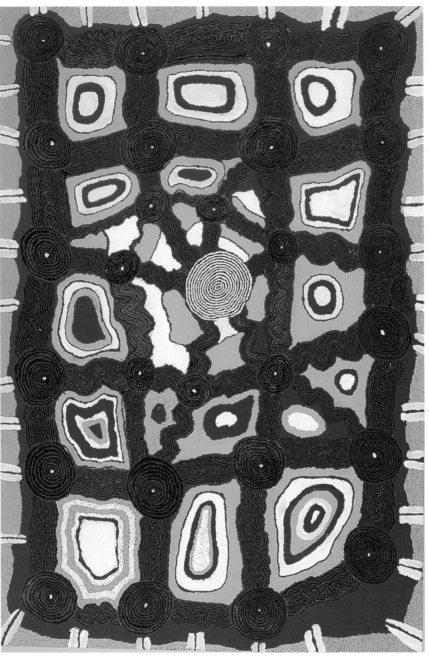

Kintore, an outstation of Papunya yet closer to Balgo, was established in 1981, these links were further reinforced.

Having observed the rise of the Papunya painting movement for some years, Balgo people tried the new medium around 1983. The first works reflected, as well as traditional Aboriginal iconography, some imagery based on Christian myths. As with the Papunya artists, acrylic on canvas was the preferred medium; unlike Papunya painters, however, Balgo artists have always preferred extremely bright, strong and numerous colours. Milliga Napaltjarri's paintings, such as *Purrungu* (page 114) are notable for their absence of definitive iconography, with the artist basing her paintings on the layers below the surface, whether they be the substructure of land or the foundation from which the designs of women's body paintings are derived. Eubena Nampitjin's superb use of colour and free design, such as her 1992 untitled work in the collection of the National Gallery of Victoria (page 130), have brought her boldy individual works international acclaim.

With no formal art structure in place until Warlayirti was

established in 1987, people painted on any available materials—including canvas, tin and building boards. Senior painter Donkeyman Lee Tjupurrula's 1990 *Tingari Dreaming at Tarkun* demonstrates the more stylised imagery in response to the rhythmic repetition of the men's Tingari song cycle (left).

In 1999 Warlayirti opened a large and expansive new arts centre. Surrounded by a large verandah on which artists paint, its bright interior comprises a large display area with colourful walls to set off the art, as well as extended office and storage areas. In 2001 an important new cultural centre was opened to house historical and contemporary art, artefacts, film and written material, as well as becoming a community meeting place to enable the daily lives of Balgo Hill's community to integrate with their culture.

Some Balgo artists
Nampitjin, Eubena; Nampitjin, Millie Skeen; Milner, Boxer; Napatljarri, Milliga; Mutji, Michael; Napangati, Bai Bai; Nangala, Ningie; Napangati, Susie Bootja Bootja; Nungarrayi, Ena Gimme; Nyumi, Elizabeth; Sunfly, Pauline; Tjakamarra, Alan Winderoo; Tjakamarra, Mick Gill; Tjampitjin, Sam; Tjampitjin, Sunfly; Tjapanangka, Tjumpo; Tjapangarti, John Mosquito; Tjapangarti, Wimmitji; Tjupurrula, Donkeyman Lee; Tjungurrayi, Helicopter; Yukenbarri, Lucy.

Where to see and buy the art
The Art Gallery of Western Australia and National Gallery of Victoria have significant holdings of Balgo art. Its main commercial outlets include Alice Springs's Desart and Gallery Gondwana; Darwin's Framed and Raft Artspace; Melbourne's Vivien Anderson, Gabrielle Pizzi and Alcaston galleries; Sydney's Coo-ee and Hogarth galleries; Adelaide's Gallery Australis; Hobart's Bett Gallery and Broome's Short Street Gallery. It can also be hired through Art Bank Sydney.

Recommended reading
All general texts as listed in the introduction to the Kimberley section and in particular *Footprints Across our Land*, Magabala Books, 1995; *Wirrimanu: Aboriginal Art of the Balgo Hills*, J. Cowan, 1994; *Yarrtji*, eds Pam Lofts & Sonya Peter, 1999.

BALGO

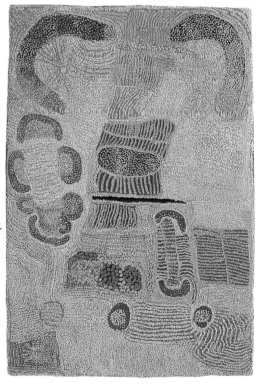

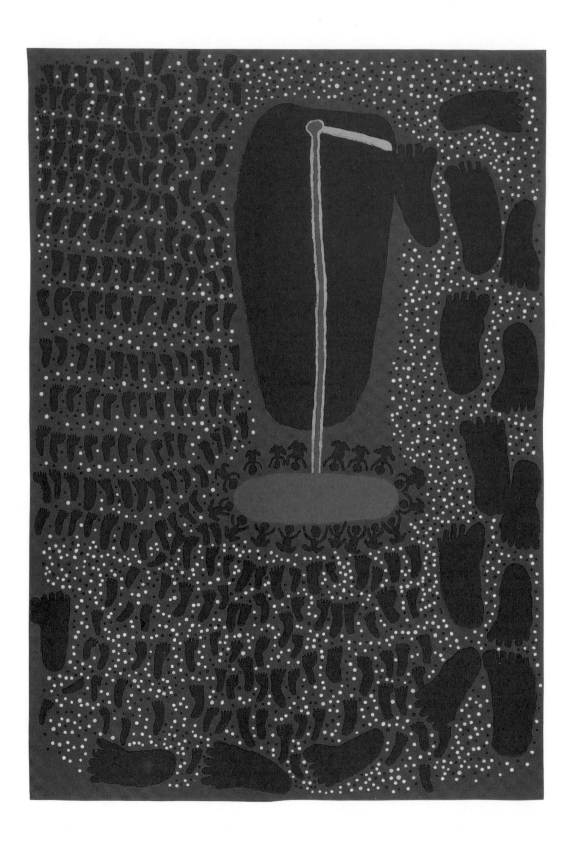

Situated on Bunuba and Walmajarri land, Fitzroy Crossing's Aboriginal population comprises Walmajarri, Wangkajungka, Bunuba, Gooniyandi and Nyigina people. Established as a ration station in the 1880s, the town has had at least a century of harsh inter-tribal and black–white conflicts. Also, many Aboriginal people now living in Fitzroy Crossing were born or have lived much of their life on pastoral stations, often hundreds of kilometres distant.

Centrally located in the Kimberley, Fitzroy Crossing has become something of a crossroads for the burgeoning tourist industry, as well as an attraction in its own right for its stunningly beautiful Fitzroy River and dramatic Geike Gorge.

Rediscovery of connections

The painting movement at Fitzroy Crossing originated in 1982 with the establishment of an adult education centre—Karrayili Adult Education Centre—following requests from several senior men to start English classes. Out of this grew a desire for people to record their personal histories visually. The first works were crayon and pencil on paper. Later, bright watercolours were introduced. Soon, more than twenty people were regularly painting and a special arts centre, Mangkaja Arts, was established as an extension of the Karrayili Centre. Mangkaja Arts Centre (*Mangkaja* means 'wet weather spinifex shelter') is a small building situated next to a supermarket in the town centre, and is readily accessible to visitors.

For many Mangkaja artists, whose work immediately attracted attention when it was exhibited in capital cities from 1986, the process of recording their histories has meant rediscovering their own heritage. This has often included making journeys of reconnection to their land.

The experience of Wakurta Cory Surprise is just one of many similar stories to be found among Mangkaja artists.

I was born in the desert. I never saw my mother or father. They died in the desert. When I was crawling age, I went to Christmas Creek station.

I was promised to an old man; he had two wives. We had no clothes …

We were all frightened. The station manager was hitting people so we ran away. The police tracked us down and put chains around the

FITZROY CROSSING

A land divided

LEFT: Jarinyanu David Downs, *Moses Belting the Rock in the Desert* (1989). The late David Downs's paintings are extremely distinctive for their combination of Christian and Aboriginal mythologies. This painting is a major work in a series of Moses story paintings, created in response to Downs's attendance at a Bar Mitzvah. It follows the work *Moses leading the Jewish People across the Red Sea*, in the collection of the National Gallery of Australia, which was highly commended in the 1988 Blake Prize for Religious Art.

men. They tied my husband up. Then I worked at the main quarters for the police, collecting eggs and washing plates.[1]

Often dispossessed for years and, in some cases, several generations from their lands, artists such as Wakurta have been able to recreate connections to their heritage through their paintings.

As with other Kimberley artists, Fitzroy Crossing painters combine modern-day events with personal experiences and traditional stories in their art. Much Mangkaja art is recognisable for its use of bright colour, large, freely drawn circular and oval shapes denoting waterholes, arrows or footprints to indicate tracks and journeys, figurative objects such as trees and animals and sometimes semi-realistic landscape.

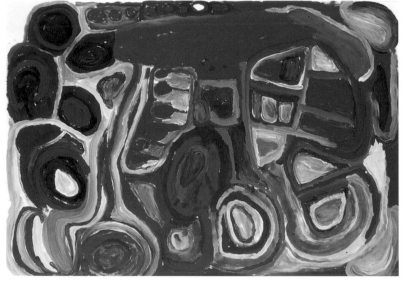

Stumpy Brown, *Untitled* (1994). The free design and brilliant colours of senior Fitzroy Crossing artist Stumpy Brown demonstrate the individuality of painting styles from this varied art-producing community.

Jimmy Pike was one of the first Fitzroy Crossing artists to gain recognition. His simplified, silhouetted figures, such as those on pages 140 and 141, and other forms often relate his latest travels or other experiences, or are based on far longer history. In conjunction with Perth-based designers Stephen Culley and David Wroth, Pike also established Desert Designs in 1981 to translate his images onto a variety of printed applications, including fabric, poster and postcards.

The late Jariniyanu David Downs's work was similarly distinctive, with its incorporation of Christian beliefs with those of traditional Aboriginal stories. Peter Skipper's work, although also reflecting a Christian influence, contains more traditional Aboriginal narrative.

Brilliant oranges and reds of the desert sand, silhouetted mountain ranges and brilliantly hued skys make the paintings of Daisy Andrews, who won the 1994 National Aboriginal Art Award, especially arresting, and particularly good examples of the journeys of joyous reconnection which characterise much of Fitzroy Crossing art.

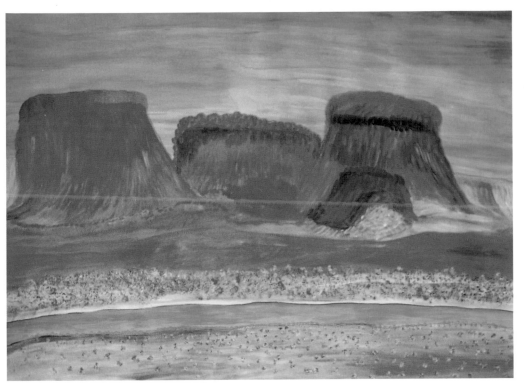

Some Fitzroy Crossing artists
Andrews, Daisy; Cherel, Janangoo Butcher; Jarinyanu, David
Downs; Jukuja, Dolly Snell; Ngarralja, Tommy May; Nyuja,
Stumpy Brown; Pike, Jimmy; Skipper, Peter; Wakartu, Cory
Surprise; Wankurta, Peanut Ford; Yankarr, Boxer; Yankarr, Paji
Honeychild.

Where to see and buy the art
The Art Gallery of New South Wales Yiribana gallery has some
fine examples of Fitzroy Crossing art, as does the National
Gallery of Victoria. Mangkaja Arts Centre, located in the centre
of Fitzroy Crossing, is open as a retail outlet which visitors may
freely visit. Frequently, the artists themselves are present to talk
to visitors about their art. Since the mid-1990s, Melbourne's
Australian Print Workshop master printer Martin King has
conducted a number of print workshops with Mangkaja artists,
resulting in accessibly priced and fine-quality works available
through the Print Workshop.

Recommended reading
General texts as listed in the Kimberley introduction, especially
Images of Power, National Gallery of Victoria.

Daisy Andrews, *Lumpu-Lumpu*
(1994). Winner of the 1994
National Aboriginal and Torres
Strait Islander Art Award, Daisy
Andrews creates jewel-like
paintings of her country which
have been a voyage of
reconnection for the artist, who
was forced to leave her lands as a
young woman. Her work also
introduced the fresh vibrancy of
contemporary art from Fitzroy
Crossing to a wide, city-based
audience.

139

JIMMY PIKE

b. c. 1940, Great Sandy Desert. Language group: Walmajarri.

A stockman in the cattle industry for some twenty years, Jimmy Pike began painting at the age of forty—introduced to the medium by art

Jimmy Pike, *Jumu Yirrjin* (1991). A seasonal waterhole (Jumu)—seen in the middle of this work—is surrounded by bush peanut trees, whose nuts are cooked in the fire to open before eating.

teacher Steve Culley in classes he took while in Fremantle Prison. Developing a colourful, direct imagery, Pike's images translated well into fabric design. They provided the foundation of a highly successful company, Desert Designs, started in 1985 by Pike, Steve Culley and David Wroth.

Pike's initial forays into art were first Textacolour works on paper and later black and white lino prints. Some images are based on traditional patterns and designs—such as those seen incised in decorated pearl shells; others are figurative representations of events and observations

from Pike's everyday life.

Widely exhibited in solo and group exhibitions in Australia and internationally since 1985, Pike's paintings and prints speak, as curator Michael O'Ferrall describes in the artist's monograph, of an 'individual mind at work … symbolising [along with artists including Robert Campbell Jnr, Rover Thomas and Ginger Riley Munduwalawala] the emergence of a significant new independent Aboriginal cultural voice'.[2]

Pike's artistic and personal explorations during the 1990s have included an ongoing collaboration with Chinese artist Zhou Xiaoping, who travelled with Pike in his Kimberley home country. The pair painted side by side, collaborating on some works, resulting in a body of works exhibited in both Australia and China.

A senior figure in his tribal group, Pike has been involved, along with many other Kimberley artists including Fitzroy Crossing's Peter Skipper, in land claims and other issues affecting Aboriginal people. As Michael O'Ferrall wrote:

From the time he first left the desert in the early 1950s, many changes have taken place, but his art and personal engagement with the landscape have refused to be diminished by them. Rather, they have intensified and strengthened, and through his own visionary contribution have maintained the sense of the essential continuous present encapsulated in the bond between Aborigines and their land.[3]

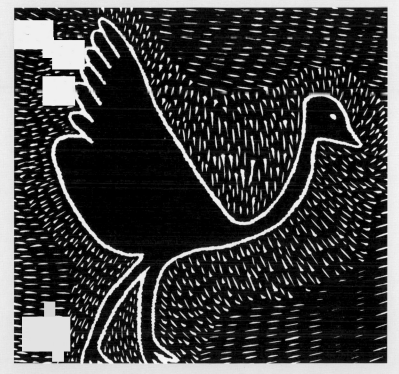

Jimmy Pike, *Pirnini Country 1* (1987). Pike is a master of black and white screenprints, such as this one which concerns a billabong story and a swan. Pike's images have brought him widespread recognition both in Australia and internationally.

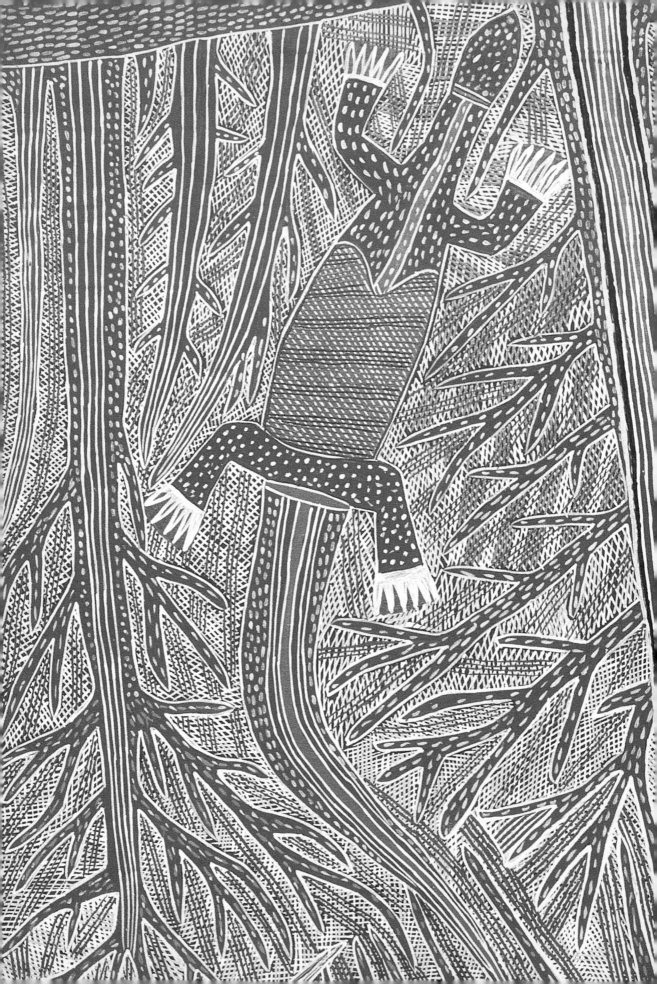

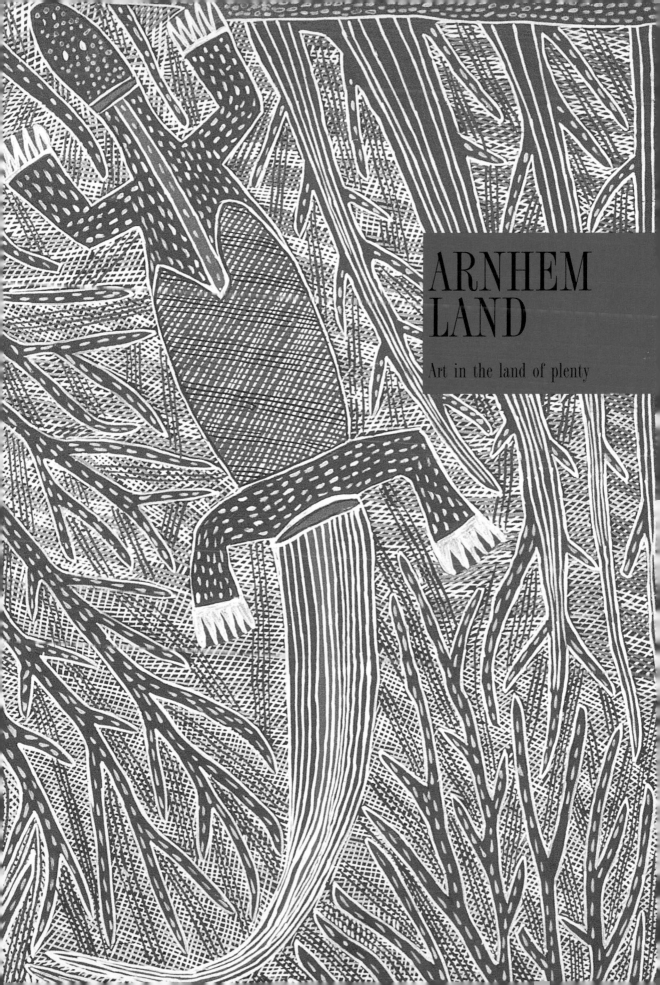

ARNHEM LAND

Art in the land of plenty

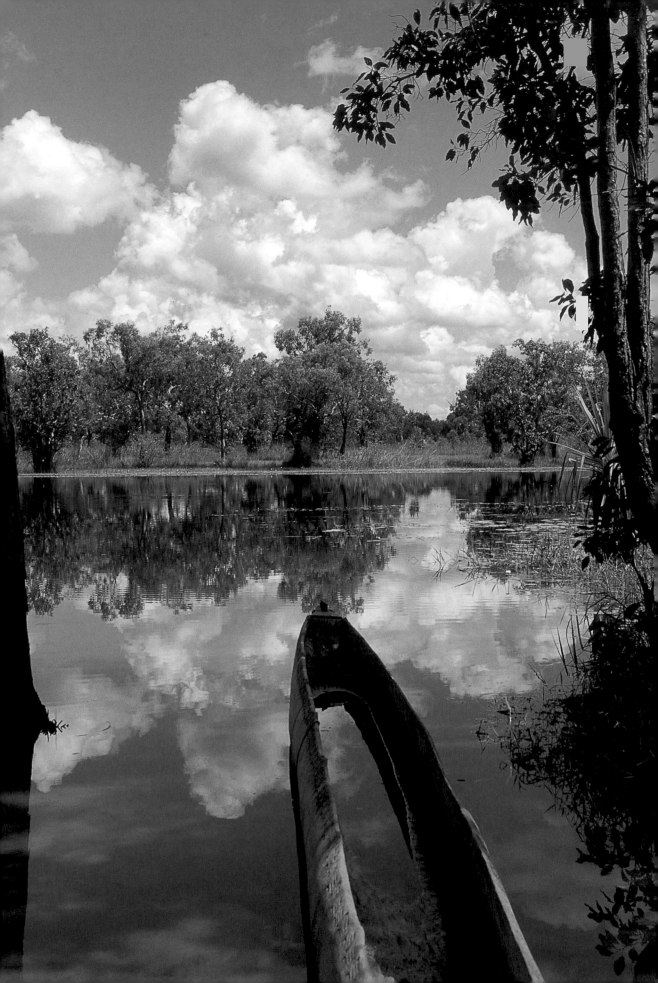

The art of Australia's far northern region of Arnhem Land reflects both the abundance of its land and its antiquity. Stretching from the Gulf of Carpentaria in the east to the West Alligator River in the west, and including the adjacent islands of Melville and Bathurst, the 150 000 square kilometres of Arnhem Land encompass a vast range of terrain, including lush, fertile grasslands, rivers and lagoons, rugged stone areas, mud flats and huge sandstone plateaux.

The region's wildlife is similarly abundant. As well as providing essential food sources, fauna such as the sea- and river-dwelling saltwater and freshwater crocodiles, dugongs, turtles and many varieties of fish, kangaroos, wallabies and other marsupials, lizards and snakes are integral to Arnhem Land's myths, lore and art.

Modern-day art in Arnhem Land and the far north is centred on seven main communities: Yirrkala on the eastern mainland tip; Galiwin'ku (Elcho Island); Ngukurr on the Roper River to the Limmen Bight; the central coastal areas of Ramingining, Milingimbi and Maningrida; and, in the west, Gunbalanya (Oenpelli), bordering Kakadu National Park on the East Alligator River.

As well as these major centres, numerous small art communities or outlets are spread throughout Arnhem Land, servicing more than 3000 artists and craftspeople.

PREVIOUS SPREAD: Detail from Ngukurr artist, Djambu Barra Barra's *Cypress Pine Mortuary Rite* (1994), page 194–195.

ARNHEM LAND
Art in the land of plenty

LEFT: The still waters of Arnhem Land's many waterways and flood plains offer a haven for wildlife of all descriptions.

People of the Top End

The single biggest group of people of Arnhem Land, whose country ranges from its centre east to the Yirrkala region, refer to themselves as Yolngu. Those further west call themselves Youl.

Arnhem Land became an Aboriginal reserve in 1931, although non-Aboriginal visitors had been required to obtain permits from 1918. Aboriginal people had been living in Arnhem Land for at least 50 000 years before regular contact with others. From the mid-1700s, people from Indonesia and further north would harvest the Chinese aphrodisiac delicacy trepang (sea cucumber) from the seas of northeast Arnhem Land from around January to May each year.

Permanent or semi-permanent camps were set up by the Macassan traders on beaches—the regular visitations led to a regular exchange of goods and artefacts, and the establishment of often ongoing relationships. Aspects of the Macassan culture and stories about the visits themselves became incorporated into the

area's lore, with some stylistic influences also carrying over into its art and craft.

From 1908 until the early 1940s, ten Methodist or Church of England missions were set up in Arnhem Land, with Roman Catholic missions established at Bathurst Island (1911) and Melville Island (1941). Most people lived at these stations until the land rights movements of the 1970s, which returned both tracts of land and the running of the missions themselves to Aboriginal control.

The continuous presence of missionaries in this part of the world had, to some extent, enabled a more gradual transition to European ways in comparison to other parts of Australia. Nor was there the 'trucking in' of peoples regardless of familial land and cultural links to form settlements under federal government edict, as occurred in many Central Desert areas. World War II, however, had a greater impact on Arnhem Land and the Top End than other parts of Australia.

Many northern areas, including a number of places in Arnhem Land, became military, navy and airforce bases. A large number of white missionaries were evacuated and the local populace left to fend for itself. Darwin was bombed severely a number of times in 1943 and 1944, as was the small Central Arnhem Land coastal town of Milingimbi in 1943.

Self-determination and beyond

Moves towards Aboriginal self-determination and return of lands to indigenous control were sparked by the Commonwealth government's granting in 1962 of mining rights for a bauxite mine on the Gove Peninsula, of which Yirrkala is the central community. The mining company planned to mine vast areas of the peninsula, with the subsidiary setting up of a processing plant at Nhulunbuy, 20 kilometres from Yirrkala.

Yirrkala's traditional owners felt this encroachment was far from acceptable and made representation to stop the mining company, presenting the Yirrkala *Bark Petition* (page 41) expressing their concerns to the federal government in 1963. Although this claim was lost and the mining company did establish huge open-cut bauxite mines on traditional lands near the settlement of Yirrkala, subsequent claims were more successful, with the Yolngu eventually regaining control of significant tracts of eastern Arnhem Land.

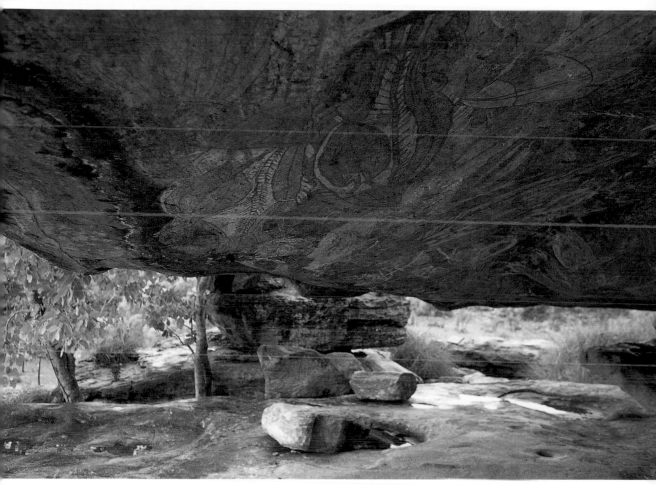

Other claims by western and central Arnhem Land people led to many lands being returned to them during the 1970s and 1980s. With an ever increasing tourist trade, especially to the central Kakadu National Park, permits are needed for many, but not all, Arnhem Land Aboriginal communities outside the main tourist centres.

An example of some of the splendid rock art seen on cave walls and rocky overhangs throughout the Kakadu National Park.

From rock to bark—a continuing artistic tradition

Arnhem Land and the far north are by far Australia's most prolific bark and rock art areas. Both these techniques have been practised for centuries, with dates continually being re-evaluated as a result of the increased sophistication of dating techniques and the discovery of new rock art sites. It has, however, been fairly conclusively established that a number of Arnhem Land rock sites date back at least 50 000 years.

More so than that of the Central and Western desert areas, the art of Arnhem Land has had a smoother transition from the

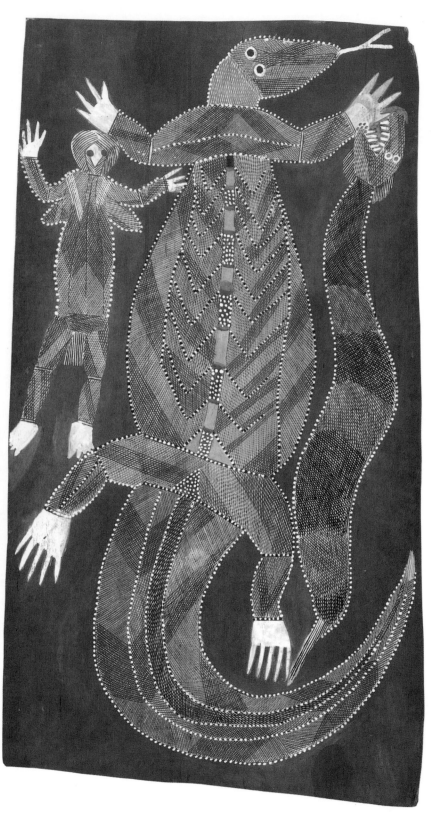

traditional to the modern. Images portrayed for generations on cave walls and bark stripped from the stringybark trees have been translated onto today's materials—predominantly bark, but also paper and board. Ochre is still the most often used paint, although some areas are experimenting to a limited extent with acrylics and gouaches. The Western techniques of printmaking—etching and lithographs—are also being explored to great effect by artists from a number of communities, with visiting printmakers or at workshops in cities.

The art of Arnhem Land can be grouped loosely into that of four geographic areas: the west from the East Alligator River around Gunbalanya (Oenpelli) and Jabiru; the central west around the coastal settlement of Maningrida; the central east between Maningrida and Ramingining; and the far east around Yirrkala. The Tiwi of Bathurst and Melville islands and the artists of the far eastern area around Ngukurr also have quite distinctive artistic styles.

One of the most striking differences between the art of western and central Arnhem Land (Gunbalanya,

Milingimbi, Maningrida, Ramingining) and that of the east (Yirrkala, Blue Mud Bay) is that, in the latter, the infill lines or crosshatching generally covers the whole canvas, whereas in the art of the central and western areas, crosshatching is generally confined within outlined images.

As anthropologist Ronald Berndt said, the art from western Arnhem Land shows a 'preference for open spaces, a concentration on the central figure or figures against a plain background; detail is subordinated to the main design; and there is an impression of suddenly arrested motion.'[1] Naturalism and figuration are emphasised, with a minimum of stylisation; roundness and curves are favoured, rather than angles and straight lines.

It is in art from the west and central areas that the famous X-ray style—so called because the internal organs are displayed in section as part of the external image—are found.

On the northeastern side of Arnhem Land, the bark is almost completely covered with design and the drawing shaped to fit into the edges of the bark sheet. Although spaces are occasionally left, the tendency is to fill in the background with crosshatching or crisscrossing of lines, even to the extent of design repetition. There is little of obvious narrative content, and sometimes a pattern is repeated many times.

Unique bark art

The highly specific designs, the organic properties of the materials and their three-dimensional qualities make barks highly individual works of art. Bark is taken from the trees at the end of the wet season (November to March). It is stripped from the trunk by making a cut at the top and bottom of a section of the tree, levering the bark outwards and pulling upwards. The bark is then placed for a few minutes on a blazing fire and the outer fibre stripped, leaving a flexible sheet which is more easily flattened. Flattening is assisted by laying the bark, weighted down with stones, on the ground in the sun for several days.

The surface is fixed with a material before ochre is applied. This fixative was traditionally the sap of tree-orchids or the yolks of sea-going turtles' eggs, but is now generally replaced by the commercially available polyvinylacetate (PVA) glue. A fine 'brush' made of a twig or blade of dried grass is used to apply ochres, ground and mixed with water to form a smooth paste.

LEFT: Peter Marralwanga, *Djirbaykbaykk, the snake man; Kawalan, the Goanna; and a woman* (c. 1975). Marralwanga's paintings, which often depicted no longer performed ceremonies such as the one relating to this picture concerned with fertility and reproduction, reflected the seniority of his position.

149

RIGHT: Yirawala, *Luma Luma and Wind Mimi* (1971). One of the most famous mid-twentieth century Arnhem Land bark painters, Yirawala's works are of great historic and artistic significance. This one tells of the ancestor figure Luma Luma, who sings for a storm assisted by the spirit Wind Mimi. On the Mimi's head is seen a bag of magic stones for storms, while power stones hang from Luma Luma's head to control the elements.

Pigments are red, yellow, black and white (with occasionally green, derived from the mixing of black and yellow). Traditionally, pigments from different areas were traded. Blue was never found naturally, although when Ricketts' dyes and washing bleach were introduced in the late 1800s, they were used in some rock art.

The images of bark paintings are both sacred and secular. Traditionally, secular images were those which told the stories of hunts and events, and were painted on walls of bark shelters and rock walls. Representations of a sacred nature were painted on sheets used in initiation and other ceremonies, and subsequently destroyed or left behind to disintegrate. (Some of these found their way into museum collections when collected by European ethnographers and explorers.) Sacred art generally represents some aspect of myths—the spirit beings of the Dreaming which set the pattern for the natural world.

Creation beings, rock sprites and other images

Two major myths dominate the creation stories of the region. These are the stories of the journeys of the two Djang'kawu Sisters, occasionally with their brother, and that of the Wagilag Sisters (pages 172–173). Variations on the journeys and events experienced vary with the region. Common elements are that the Wagilag Sisters story relates events of people in freshwater regions; those concerning the Djangk'kawu relate to the coastal and other saltwater areas. Other major spirit figures and beings from Arnhem Land include the Rainbow Serpent, the Dugong and the Mimi spirits.

Where much of the art from Australia's Central Desert regions has developed along highly individual lines, the majority of the art of Arnhem Land remains a continuation of traditional stories and long-portrayed imagery. The level of individual interpretation varies from community to community, with artists from some areas deciding on a higher level of individual interpretation than those who prefer to stay within the bounds of traditional representation. In general, the more figurative the art—that from the central coastal areas around Maningrida, Milingimbi and Ramingining—the more individually it is interpreted; in areas such as Yirrkala and Galiwin'ku where stylised patterns representing traditional clan designs predominate, individual interpretation is less prevalent.

During the mid- to late 1980s, with the interest generated in contemporary Aboriginal art through its resurgence in the Central Desert regions, bark painting was embraced more as a contemporary art form in its own right. The scale of the works also grew from the small souvenir panels whose making in the 1950s was encouraged by missionaries at Yirrkala and Milingimbi to the larger works in line with contemporary art practice.

From outstation to contemporary gallery

With the increased demand, art coordinators and centres, similar to those which had been developed in the desert regions, were appointed and established at a number of major art-producing communities. At Gunbalanya (Oenpelli), Dorothy Bennett, working with the federal-funded body Aboriginal Arts and Crafts (which during the 1970s to mid-1980s made a significant contribution to the marketing of art from the Top End and Kimberley regions), represented artists of the area. Milingimbi established a profitable craft shop outlet in 1967, which has operated with fluctuating volume ever since. Nearby Maningrida's arts

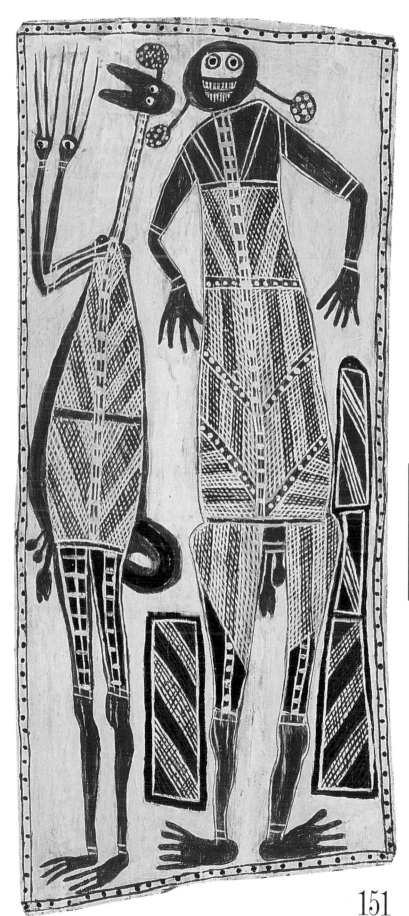

centre started as a branch of the local progress association in 1968, following the Milingimbi model. Yirrkala's designated arts centre Buku Larrngay Mulka followed in 1975 and Ramingining's Bula'bula cooperative in the early 1980s.

Major artists of the Top End

During the 1980s and 1990s, major individual exhibitions by Arnhem Land artists including Yirawala, Naritjin Maymura, George Milpurrurru, John Wululu, David Malangi, Banduk

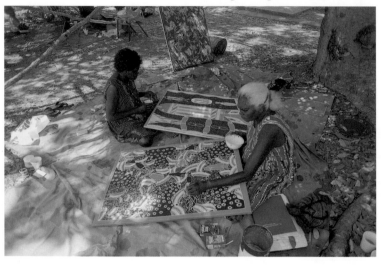

Marika, Paddy Fordham Wainburrunga, Bardayal Nadjamerrek and Mick Kubarkku have been held in leading public galleries. The work of Arnhem Land artists has also played a fundamental role in every survey exhibition of Aboriginal art. In 1993, Maningrida's Jack Wunuwun became the first Aboriginal artist to hold a solo exhibition in a major public gallery (the

Two painters from the eastern Arnhem Land community of Yirrkala sit in the dappled shade outside their home, working on a bark painting.

National Gallery of Australia). In 1995, the Museum and Art Gallery of the Northern Territory curated a touring exhibition, Rainbow Sugarbag and Moon, of Central Arnhem Land artists Bardayal Nadjamerrek and Mick Kubarkku. During the 1990s, the barks of Yirrkala and Maningrida, in particular, started to attract attention for their increased scale.

Where to see and buy the art

There are many places in the Top End for the interested tourist or collector to view the art in situ, perhaps meet the artists and purchase barks, weavings, beads and other artefacts, as well as fabrics and sculpture.

The art-producing communities of Yirrkala and Gunbalunya (Oenpelli), as well as Bathurst Island's Tiwi Designs, welcome visitors into their well set-up display rooms and galleries. Adjacent to Yirrkala's Buku Larrngay Mulka Arts is a museum containing important examples of eastern Arnhem Land art, including the encylopedic, historically significant bark Church Panels.

The arts centres at Maningrida, Ramingining, Melville Island and Galiwin'ku welcome visitors to a limited degree. To visit these communities, and also Gunbalanya, permits must be obtained from the communities themselves (see Directory page 226) or from the Northern Land Council in Darwin. While largely operating as wholesale outlets for works destined for city galleries in Australia and overseas, depending on supply, these centres may sell artworks to visitors. Maningrida and Melville Island's Jilamara Arts Centre also feature separately housed keeping place museums, which offer an excellent introduction to the history and art of the area.

Special buys

Barks Yirrkala, Maningrida, Ramingining and Gunbalanya (Oenpelli) are the great bark-producing centres of Arnhem Land. During the 1990s, 'big barks' standing up to 3 metres high have been produced at Yirrkala and Maningrida. Many have been ordered and displayed in major contemporary international and Australian survey exhibitions and collections.

Beads and other artefacts Of the community-based centres, Yirrkala's Buku Larrngay Mulka Arts has the most comprehensive stock of beads and small sculptures, as well as woven baskets and small, inexpensive, but often finely wrought bark paintings.

Weavings and sculpture All of Arnhem Land's major bark-producing centres—Yirrkala, Gunbalanya, Maningrida and Ramingining—sell woven baskets and circular floor mats, as well as a wide variety of dilly or carry bags (found especially at Maningrida) and other weavings. Loose-weave carrying bags and fish nets, and many other weavings, are found especially at Elcho Island's Galiwin'ku Arts Centre.

Most of the major centres also sell sculpture and carvings, such as the Tiwi people's figurative birds, animals and the burial Pukumani poles (found at Bathurst and Melville islands). Maningrida and Ramingining have also become important sculpture/carving areas producing a great variety of carved spirit figures, as well as hollow log coffins. Galiwin'ku carvers also produce the sculptural, decorated Morning Star poles (page 193), now made for commercial purposes as well as for their traditional role in burial ceremonies.

Fabrics Tiwi Designs at Bathurst Island is Arnhem Land's major fabric-producing centre. Much of the screenprint designs produced here are shipped immediately to city gallery outlets.

Works on paper A number of bark artists have become adept at printmaking in the media of lino cuts, screenprints and etchings, or creating individual paintings on paper. Some of the arts centres stock supplies of recent printmaking ventures, with Darwin's University of the Northern Territory printmaking workshop often working in conjunction with the communities. Gunbalanya (Oenpelli) and Melville Island's Jilamara and Munumpi arts centres are those most associated with the one-off individual works on paper.

RIGHT: Mathaman Marika, *Morning Star Myth* (late 1950s). This historically significant painting, by one of eastern Arnhem Land's most important painters, relates the story of the Morning Star myth (page 193). It was painted with impeccable detail in order to preserve the story correctly for future generations at a time when the Yolgnu of this area were concerned that mining operations would permanently destroy their lives and lands.

Where to see and buy the art outside Arnhem Land

Northern Territory Many of the best displays and purchases of barks, sculpture, works on paper and artefacts can be found in public and private galleries in the Northern Territory, especially those in Darwin. With the second largest Aboriginal collection of any public gallery, Darwin's Museum and Art Gallery of the Northern Territory has 1300 barks and hundreds of Arnhem Land weavings, fabric, sculpture, with a sequential introduction to the art of the area in an historical display. A group of Pukumani poles outside its entrance signals the importance of Aboriginal art to this gallery.

Similarly, a number of Darwin's commercial galleries, such as Framed, Karen Brown Gallery and Aboriginal Fine Arts Gallery, contain some of the best examples of art and artefacts of Arnhem Land available for purchase.

Other public galleries and museums Major ethnographic collections of Arnhem Land art of the late nineteenth century are largely contained in Australia's museums, especially Canberra's National Museum, the Museum of Sydney, Museum of Victoria and the South Australian Museum. The University of Melbourne also contains a major collection of early ethnography, while the Art Gallery of New South Wales was one of the earliest galleries to collect twentieth-century barks and carvings, and place them in an art, rather than an ethnographic, context.

More recently, Melbourne's National Gallery of Victoria and Canberra's National Gallery of Australia have especially concentrated on purchasing major works of Arnhem Land artists and carvers. Sydney's Museum of Contemporary Art (MCA) also holds major collections of barks, weavings and sculpture from the north, including the historical Arnott's collection of 273 bark paintings from the 1930s to 1970s featuring forty-one paintings

by leading painter Yirawala. The MCA has, since 1990, also acquired 800 works from the communities of Ramingining and Maningrida (the latter being held in trust for the people of Maningrida).

Southern state commercial specialists Major commercial galleries specialising in the exhibition and display of Arnhem Land art include Melbourne's Alcaston Gallery (art of the Tiwi), Gallery Gabrielle Pizzi (works from Maningrida and Ramingining), Sydney's Hogarth Galleries (works from Bathurst and Melville islands, Maningrida and Ramingining) and Annandale Galleries (especially the 'big' barks from Yirrkala and Maningrida).

While it may be possible for the lucky collector to chance upon an older (pre-1970s) bark in the occasional second-hand shop, by far the greatest majority of older barks are to be found in Australia's art auctions. The greatest range is to be found at Sotheby's auctions, which hold regular annual sales of important Aboriginal art and artefacts in Melbourne and, occasionally, Sydney. Both older and more contemporary barks can be found, as well as a wide range of art and artefacts.

Recommended reading

For publication details see Recommended Reading page 233.
Aboriginal Art, Wally Caruana, 1993; *Oxford Companion to Aboriginal Art and Culture*, eds Neale & Kleinert; *2000 Visual arts and crafts sources directory*, ATSIC, 2000; *Aboriginal Art*, Howard Morphy, 1998; *Aratjara: Art of the First Australians*, exhibition catalogue, 1993; *Australian Aboriginal Paintings*, Jennifer Isaacs, 1989; *Dreamings*, ed. P. Sutton, 1988; *Nangara The Australian Aboriginal Art Exhibition*, Ebes Collection, 1996; *The Inspired Dream*, Margie K. C. West, 1988; *The Painters of the Wagilag Sisters Story 1937–1997*, Wally Caruana & Nigel Lendon, 1997; *Rainbow, Sugarbag and Moon: Two Artists of the Stone Country*, Margie West, 1995; *Spirit in Land: Bark Paintings from Arnhem Land*, Judith Ryan, 1990; *Windows on the Dreaming: Aboriginal Paintings in the National Gallery of Australia*, Wally Caruana, 1989; *Saltwater*, Yirrkala, 1999.

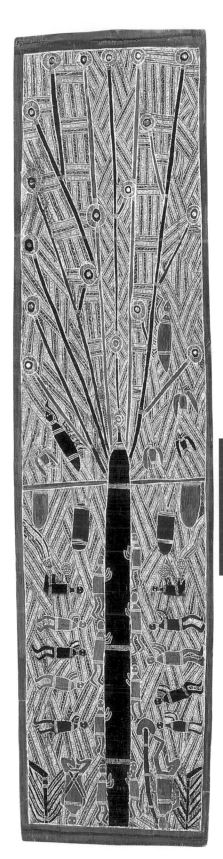

ARNHEM LAND

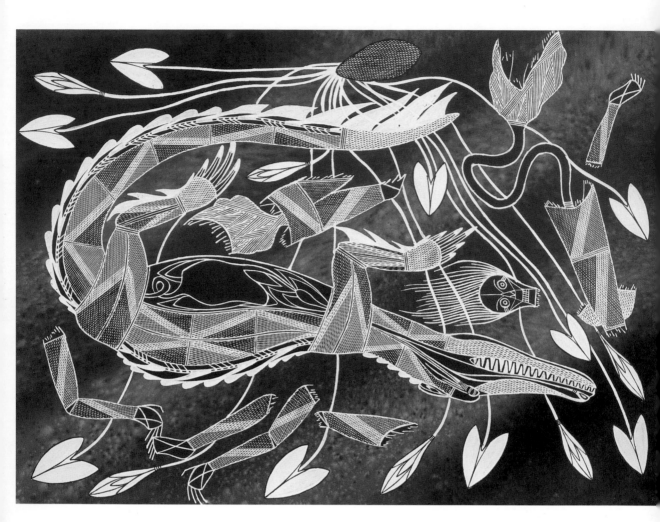

Gabriel Maralngurra, *Freshwater Croc & Black Bream* (1994). This work on paper, by one of Injalak Arts Centre's younger painters, typifies the style for which the centre has become famous since the early 1990s.

The settlement of Gunbalanya (Oenpelli) is on the western border of Arnhem Land, adjacent to the flood plains of the East Alligator River, 300 kilometres south of Darwin. Surrounding the small settlement are wide, sweeping plains of lush wildlife-filled plains rising to dramatic, rocky escarpments containing the most extensive rock art galleries in Australia.

Thousands of tributaries seeping out over the flood plains from the sweeping breadths of the Alligator River sustain vast quantities of wildlife, including numerous flocks of ibis, duck and other water birds congregating at the still waters for their abundant fish and aquatic plants.

GUNBALANYA

A land of dramatic contrasts

Antiquity meets modernity in a plentiful land

Supplies of food and raw material for utilitarian objects such as canoes, spears, boomerangs and shelters are in abundance around Gunbalanya, while the numerous caves make ideal cover during the prolonged wet season. Traditionally, bark shelters were also constructed for this purpose. Both were decorated with paintings of Dreaming beings and spirits, as well as flora and fauna. The earliest bark paintings collected this century are from this area. They include the famous X-ray paintings (so called because the internal organs are revealed, as well as the external features) of figures, animals birds and fish, and those featuring the Mimi spirits said to inhabit rock crevices, the Rainbow Serpent and many other beings.

By the early 1900s, an ad hoc settlement had grown up around Gunbalanya, originally as an adjunct to the bases set up by regularly visiting anthropologists and white traders, travellers and workers. Anthropologist Baldwin Spencer based himself there in 1912 to research the people's culture and lifestyle.[1] Later anthropologists to visit and record the way of life included Charles Mountford (American Australian Expedition to Arnhem Land 1948 and 1949) and Ronald and Catherine Berndt (1947, 1950).

In 1925, a missionary station was established and, in 1963, Gunbalanya became part of the Arnhem Land Aboriginal Reserve. Today, the population numbers around 800, around 150 of whom are painters. While there are about ten language groups in the area, the vast majority of the population are Kunwinjku, whose ancestral land and Dreaming paths range the whole of western Arnhem Land.

Rainbow serpents and lightning spirits

Arnhem Land artists travel widely throughout their country and the same artist may sell work through a number of different centres. The stories and many of the images of central, as with almost all, Arnhem Land are drawn from the same images as those painted for centuries on rock walls and bark shelters. Peter Marralwanga's 1975 *Djirbaykbaykk the snake man, Kawalan, the goanna, and a woman* (page 148) reflects the senior status of the artist as it is taken from a now rarely performed ceremony relating to reproduction and fertility.

Namarrkon the Lightning Spirit (left) portrays a frequently seen traditional image of the spirit whose presence appears every year

Mick Kubarkku, *Namarrkon, the Lightning Spirit* (1991). The Lightning Spirit, which brings the dramatic electrical storms which occur frequently over Arnhem Land, has been depicted here with a band of lightning surrounding his body by leading Arnhem Land artist Mick Kubarkku.

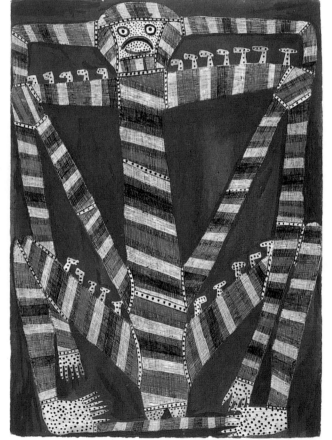

as a precursor to the Wet, creating the intense electrical storms and lightning. In this painting, leading painter Mick Kubarrkku offers a particularly dramatic interpretation.

Central Arnhem Land artist Crusoe Kuningbal, best known for his representations in paintings and carving of Mimi spirits, also carves and paints the Morkuy spirit figures. A Morkuy is carved and painted as soon as possible after the death of a male of the Kunwinjku tribe to house the man's 'shade', in order to prevent it wandering and creating damage until mortuary rites are performed some months later.

Although many Kunwinjku artists still paint on bark, during the 1990s the medium of ochre on paper, such as that used in Gabriel Maralngurra's *Freshwater Croc & Black Bream* (page 156), was introduced for both convenience and because of the shortage of bark which is causing environmental problems. About three-quarters of works made at Injalak are now on paper, which has been primed with different shadings of gouache by art centre staff.

Some Gunbalanya artists

Marralwanga, Gabriel; Nabarrayal, Lofty; Nadjamerrek,

Bardayal; Nadjamerrek, Lofty; Nganjmira, Bobby; Nganjmira, Peter; Nganjmira, Robin.

Where to see and buy the art

Most state public galleries (Art Gallery of Western Australia, Art Gallery of New South Wales, Art Gallery of South Australia and the Museum of Contemporary Art) and major state and national museums have rich historical collections of central Arnhem Land art. That of the Museum and Art Gallery of the Northern Territory in Darwin, however, stands out. The museum often presents specific exhibitions featuring art from this area, such as the 1995 Rainbow, Sugar Bag and Moon of the work of Bardayal Nadjamerrek and Mick Kubarkku. The National Gallery of Australia in Canberra houses the collector Sandra Holmes's important collection of the work of famous Western Arnhem Land artist Yirawala (1903–1976).

Injalak Arts Centre at Gunbalanya, situated at the gateway of Arnhem Land, is one of the more accessible of the community-based arts centres and sells direct to visitors, as well as wholesaling work for exhibition. A permit is needed, however, to visit the area. Works on paper, which range in price from fifty to several hundred dollars, have proved highly popular and are also widely available through galleries and shops selling Aboriginal art in the Northern Territory, and in some southern city galleries such as Melbourne's Axia Gallery, which occasionally holds specific exhibitions of Injalak's latest works.

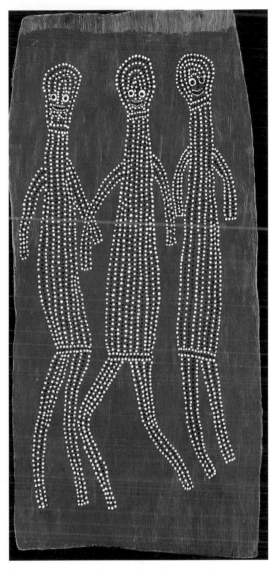

Crusoe Kuningbal, *Morkuy Figures* (c. 1970s). A major painter and carver of Mimi and other spirits, in this bark painting, Crusoe Kuningbal depicts the Morkuy carved by West Arnhem Land people to capture a man's spirit or 'shade' after he dies to prevent it creating damage in the community. The 'shade' stays in the Morkuy until the final ceremony, about a year after the death, releases it.

Recommended reading

For publication details see Recommended Reading page 233. General texts as in the Introduction to Arnhem Land section, especially *The Inspired Dream*, Margie West, 1988; *The Painters of the Wagilag Sisters Story 1937–1997*, Wally Caruana & Nigel Lendon, 1997; *Rainbow, Sugarbag and Moon: Two artists of the Stone Country*, Margie West, 1995; *Spirit in Land: Bark Paintings from Arnhem Land*, Judith Ryan, 1990; *Windows on the Dreaming: Aboriginal Paintings in the National Gallery of Australia*, Wally Caruana, 1989.

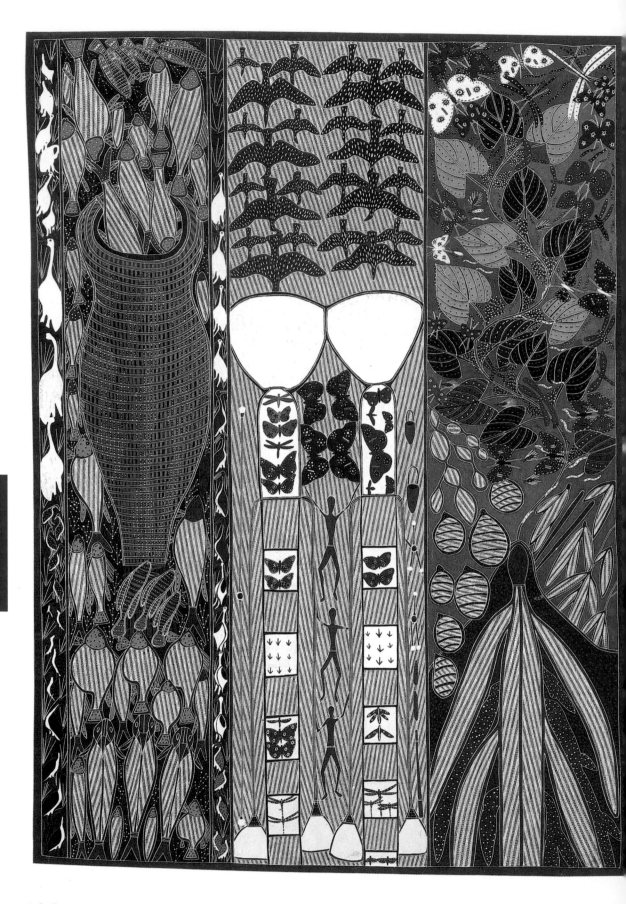

Situated on the coast of central Arnhem Land, Maningrida is bound by the Arafura Sea and the Liverpool River. The settlement grew from a late nineteenth-century trading station which became a medical centre. By 1957, a settlement of some 500 people had become established. The area is home to eight language groups, including the Kunwinjku from the west; the Rembarrnga and Dangborn to the south; and the Gungurongi and Djinang to the east. Each group has its own style of painting and ceremonial ritual objects. Some of the stories link people from the Kimberley and desert areas, others are more specific to the area. Some, such as the ceremonial dilly bags, are decorated in a particular manner not found anywhere else.

Covering an area of 10 000 square kilometres, the Bawinanga Aboriginal Corporation is owned by the 800 to 1000 Maningrida and outstation residents. The corporation services some thirty outstations, as well as the larger settlement of Maningrida. The arts centre is large and multi-faceted. In one section are well-appointed office areas leading onto a tall-ceilinged, fan-cooled display area in which bark paintings, sculpture and weavings are stacked against walls and in racks. Adjacent in a temperature-controlled room are held works destined for exhibitions and commissions awaiting dispatch.

A short walk away is the Djomi Museum, which aims to keep in the community some of the area's best cultural material for the benefit of younger generations. It also houses an encyclopedic historical and contemporary display.

Freedom, vigour and the ability to innovate

Diversity of imagery and media characterises the art of Maningrida. Sculpture and carving are important facets, as are weaving and bark painting.

The influence of the missionaries in the area in general, if not in the Maningrida community (which was never a mission station) specifically, can be seen in the adoption of certain artistic practices. Pandanus palm coil weaving was introduced by missionaries from the southern parts of Australia in the late nineteenth century. A wide range of weavings had been introduced to the coastal areas before this by the Macassans in their regular trade journeys. Women weavers find pinks and reds from ochre, yellow from skin of roots of plants, blues from fire ash and browns from leaves with which to dye fibres to make woven objects of subtle shading.

MANINGRIDA
Art in the land of diversity

LEFT: Jack Wunuwun, *Banumbirr, the Morning Star* (1987). This masterful painting relates in three distinct sections the myth of the Morning Star (page 193), symbolic of life, death and regeneration. Included is the artist's special totem, the Yam—its growth and death, and the vine on which it grows, symbolic of the string to which the Morning Star is attached.

BELOW: Baku Ray, *Hollow Log Coffin* (late 1950s). Bones of the deceased are placed in decorated logs, their naturally hollow interiors made greater by carving, as part of central Arnhem Land burial rites.

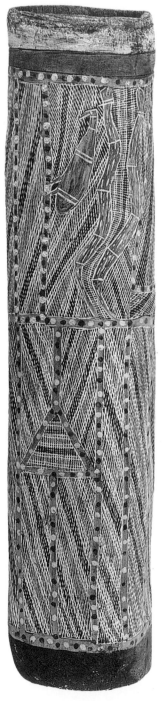

Like many Arnhem Land artists, Maningrida artists, whether they be weavers, sculptors or painters, have never used acrylics, canvas or other manufactured materials. Painting is on bark; sculpture made from wood and weaving carried out using palm fronds and other plant material. The late Lin Onus, a Melbourne artist, regularly visited Maningrida. He related that, during the preparation of a group show of the work of Jack Wunuwun, Les Midikuria, England Bangala and George Garrawun in 1987 and 1988, Jack Wunuwun used canvas to the interest of the other artists. Its use, however, did not take off, largely Onus believed because of the ready availability of bark, its better painting surface and a desire to stick to traditional methods.[1]

The imagery of Maningrida art, as in John Mawurndjul's 1980 *Ngalyod and the Yawk Yawk Girls* (right), has a freedom and individual expression distinct from the more formal quality of eastern Arnhem Land art, which is characterised by a self-imposed limitation to reproducing clan designs and other traditional imagery.

'One of the exciting things about Maningrida art,' says former cultural officer Murray Garde, 'is its vigour and that artists have the freedom to innovate. They take traditional iconography from Western and Eastern Arnhem Land and do have the ability to create works of great individual difference.'[2]

A noticeable trend during the 1980s was the increase in size of barks and sculptures.[3] An example was the display of huge fishing drag nets and string hunting bags shown to great effect in Sydney's Museum of Contemporary Art in 1992. Suspended from the ceiling by invisible line, their freely defined forms and spider-web like patterns evolved from their original utilitarian purpose to become splendid examples of three-dimensional abstract art.

On one visit to Maningrida, Lin Onus had also sensed a great deal of excitement amongst the artists over the discovery of new colours. In the 1980s, a green, hitherto unseen, had appeared in some works. 'My understanding in conversations with George Garrawun, who seemed to pioneer the use of green, was that

Right: John Mawurndjul, *Ngalyod and the Yawk Yawk Girls* (1980). The white pigment used in this painting, collected by Mawurndjul from a sacred site, is said to derive from the transformed faeces and bones of the ancestral beings swallowed by the Rainbow Serpent, Ngalyod, making it a potent force in image making.

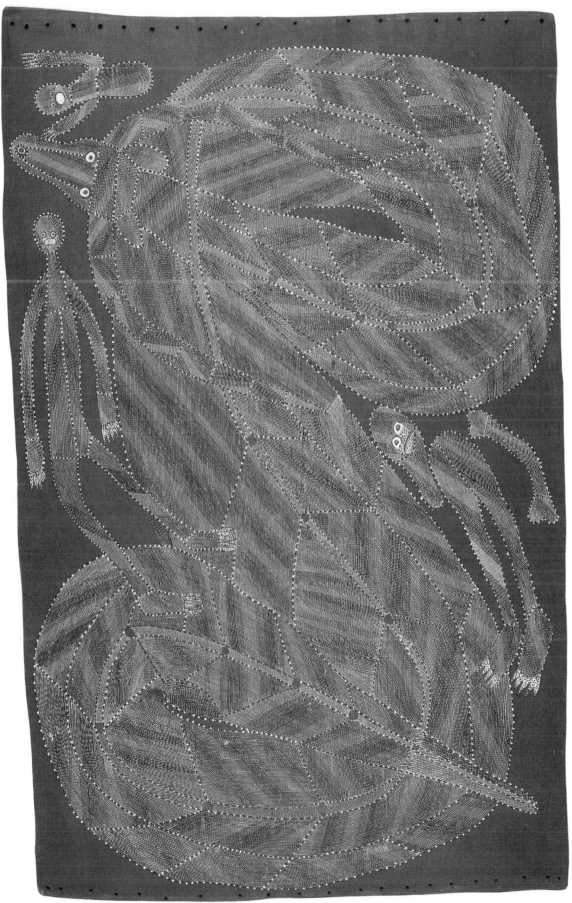

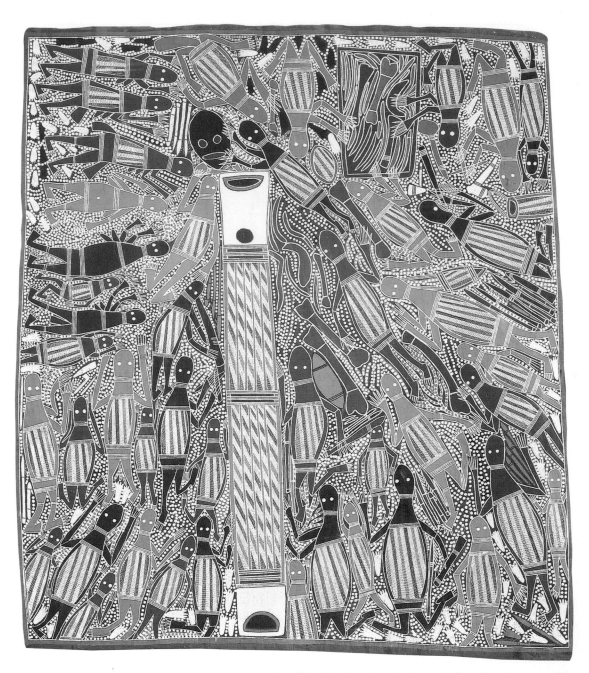

John Bulun Bulun, *Mortuary Story* (1982). This lyrically patterned work depicts the final stages of a burial ceremony in which the deceased's bones are broken and placed in a hollow log coffin.

green was a "nothing" colour,' said Onus. 'Therefore he was able to experiment with imagery and concepts that would ordinarily fall outside his prescribed moiety [clan] entitlements.'

Les Midikuria and his colleagues at Gotjan Jiny Jirra (Cadell Outstation) showed even greater innovation with colours, including pinks, browns, greens and occasional mauves. Onus also asked Jack Wunuwun about the use of a brilliant orange which he had not seen before.

'He told me the colour was "airstrip" and mined from a small deposit of ochre at the southern end of the Maningrida tarmac.'[4] All pigments, however colourful, continue to be derived from the

land, with acrylics or other artificial paints not used.

The figurative elements open to the individual visual stylistic interpretation characteristic of Maningrida paintings are clearly seen in Jack Wunuwun's 1987 *Banumbirr, the Morning Star* (page 156). Its three internal panels combine numerous images drawn together through differing but related crosshatching. John Bulun Bulun's *Mortuary Story* (page left) shows the final stage of a mortuary ceremony, during which the stripped bones of the deceased are broken before being placed in a hollow log coffin.

Some Maningrida artists

Bangala, England; Bulun Bulun, John; Burruwal, Bob; Mandarrk, Wally; Kubarkku, Mick; Kuningbal, Crusoe; Mawurndjul, John; Midikuria, Les; Mithinari; Wunuwun, Jack.

Where to see and buy the art

Serious art buyers can visit Maningrida Arts and Culture after obtaining a permit from the centre itself.

In Sydney, the Museum of Contemporary Art holds a collection of 560 works by 129 Maningrida artists. Acquired in 1990, the collection is not owned by the museum, but is managed in trust for the people of Maningrida.

Selections of Maningrida's barks, sculptures and weavings are found in Darwin galleries, such as Framed and Aboriginal Fine Arts Gallery. Southern city galleries include Melbourne's Gallery Gabrielle Pizzi and Sydney's Hogarth Galleries. Gallery Gabrielle Pizzi featured a selection of sculpture from Maningrida in a 1997 exhibition in Venice, which coincided with Australia's representation of three Aboriginal women artists at the Venice Biennale.

Recommended reading

For publication details see Recommended Reading page 233. General texts as in the Introduction to Arnhem Land section, especially *The Inspired Dream*, Margie West, 1988; *The Painters of the Wagilag Sisters Story 1937-1997*, Wally Caruana & Nigel Lendon, 1997; *Rainbow, Sugarbag and Moon: Two artists of the Stone Country*, Margie West, 1995; *Spirit in Land: Bark Paintings from Arnhem Land*, Judith Ryan, 1990; *Windows on the Dreaming: Aboriginal Paintings in the National Gallery of Australia*, Wally Caruana, 1989.

Bob Burruwal, *Walka-Fish at Bolkjdam* (1997). Maningrida has become known for its superb large decorated carvings, such as this elegant example of an ancestor fish spirit.

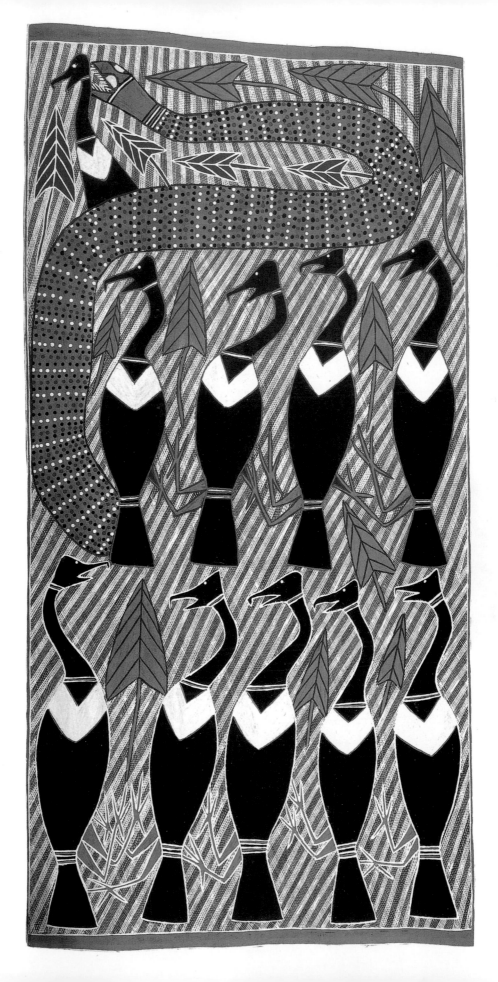

Ramingining, 85 kilometres east of Maningrida, was established in the early 1970s and, in 1980, was the first Aboriginal community to have work included in the Sydney Biennale. Its Bula'bula arts centre, set high off the ground amidst the branches of lush-foliaged trees and palms bordering the rainforest, was established shortly after.

Since, and particularly during the 1980s with the appointment of Djon Mundine as art coordinator (1980–95), Ramingining art has become widely represented.

A powerful moment—the Aboriginal Memorial

In 1988, Ramingining artists were responsible for one of the largest and most powerful visual arts responses to Australia's Bicentennial. The *Aboriginal Memorial* consists of 200 mourning poles by some forty-three Ramingining artists, including Paddy Dhatangu, George Milpurrurru, Jimmy Wululu and David Malangi, assisted by Djon Mundine, made to mark each year of white settlement of their land. Similar to the coffins used in reburial ceremonies throughout Arnhem Land, the logs were painted with the clan designs and major Dreamings of the artists.

National Gallery of Australia curator Wally Caruana ends his book *Aboriginal Art* with a summation of the memorial's significance.

The Memorial's relevance, however, is not confined to the past. It speaks of life, continuity and a new beginning. An imposing forest of imagery, it confidently asserts a place for Aboriginal people in contemporary society … On the one hand it reflects traditional ceremonial and artistic activities which continue to be practised across the country carrying the spiritual forces of the ancestral beings from one generation to the next … on the other hand the memorial signifies the important role of art in expressing Aboriginal values and perspectives to a world which in many cases continues to be hostile to Aboriginal aspirations. The vital nature of Aboriginal culture is evident in the ways in which artists are taking the traditional Aboriginal art with conviction and integrity to the world at large.[1]

LEFT: George Milpurrurru, *Gurramatji, magpie geese and water python* (1987). This classic work by one of Central Arnhem Land's greatest artists depicts a favourite theme of the prolific magpie geese being eaten by a water snake.

RAMINGINING
An ancient tradition reinterpreted

ABOVE: Geese and other birds form part of a prolific wildlife tapestry in the lush countryside of Arnhem Land.

An image abused

Ramingining has also been a centre for other works of a political nature. One incident to spark the issue of unauthorised use of images was the use, without his knowledge or consent, of the designs of Ramingining's David Malangi on the first Australian dollar bill in 1966.

Malangi's painting *The Hunter* had been purchased by Hungarian art collector Karel Kupka three years before. Donating the work to a Paris museum, Kupka showed photographs of the bark painting to graphic designer Gordon Andrews, who incorporated a 'line interpretation' of Malangi's design into his design for Australia's new paper decimal currency. The image was recognised by a former teacher at Milingimbi and the story of the stolen design reached the press, causing severe embarrassment to the then head of the Governor of the Reserve Bank, H. C. (Nuggett) Coombs, a well-known champion of Aboriginal rights who had assumed the image had been derived from some 'anonymous and probably long dead artist'. Recompense, which included a $1000 fee and a silver medal, was organised for Malangi.[2]

The focus on barks

The coastal region surrounding Ramingining is one of the great bark-producing areas of Australia. Bula'bula services some 200 artists living either in the main community or at one of the area's numerous outstations, as well as the 5600-hectare island of Milingimbi, just off the coast west of Ramingining. A Methodist mission was established on Milingimbi in 1923 because of the island's plentiful freshwater supply and its easily beached coastline.

During the 1950s, the missionaries encouraged the making of bark paintings and artefacts for sale and, in 1954, took the unusual step for those days of persuading two artists to enter a national award—the National Alcorso Design Award. (Works by one, Djawa, were purchased by the National Gallery of Victoria.)[3] Art enthusiast Alan Fidock worked with and promoted the art of Milingimbi artists during the 1960s.

The painters of Witij, the Great Python

As with other central Arnhem Land clans, two of the main themes in Ramingining art are those of Witij, the Great Python

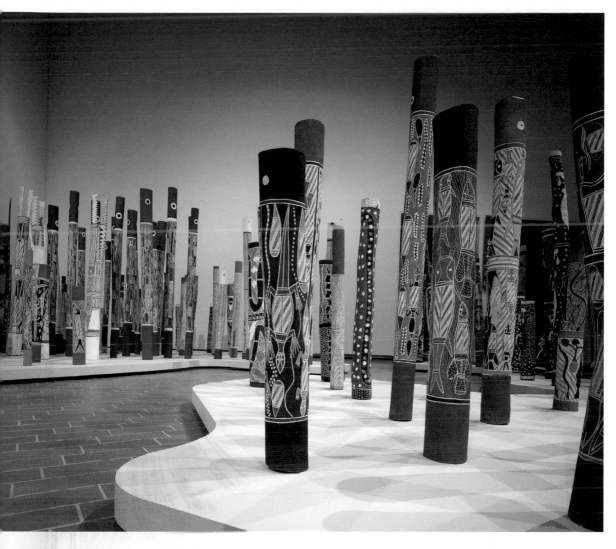

and the journeys of the Wagilag Sisters. Major Milingimbi–Ramingining artist Dawidi Djulwarak became entitled to paint the entire Wagilag sisters story in 1963. His 1967 *The Wagilag Story* (pages 172–3) includes both the narrative elements of the story through representations of characters of the myth, as well as the stylised elements of landscape in which the journeys occurred, and representations of significant occurrences.

Works such as the 1987 *Gurramatji, magpie geese and water python* (page 166), with their strongly defined figurative images against a unifying, crosshatched design, have led to George Milpurrurru's paintings becoming both extremely distinctive and widely acclaimed. Equally distinctive are the more geometrically executed images of Philip Gudthaykudthay's paintings, such as the 1984 *Witij, olive python* (page 170).

Various artists, *The Aboriginal Memorial, 200 hollow log coffins* (1988). Carved by the men of the Ramingining area as a response to Australia's 200 years of white occupation, this moving memorial can be walked through in its display at Canberra's National Gallery of Australia.

169

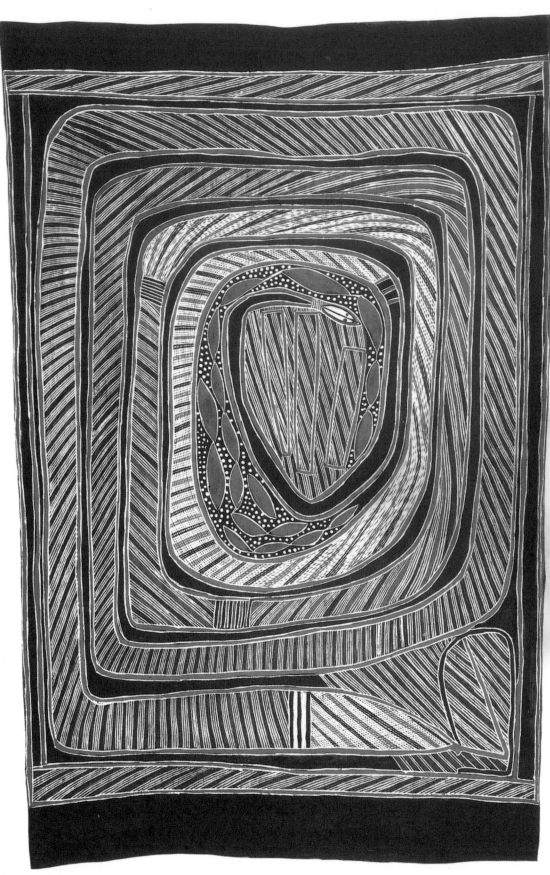

Some Ramingining artists

Ashley, Djardi; Dawidi; Dhatangu, Paddy; Djukukul, Dorothy; Gudthaykudthay, Philip; Malangi, David; Mandarrk, Wally; Wululu, Jimmy.

Where to see and buy the art

Ramingining art is well represented in most state and territory public galleries (especially those of Western Australia, Victoria, New South Wales, South Australia and the Northern Territory). The National Gallery of Australia holds a major collection of largely contemporary works by Ramingining artists, while historical collections are found in the Art Gallery of New South Wales, the Art Gallery of Western Australia, Canberra's National Museum and the museums of South Australia, Victoria and New South Wales. Sydney's Museum of Contemporary Art holds a comprehensive specialist collection of around 220 contemporary Ramingining works by more than seventy artists, which the museum acquired in 1984–85.

LEFT: Philip Gudthaykudthay, *Witij, olive python* (1984). Finely applied paint and delicate lines characterise this image related to the Wagilag sister's stories and the great python, Witij.

Largely a wholesale centre supplying to galleries, the Bula'bula Arts Centre in Ramingining welcomes visitors to a limited degree. Permits must be obtained from the centre (see Arts Centre listings) and limited overnight accommodation is available.

Raminginging art is available for sale in a number of outlets, including Darwin's Fine Aboriginal Art Gallery; Perth's Desert Designs; Alice Springs's Gondwana Gallery; Adelaide's Anima Gallery; Sydney's Hogarth and Coo-ee galleries; and Yulara's Mulgara Gallery. Limited-edition screen prints by Ramingining artists are quite widely available in specialist Aboriginal galleries throughout Australia.

Recommended reading

For publication details see Recommended Reading page 233. General texts as in the Introduction to Arnhem Land section, especially *The Inspired Dream*, Margie K. C. West, 1988; *The Painters of the Wagilag Sisters Story 1937–1997*, Wally Caruana & Nigel Lendon, 1997; *Spirit in Land: Bark Paintings from Arnhem Land*, Judith Ryan, 1990; *Windows on the Dreaming: Aboriginal Paintings in the National Gallery of Australia*, Wally Caruana, 1989.

WAGILAG SISTERS

BELOW: Dawidi, *The Wagilag Story* (1967). Inheriting the rights to paint the full Wagilag cycle in 1956, this major central Arnhem land artist painted a comprehensive body of Wagilag story works during the 1960s. This detailed

One of the most dominant creation story narratives, the story of the Wagilag sisters, is also one of the most frequently represented by members of the Dhuwa clan of central and eastern Arnhem Land. It relates the people's human and animal ancestors, and their interaction with the land and natural forces.

As the curators of the 1997 National Gallery of Australia exhibition the Painters of the Wagilag Story intimate, accounts of the story vary, but some details remain constant in most versions.

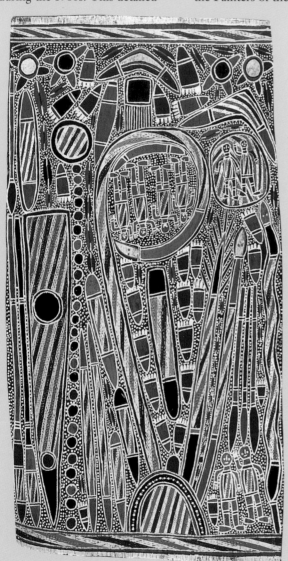

'Two sisters, the older of whom has a child, the younger who is pregnant, are fleeing their home in the southeast … followed by clansmen … As they continue … they encounter animals, plants and country on which they confer names … [deciding] to camp in the rich and fertile country surrounding the waterhole at [the Upper Woolen River] waterhole of Mirrmina.'

According to some versions of the story, one of the sisters 'pollutes the waterhole, which arouses the [python] Witij from his sleep. The younger sister gives birth, further inciting the Snake. Unsuspecting, the sisters make camp … but things begin to go wrong and the animals and vegetables come to life and leap into the waterhole.'

Witij emerges and creates a storm cloud, washing the sisters into the waterhole and flooding the land. The sisters perform to deter the Python until, finally, they are exhausted. Witij enters the hut and swallows them. Later, after developing a great stomach ache, he vomits them up, but then beats them with clapsticks and swallows them again. The sisters, however, come to their clansmen in a dream and reveal the secrets of the sacred dances and songs they composed in their efforts to stop the rain.[4]

work contains most of the major references to the entire story of the Wagilag sisters.

RIGHT: Dawidi, *Nguja*, feathered head ornament (1965). A variety of body ornaments such as this brilliantly coloured feathered head dress accompany many Aboriginal ceremonies.

ARNHEM LAND

172

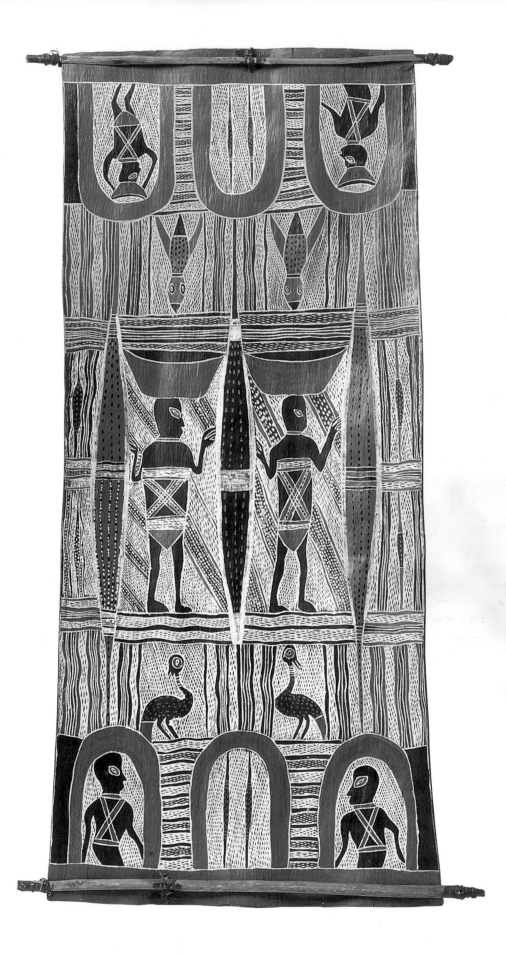

174

Lush palms and rainforest trees surround the two buildings of Yirrkala's arts centre and museum, Buku-Larrngay Mulka Arts, which services around 300 artists throughout the region. An old mission house converted to an arts centre in 1975, the museum was opened in 1988 and renovated and expanded with a new courtyard and gallery in 1995. Separated from the main display/museum building by a courtyard built around a pool, a light-filled exhibition area displays either a number of major works or a range by a single artist.

Adjacent is the museum, which contains a comprehensive display of important paintings, photographs, hunting and other materials tracing the history of the Yirrkala Yolngu. In central position are two pivotal 1963 paintings, the Yirrkala Church Panels. These striking 4-metre x 3-metre ochre on masonite paintings were made at a time when the Yolngu felt their land and lifestyle under increasing threat from mining operations and other Western incursions.

Intricately painted and meticulously detailed, the multi-panelled works relate the events and mythologies of the ancestral spirits and ceremonies which shape the lives of today's Yolngu. (Other smaller works similar in content by several of the same artists are in the collection of the Yiribana Gallery of the Art Gallery of New South Wales).

Eight of the most highly regarded artists of each clan group were chosen to paint the work, which took many months to complete. Made and shown first in the church across the way from today's arts centre, their unveiling was a major part of the events of the first visit by a federal parliamentary delegation on a visit to Yirrkala in 1963, while gathering information about land claims.

YIRRKALA

Art, culture and land rights in a tropical paradise

LEFT: Naritjin Maymura, *Aspects of the Napilingi Myth* (c. 1965). A sense of balance and fine execution of paint is the effect many eastern Arnhem land artists are aiming to achieve in their works such as this finely preserved example from Yirrkala.

Bark Petition

Later that year Yirrkala elders produced a bark petition—the Yirrkala *Bark Petition* (page 41)—to present to the government to assist their plea for land claims when the mining company Nabalco exercised mining rights over their land. Although this case against mining leases was lost, the *Bark Petition* created much publicity and provided an important key to understanding the Aboriginal perspective and view of life. It remains a key work in the history of Aboriginal land rights and is in the collection of the Parliament of Australia.

ARNHEM LAND

Control to self-determination

Situated at the mouth of a small freshwater creek called Yirrkala, the settlement services the area within a radius of 250 kilometres and supports about twenty-six small outstation or homeland centres. Arnhem Land had been established in 1931 as an Aboriginal reserve, with a Methodist mission at Yirrkala established in 1934. It was nevertheless clear, as artist Banduk Marika, a member of one of the area's lead clans, notes 'fairly early on when men closely related by my father, Mawalan, were jailed for killing Japanese fishermen, that the Commonwealth Government intended to control us in specific ways'.[1] And as the scenes only several kilometres away from the peaceful setting of the community and arts centre attest, it has been one of the most invaded of all landscapes. Huge areas have been mined for bauxite, and lie denuded in a devastation so complete it is hard to imagine regeneration occurring in the foreseeable future. The 2-kilometre point outside the town of Gove—the mining settlement established for mine workers—marks the line beyond which Aboriginals may not consume alcohol.

Although new royalty agreements give Aborigines an increased share of mining spoils, the influx of people caused by mining activities has, says artist Banduk Marika, had a vast impact on the community.

… A division exists between the members of the Rirritingu clan willing to accept mining royalties and those of us who do not want it ever. Alcoholism, chronic smoking, kava, petrol-sniffing, violence within families, untraditional marriages and harmful sexual behaviour, the stupid use of money, time-wasting gambling, suicide and murder have entered our lives … New tracks have caused soil erosion, vegetation damage and destroyed turtle nesting areas. Pollution … affects our sea food … our offshore islands [are] used for target practice …[2]

Clan designs

Yirrkala art has been made for sale to the Western market since the 1940s, with the making of decorated objects and artefacts. During the 1950s, lay missionary Douglas Tuffin instigated the system of attaching a split stick to the top and bottom of barks to make them both more durable and more readily able to be hung for display. By 1964, the system of labelling the back of the barks to indicate authenticity and provenance was introduced and a

RIGHT: Yanggarriny Wunungmurra, *Gangan* (1997). The winner of the 1997 Telstra National Aboriginal and Torres Strait Islander Art Award, this fine work by a senior Yirrkala painter, assisted by members of his family, shows the continuation of an ancient painting tradition into the modern context.

marketing system was brought in first at the mission station and then based around the museum.

With the building of the arts centre in the mid-1970s, the art became readily accessible to visitors and painting for sale developed more strongly—although, as in other areas of Arnhem Land, it had been practised to some extent from the mid-twentieth century.

As do most Arnhem Land artists, Yirrkala painters prefer to use the natural materials of ochres on bark. The art of eastern Arnhem Land has a formal quality quite distinctive from that of the freer, more figuratively based barks of central and western Arnhem Land. While some barks from the 1950s were slightly more freely drawn, the paintings have become more structured and figurative elements more formal. The work of senior painter Yanggarriny Wunungmurra, as in that seen at right, shows the densely textured quality of crosshatching, and the formal clan design typical of Yirrkala works.

Often of prime artistic concern is creating works of sharp brilliance to evoke the living spirit of ancestral power, such as in Naritjin Maymura's 1995 painting *Aspects of the Napilingi Myth* (page 174).

Most Yirrkala painters are men, as men in the structure of Yolngu society are the custodians of the sacred stories. Banduk Marika, however, one of the three daughters of Mawalan Marika who were all taught to paint by their father, is now a leading Australian artist and spokesperson for her people. She has assisted in a new direction for Yirrkala women and senior painter Yanggarriny Wunungmurra taught his two daughters, as well as his three sons, to paint. Husband and wife Yalpi Yunipingu and Yananymal Mununggurr create joint works.

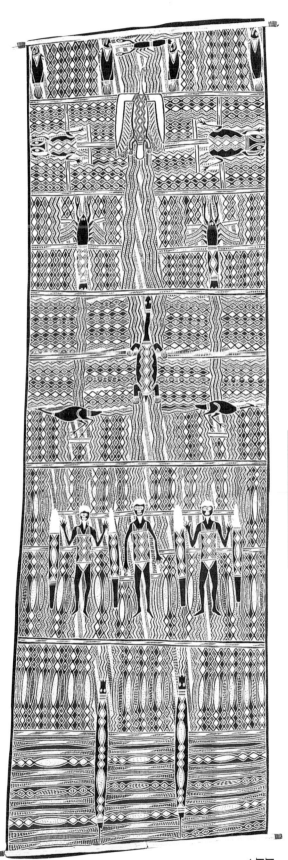

Tradition in the contemporary context

In 1995, Buku Larrngay Mulka Arts started working with artists to create a series of 'big barks'. Standing up to 3.5 metres tall, these paintings are the largest of any barks created to leave the community and are produced with the aim of displaying to the Western art museum and commercial gallery world the impact of the medium and its imagery.

During the 1990s a strong printmaking movement evolved at Yirrkala resulting in a series of limited edition prints. During 1997 and 1998 the Northern Territory University's printmaking department manager of editions, Basil Hall, conducted five printmaking workshops at the Buku Larrngay Mulka Centre, training artists as printmakers. The translation from bark to linocut and screen print has been particularly successful, enabling the artists also to experiment with colour. The results have been seen in exhibitions throughout Australia with a number of galleries holding stocks of the prints.

Some Yirrkala artists

Marawili family including Djambawa, Yalmakanmy, Nongirrn; Marika family including Banduk, Dhuwarrwarr, Mawalan, Wandjuk; Maymura family including Naminapu, Naritjin, Ninyama; Mithinari; Mununngurr family including Marrnuyla, Rerrkirrwapa; Wanambi, Boliny; Wunungmurra, Yanggarriny; Yunipingu family including Gayaili, Nyapanyapa, Yirrinyina.

Where to see and buy the art

The art galleries of New South Wales, Queensland and South Australia have all purchased 'big barks' since 1995, but the National Gallery of Australia and the National Gallery of Victoria have acquired the most significant collections. Yirrkala artists are also well represented in the Art Gallery of Western Australia, the Art Gallery of New South Wales, the Museum of Victoria, Sydney's Museum of Contemporary Art and the National Museum in Canberra and the Museum and Art Gallery of the Northern Territory in Darwin. Internationally, a collection of thirty of the 'big barks' was commissioned by American collector John Kluge for his collection housed at the University of Virginia. The Museum of Oceanic and African Art in Paris also has an important collection of early works.

The Buku Larrngay Mulka arts centre at Yirrkala is the best

venue to see the range of Yirrkala barks, sculptures, beads and weavings. It is open to the public and no permit is needed to visit this well-stocked, light-filled exhibition space. A separate gallery often includes a display by a solo artist or a group of works of a particular theme. As well as the barks, which range in size from small works selling for upwards of $50, the centre often stocks some substantial figurative sculptures—especially of birds and

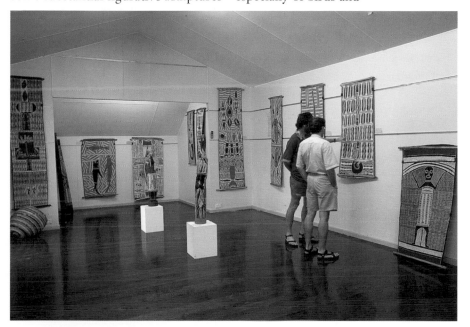

other animals associated with coastal life.

Since 1996, Sydney's Annandale Galleries and Melbourne's William Mora Galleries have held regular exhibitions of Yirrkala barks and sculptures, as have Sydney's Hogarth Galleries. Hogarth's gallery in The Rocks area of Sydney carries a good stock of smaller barks and artefacts.

The Buku Larrngay Mulka Arts Centre combines a museum displaying historically important paintings and other objects with a light-filled retail sales and display area.

Recommended reading

General texts as in the Introduction to Arnhem Land section, especially *The Inspired Dream*, Margie K. C. West, 1988; *The Painters of the Wagilag Sisters Story 1937–1997*, Wally Caruana & Nigel Lendon,1997; *Spirit in Land: Bark Paintings from Arnhem Land*, Judith Ryan, 1990; *Windows on the Dreaming: Aboriginal Paintings in the National Gallery of Australia*, Wally Caruana, 1989; *Wandjuk Marika*, Jennifer Isaacs, 1996; *Buku Larrangay*, Mulka Printmakers 1996-1998; *Saltwater: Yirrkala, Bark Paintings of Sea Country*, 1999.

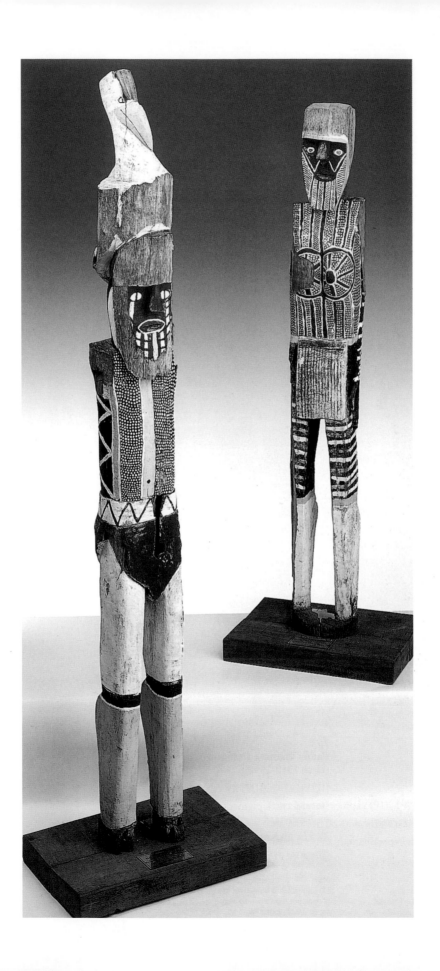

Melville Island, 80 kilometres off the northern Australian coast, is a spectacularly beautiful, rainforested island. Comprising 3200 square kilometres, it is, after Tasmania, Australia's largest island. Melville has a population of around 800 Tiwi people. With plentiful supplies of fresh water, both aquatic and plant life are abundant. Similarly bountiful is the sea life, which includes dugong, turtles, sharks, numerous varieties of fish and freshwater and saltwater crocodiles.

The treacherous nature of the seas separating Melville from the mainland means the art and culture of the Tiwi have developed in relative isolation; Tiwi art is quite distinctive from that of the nearest coastal areas of Arnhem Land.

Sacred images in abstraction

Characteristic of Tiwi art is geometric abstract design relating to sacred or significant sites and seasonal changes. Geometric abstraction is the basis for the shapes of traditional carvings such as the Pukumani poles used in burial ceremonies, as well as the basic imagery on barks and, more recently, works on fabric, paper and canvas.

The abstract patterns give the works a unique, formalised quality which still, however, allows for great personal interpretation. Innovation is rated highly by the Tiwi, which is one reason modern techniques and ideas have been embraced so keenly.

Pukumani ceremony and burial poles (*tutini*)

The Pukumani ceremony is the Tiwi people's burial ceremony, which comprises song, dance and the carving and making of special artefacts.

Large poles called *tutini* are carved to represent the deceased person's life, attributes and spiritual journey. Now commissioned by galleries and other collectors, these days they are also carved for non-ceremonial purposes.

Standing up to 4 metres high, the *tutini* are carved from a single, dense, ironwood tree trunk, cut during the wet season (November to April) and placed over a fire to harden and seal before carving. Geometric symmetry is evident in both the placement of the poles in relation to each other and the carvings on each individual pole. Angular cuts, in which the trunk is cut completely through, form framed 'windows'. The poles are

LEFT: Mani Luki (Harry Carpenter Wommatakimmi), *Purukapali and Bima* (c. 1962). Representing the god king who created the first Tiwi Pukamani (burial ceremony) and his goddess wife, Bima.

MELVILLE ISLAND
Art of tropical isolation

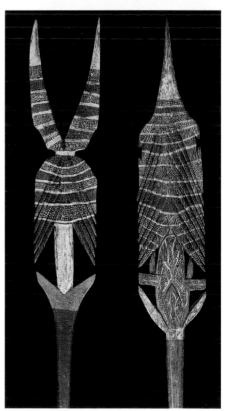

ABOVE: Two ironwood carved Tiwi ceremonial spears show intricate skill in their marking and decorating.

painted with crushed white clay and then yellow, brown and red ochre using a gum twig brush. (In traditional ceremony, the painter disguises himself with a false beard and face paint so as not to be recognisable to the spirit of the deceased.) A woven basket is placed over some of the poles to assist the spirit in the afterlife. In their ceremonial sites, groups of ten to about thirty *tutini* are placed together and left to weather naturally, occasionally being repainted as ceremony dictates.

In 1958, a group of these burial poles caused an artistic furore when deputy director of the Art Gallery of New South Wales and artist Tony Tuckson commissioned them for the gallery. The poles were displayed in the gallery's foyer as a statement of their artistic, as well as ethnographic, significance.

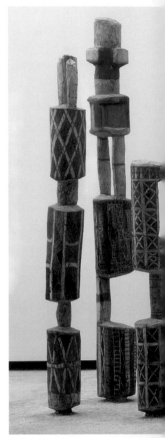

Contemporary art and its development

Development of modern art at Melville has occurred at two main centres. At Milikapiti (Snake Bay) on the island's western tip, the Jilamara Arts and Crafts grew out of women's adult education classes in the mid-1980s. Adjacent to the Jilamara Arts and Crafts building—a long, corrugated iron building the sides of which can be opened to allow the cooling sea breezes to flow through—is the Muluwurri Community Museum. A small, temperature-controlled building, it contains many fascinating artefacts and carvings from the area dating back to the nineteenth century, as well as examples of work produced today. Thirty kilometres away at Pularumpi, Munupi Arts and Crafts incorporates a pottery and print-making facilities.

The art of the two centres is quite distinctly different. Jilamara artists prefer to concentrate on more traditional designs, while allowing for great individual differences and the use of natural ochres; artists from Munupi use multicoloured acrylics and often incorporate figurative elements, as well as the traditional.

With the employment of fabric artist James Bennett as arts

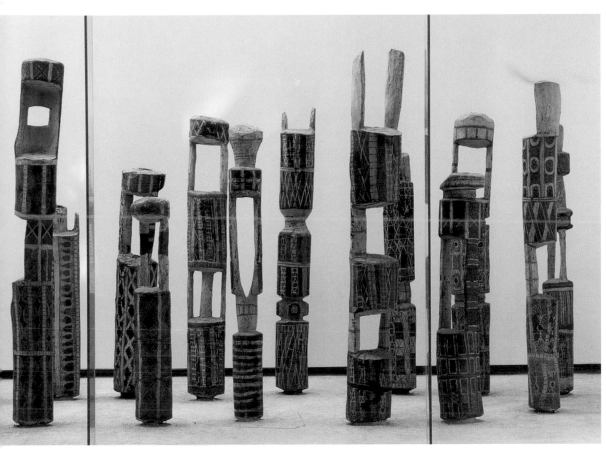

adviser at Jilimara in the mid-1980s, the centre became a thriving fabric printing centre. Material used was largely silk dyed in vibrant colours and painted with traditional designs. During the 1990s, with other art advisers (notably Felicity Green), the artists developed an interest in re-creating the designs collected in paintings on bark by explorer Charles Mountford in the earlier parts of the twentieth century. They started using these as the basis for highly individual ochre works on canvas and paper. Circles, squares, rectangles and lines are infilled with finely drawn crisscross strips of varied yet restricted colours—a technique which increases visual depth and varying perspective.

Various artists, *Pukumani Grave Posts* (1958). These poles caused interest and some controversy when the Art Gallery of New South Wales displayed them as art, rather than ethnographic objects, in its foyer after they had been commissioned from Melville Island carvers in the late 1950s.

Artists of tradition and innovation

Today's artists re-create traditional designs using paper and canvas, as well as continuing to carve. Senior artist Kitty Kantilla's work has become especially distinctive for its linear form (horizontal or vertical) comprising a myriad of minutely executed dots. While much of the same geometric patterning informs the Munupi work, it is differentiated, as the work of

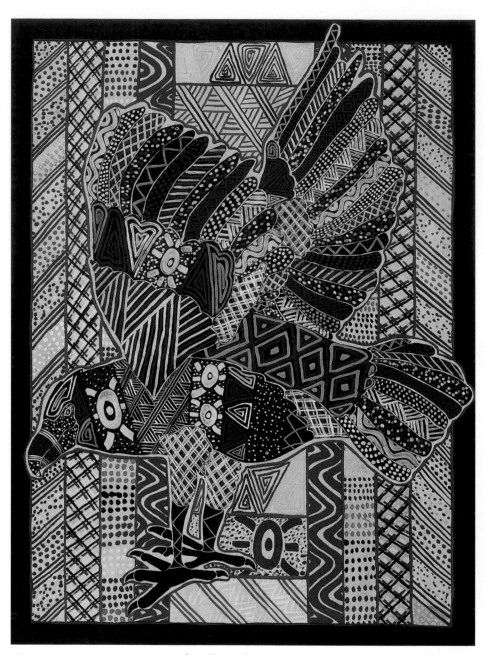

Fiona Paruntatameri, *Jungle Fowl* (1996). This young Munupi artist uses brilliant colours in her prints and paintings such as this work representing one of her people's ancestral figures.

young printmaker Fiona Paruntatameri demonstrates, by a multi-hued palette and its many figurative elements.

Some Melville artists
Apuatimi, Declan; Aruni, Mickey; Carpenter, Harry Wommatakimmi; Kantilla, Kitty; Paruntatameri, Eddie; Paruntatameri, Fiona; Tungatalum, Bede; Wonaemirri, Pedro.

Where to see and buy the art
Although visits are usually only possible through private tour operators or by organising one's own small plane, Jilamara Arts

Centre and Munupi Arts Centre welcome visitors who may apply to them for a permit (see arts centre listings).

The most substantial collections of Tiwi art in public galleries are to be found at the Museum and Art Gallery of the Northern Territory, the National Gallery of Australia, the Museum of Australia and the National Gallery of Victoria, which has acquired significant collections of 1990s works on paper and canvas. Pukumani poles are on permanent display at the Art Gallery of New South Wales's Yiribana gallery, at the entrance to the Museum and Art Gallery of the Northern Territory and in the Darwin Supreme Court. They have also been acquired by the National Maritime Museum in Sydney.

Production of fabric is currently not sufficiently consistent to recommend outlets, but since 1997 artists have been making silver and gold jewellery.

All of these may be found at Darwin's Framed Gallery; Sydney's Aboriginal and Pacific Art Gallery; Perth's Indigenart; Brisbane's Savode Gallery; Melbourne's Alcaston Gallery; and Alice Springs's Gallery Gondwana. Limited-edition etchings have been made by the Australian Print Workshop and screen prints by Red Hand Prints.

Recommended reading
For publication details see Recommended Reading page 233. General texts as in the Introduction to Arnhem Land section, especially *Spirit in Land: Bark Paintings from Arnhem Land*, Judith Ryan, 1990; *Windows on the Dreaming: Aboriginal Paintings in the National Gallery of Australia*, Wally Caruana, 1989; and *Tiwi People of Melville Island*, Munupi Arts & Crafts and Jilamara Arts & Crafts, Melville Island, 1997.

Various artists, *Untitled* (1996). These long, heavy cotton panels demonstrate the versatility of media—which includes paper, canvas, carving and jewellery making—seen in the work of today's Milikapiti (Snake Bay) artists from Melville Island.

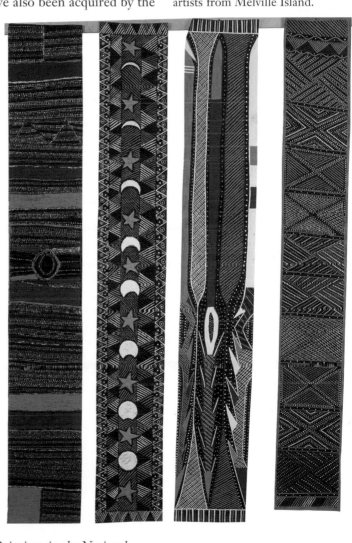

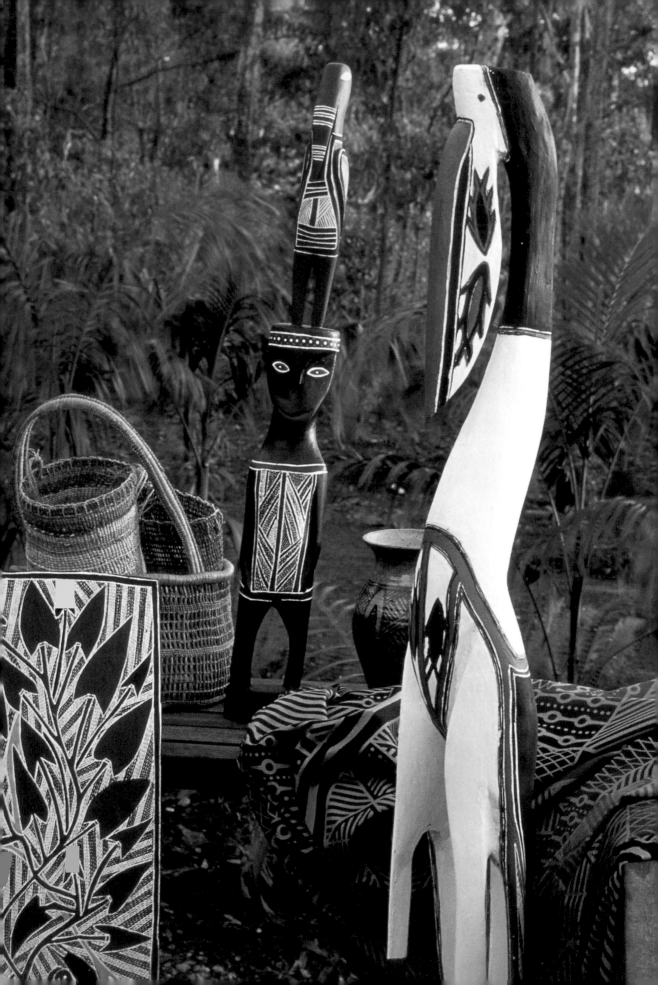

The silk-screening workshop of Tiwi Designs at Bathurst Island is housed in an open-sided shed with a separate enclosed display area carrying fabrics, some paintings and Tiwi carvings of birds and animals. Both the island itself and Tiwi Designs are readily accessible to visitors to Darwin through regular commercial plane/bus tours. As well as selling to visitors to the centre, the arts centre supplies its distinctive fabrics to galleries and art and craft shops throughout Australia.

Tiwi Designs was started in 1969 by Madeleine Clear, an art teacher working at the Central Mission School who encouraged three teenage boys to make woodcuts of animals, birds and insects. Translated via rice paper to silk screen, the designs were printed on fabric and made into tablecloths and dress lengths. Largely realistic in imagery, they were, at their best, wrote former art coordinator Diana Conroy, designs with 'vividly observed charm, with something of the quality of Eskimo art, while not being at all closely related to indigenous Tiwi art'.

When Diana Conroy arrived at Bathurst Island early in 1974, employed by the Aboriginal Arts Board of the Australia Council to act as art adviser to Tiwi Designs, the same animal and bird patterns had been in use for five years.

'I worked mainly with Bede [Tungatalum, one of the original screen printers],' she says. 'We tentatively explored other possibilities of screen printing, using all-over, repeating patterns instead of isolated "floating" motifs. We changed to printing on calico and Indian cotton, as well as linen.'[1]

Conroy's admiration for traditional Tiwi bark paintings was a surprise to the screen printer. 'Bede, in particular, showed great interest in reproductions of the magnificent bark paintings collected in Snake Bay [Milikapati] on Melville Island, which were generally finer than the barks being produced at the time on Bathurst Island.'

She describes how, during the next few months, Bede Tungutalum made many striking designs 'similar in feeling to the traditional style, using irregular circles and crosshatching to make all-over fabric design.'[2] Another of the original artists, Giovanni Tipungwi, became equally inspired, and produced many asymmetrical geometric patterns related to traditional designs.

Most successful of the early colours—although this broadened considerably in the 1980s and 1990s—were those of the natural ochres: yellow, red, black and white. And the new designs proved

BATHURST ISLAND
Home of screenprinted fabric

LEFT: These wooden carvings of birds and ceremonial figures, paintings, fabrics and woven baskets can all be purchased at Bathurst Island's Tiwi Design.

RIGHT: Colours of the earth and sea are reflected in these popular screenprinted fabrics from Tiwi Design.

popular, leading to more orders from art and craft shops in Alice Springs, Derby, Canberra and Sydney than the workshop could supply.

Some pottery was also produced at Tiwi Designs in the 1980s by original screen printers the late Eddie Paruntatameri and John Boscoe Tipiloura, with the pots being decorated with traditional abstract designs.[3]

Production of printed fabrics—now more often bright screen prints and, since the late 1980s, some batiks—has continued successfully at Tiwi Designs, which also has become a centre for the distribution and sale of Tiwi carvings from other areas of Bathurst Island.

Some Bathurst Island artists

Puruntatameri, Eddie; Tipiloura, John Bosco; Tipungwi, Giovanni; Tungutalum, Bede.

Where to see and buy the fabric

Tours of Bathurst Island which include Tiwi Designs have become popular items on the agenda for many visitors to Darwin, who can take plane/bus tours of the island conducted by Darwin tourist companies. Permits are arranged by the tourist company. Next to the large screenprinting workshop, Tiwi Designs' sales outlet stocks a good range of inexpensive screenprinted goods, including T-shirts and table linen, as well as rolls of printed cotton fabric. The centre also generally offers a wide range of sculptures and some small bark paintings from around the island.

Sydney's Coo-ee and Hogarth (The Rocks) galleries carry Tiwi Designs material and sculptures.

Recommended reading

For publication details see Recommended Reading page 233. General texts as in the Introduction to Arnhem Land section, especially *Spirit in Land: Bark Paintings from Arnhem Land*, Judith Ryan, 1990; *Windows on the Dreaming: Aboriginal Paintings in the National Gallery of Australia*, Wally Caruana, 1989.

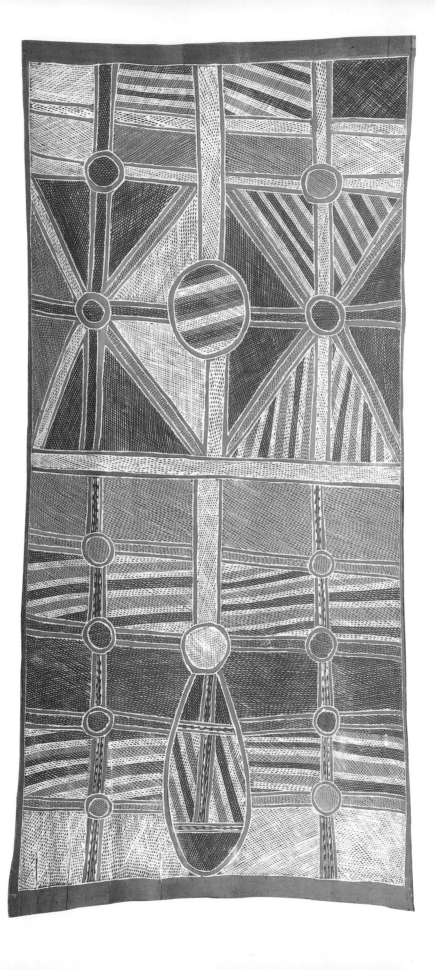

190

Galiwin'ku (Elcho Island) is 550 kilometres northeast of Darwin, off the coast of Arnhem Land midway between Yirrkala and Ramingining. Approximately 50 kilometres long and 6 kilometres wide, it has a fluctuating population of around 1500 from about thirteen different clans and languages.

Established as a mission in 1942, a dramatic breakthrough in black–white dialogue happened in 1957 when clan leaders decided to erect a set of carved and painted ceremonial objects near the church. The act, as curator Judith Ryan describes — changed the context of mission life.

'By revealing objects hitherto unseen except in men's ceremonies, the leaders created a symbol of the power of their religion which transcended clan differences ... [aiming] ... to establish unity at a regional level so they would have a stronger voice in negotiating with Europeans.'[1]

The act marked an important shift in re-establishing people's power over their lives—a move reflected in the increased making of traditional barks and weavings. In 1997, the island's Galiwin'ku Art Centre celebrated the fortieth anniversary of the making of the carvings by organising, with the assistance of federal funding, a brush hut cover and fencing to protect the carvings and the graves next to them.

GALIWIN'KU
Land of the morning star

LEFT: Mick Daypurryun, *Djang'kawu ancestral landscape* (1982). A series of linked waterholes created by the Djang'kawu sisters—ancestors of the first generation of one group of central Arnhem Land's people—is seen in this finely executed work.

Individuation within tradition

Barks from Galiwin'ku bear strong resemblances to those of both Yirrkala and Ramingining. Many of the island's Dreamings, such as *Djang'kawu Ancestral Landscape* (left) by Mick Daypurryun, are interwoven with those of the mainland. Notable amongst Galiwin'ku's artistic representations are the ritualistic burial carvings called Morning Star poles and weavings, ranging from fishing nets to a large variety of carrying bags and baskets. The baskets vary in style from those of knotted string to more intricately dyed, solid-weave baskets.

Both the weavings and the bark paintings have been produced for sale at Galiwin'ku since the 1920s. Until the establishment of Galiwin'ku's own arts centre in 1990, they were marketed through centres at Milingimbi and Ramingining. During the 1990s, the arts centre also established screenprinting workshops, which are currently in abeyance awaiting funding and the resources of a suitable supervisor. The arts centre services around 180 painters, weavers and carvers (about 60 male and 120 female).

Some Galiwin'ku artists

Daypurryun, Mick; Djawa; Mandaark; Mandjuwi.

Where to see and buy the art

Collections of Galiwin'ku art are found in the public galleries and museums which feature art from this area—notably the art galleries of Western Australia and Victoria (which has an important collection of Morning Star poles), as well as New South Wales. The Museum and Art Gallery of the Northern Territory is the best Top End venue in which to see the art. The museum's publication *The Inspired Dream* (which accompanied an exhibition held in 1988 with the Queensland Art Gallery) offers some excellent reproductions of some of the more significant items.

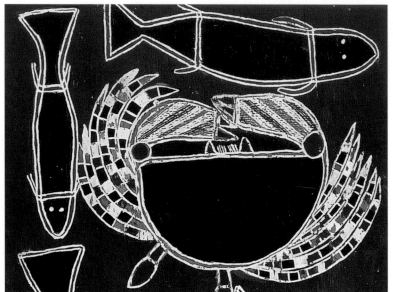

Detail from Djawa I's *Mangrove Crabs* (1978). The pattern on these boldly depicted mangrove crabs symbolises the foam on the water's surface, while the humans depicted at the bottom of the picture are two sisters who, along with their brother, were the Djankg'kawu creation ancestors of central Arnhem Land people.

Elcho Island's Galwin'ku Arts Centre welcomes one-day visits by potential clients, educational groups and art tour groups, with permits (available from the arts centre) costing $15 per person. Due to distance and cost, however, other than on group tours often organised by specialist operators visits by individuals to the island itself are largely prohibitively expensive and difficult to arrange.

Galleries which represent Elcho Island art include Melbourne's Kimberley Art Gallery; Darwin's Framed Gallery; and Perth's Indigenart.

Recommended reading

For publication details see Recommended Reading page 233. General texts as in the Introduction to Arnhem Land section, especially *The Inspired Dream*, Margie K. C. West, 1988; *The Painters of the Wagilag Sisters Story 1937–1997*, Wally Caruana & Nigel Lendon, 1997; *Spirit in Land: Bark Paintings from Arnhem Land*, Judith Ryan, 1990; *Windows on the Dreaming: Aboriginal Paintings in the National Gallery of Australia*, Wally Caruana, 1989.

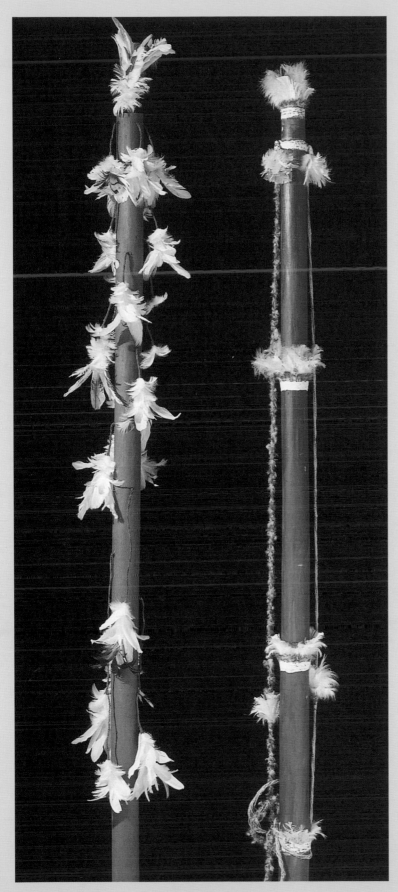

MORNING STAR POLES

Morning Star poles are used in performance by members of Elcho Island's clan, as well as other Galpu clan members, in ritual burial ceremonies. The feathered string connects the deceased's soul to the Morning Star, to guide it to its resting place. As well as ceremonial performances and song cycles relating to life and death, birth and rebirth, the Morning Star also refers to the planet Venus. In the Galpu clan's Dreaming story, the Morning Star is believed to belong to an old woman who lives on an island of the dead. Before dawn, she releases the star, tethered by a long piece of feathered string to the island, whence it returns to be kept in a basket until its next rising

Mandjuwi, *Morning Star Poles* (1979).

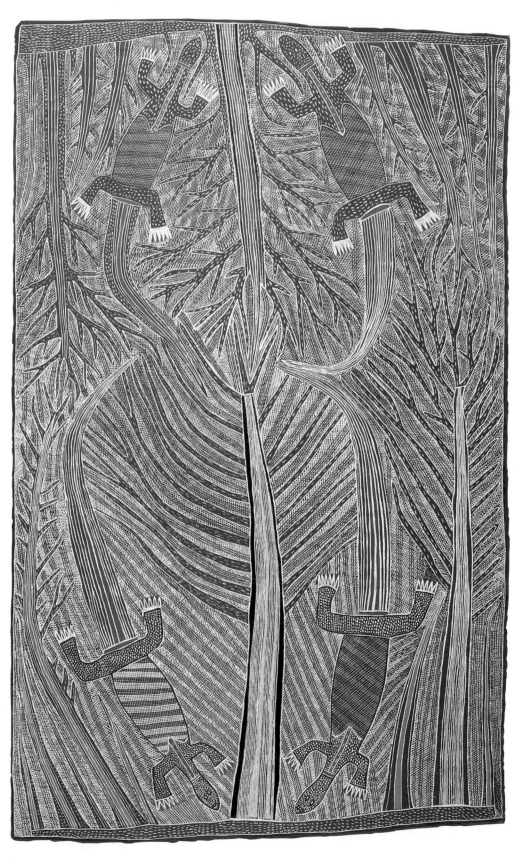

Open rainforests broken by swathes of lush, grassy plains surround the Ngukurr township, located on the eastern edge of Arnhem Land and bordered on one side by the sweeping Roper River. To the east, through several hundred kilometres of high-growing grasses interspersed with wildlife-filled wetlands, is the Gulf of Carpentaria and, to the south, the township of Borroloola.

Established by the Anglican Mission Society in 1908, Roper River Mission became a focal food and shelter point for people within a radius of several hundred kilometres whose traditional way of life had been severely disrupted. In 1968, the mission, with its community of around 800 people, reverted to Aboriginal control and its name changed to Ngukurr.

Nine major language groups live at Ngukurr, whose contemporary painting movement has proved not only a fulfilling occupation and a means of making a living in Western terms, but also a major step in people's re-establishment of stronger links with their land and traditional ways.

NGUKURR
Lush vibrancy and jewel-coloured paintings

A joyous painting movement

Modern-day painting started at Ngukurr in the late 1980s through the Katherine Open College of TAFE, which set up a screenprinting workshop in the community.

Painters such as Ginger Riley Munduwalawala, Djambu Barra Barra and the late Willie Gudabi were attracted by the strong, clear colours of the new medium. They developed highly individual interpretations of both traditional stories and more contemporary events.

While a community group, the Ngundungunya Association, was set up under the umbrella of Aboriginal Legal Aid in Katherine in 1989, no formal arts centre to manage the art has ever been established at Ngukurr.

Individual evocations of the fertile land

Despite the lack of formal structure, a thriving painting movement involving some twenty to thirty artists—each painting in highly individualistic style—has evolved in the community and surrounding areas.

It is also a major didgeridoo-producing area. In the work of senior painter the late Willie Gudabi, vividly coloured, segmented canvases are drawn from the images of the walls of the

LEFT: Djambu Barra Barra, *Cypress Pine Mortuary Rite* (1994). This leading Arnhem Land artist's work reflects the antiquity of his subject matter in a new medium of paint on canvas

caves in Gudabi's country. Favouring a decorative figurative style, each of his panels tells its own story and also relates to that of its neighbours, often incorporating modern events such as World War II with traditional stories. Moima Samuels, Willie's wife of more than fifty years who used to paint love stories with Willlie, continues to paint her equally distinctive paintings alone.

Djambu Barra Barra, whose country is many kilometres further northwest, focuses on fewer, more stylised images. In paintings such as *Cypress Pine Mortuary Rite* (page 194), elements of the traditional crosshatching, X-ray figures and restricted palette of traditional-based Arnhem Land bark painting can be seen.

Today, a younger generation of Ngukurr artists includes the Joshua sisters, Wilfred Ngalandarra, Amy Johnson Jirwulurr and Barney Ellanga, who have joined senior artists in what has become a highly creative and ever developing informal art school.

RIGHT: Willie Gudabi (deceased), *Alawa Story* (1995). Colour and powerful design tell the stories of Gudabi's ancestors integrated with modern-day life.

Some Ngukurr artists

Barra Barra, Djambu; Gudabi, Willie; Munduwalawala, Ginger Riley; Samuels, Moima.

Where to see and buy the art

With no formal art outlet established at Ngukurr, most of the art produced in this area is destined straight for galleries, although occasionally the local general store sells and displays pieces. Melbourne dealer Beverly Knight represents Ginger Riley and other Ngukurr artists, including Djambu Barra Barra and the late Willie Gudabi, through her Alcaston Gallery. In Darwin, Karen Brown Gallery displays the work of a number of Ngukurr artists, including many of the younger generation. Paintings by Ginger Riley are seen in other galleries around Australia.

Recommended reading

For publication details see Recommended Reading page 233. General texts as in the Introduction to Arnhem Land section and *Ginger Riley*, catalogue, Beverly Knight and Judith Ryan, 1998.

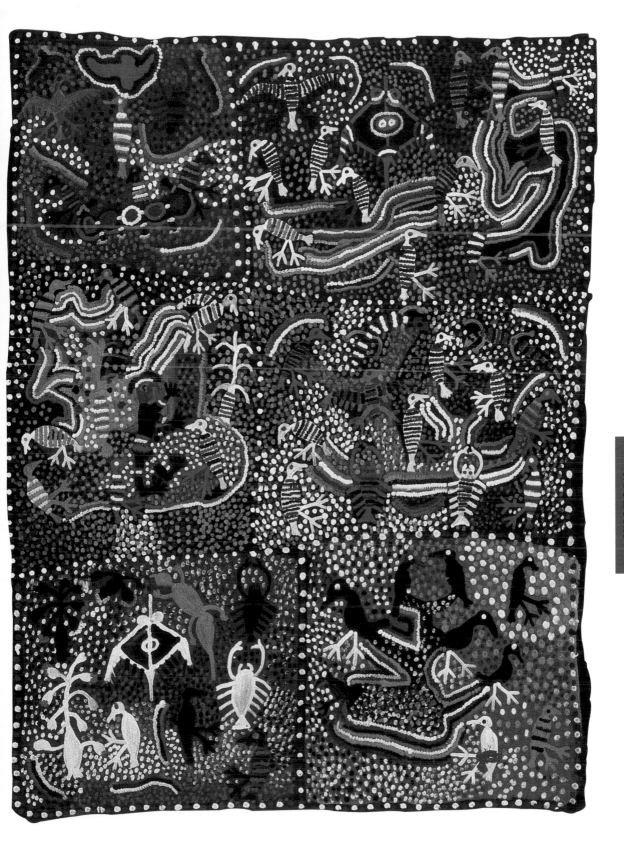

GINGER RILEY MUNDUWALAWALA

b. c. 1937, Limmen Bight, NT. Language group: Mara.

Exuberant, vibrant, vital and powerfully individual, in 1997, Ginger Riley's paintings burst from the grey walls of the National Gallery of Victoria's Murdoch Court in the first solo retrospective by an Aboriginal artist that this gallery had ever held.

Ginger Riley paints the country of his people—the stunningly lush Limmen Bight area of the Gulf of Carpentaria. The colours of the landscape—luxuriant greens of the spinifex-covered plains and dense swamp grasses, brilliant blues of the sea and sky, reds of the earth, whites of the clouds—are Riley's colour base. His subjects are the elements of the land—the important ancestral sites, the rivers and landforms from which a myriad of journeys and myths have been created.

Riley started painting continuously in 1986 when the Northern Territory Open College of TAFE established a printmaking workshop in Ngukurr—the closest town to his country. It was an opportunity for which Riley, then aged almost fifty, had been unconsciously waiting for for years. 'I had known since I was a little boy that I wanted to paint', he said. 'My father and father's father would paint on the coolamons (wooden baskets) for the babies. They'd sing me the stories and I learnt the stories and how to paint them'.[1]

Ginger Riley, *Garimala—Wet Season* (1990). One of Riley's classic subjects, his country's lush wet season, is depicted in this painting.

As a teenager on a visit to Alice Springs, he met the famous Arrernte watercolourist Albert Namatjira—the clarity with which Namatjira painted his realistic watercolour landscapes impressing the young man who then tried to emulate Namatjira's style in ochres. The result, he

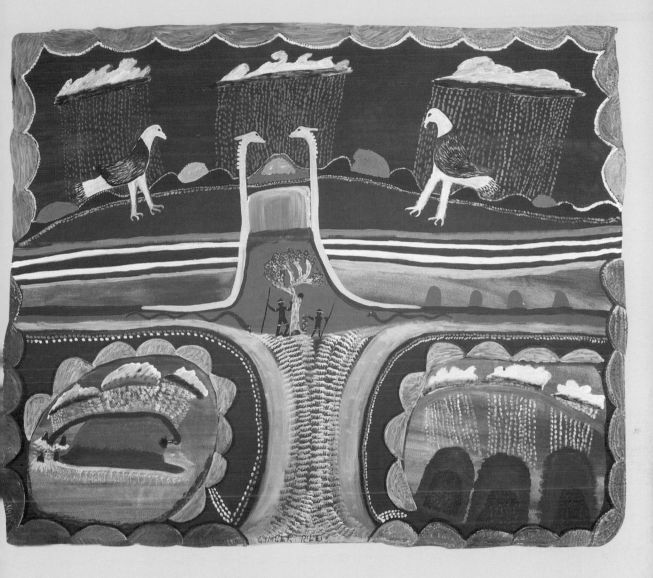

Ginger Riley, *Ngak Ngak in Limmen Bite Country*, 1994. This major work depicts Riley's saltwater country and the rock formation the Four Archers, which are pivotal in his imagery.

said, was disappointing and, discouraged, Riley put painting aside as he earnt his living, as did so many outback Aboriginal men during the 1940s, 1950s and 1960s, as an itinerant stockman travelling all over the thousands of kilometres of the Northern Territory.

'When the painting people started at Ngukurr I just pulled a bit of board out of the rubbish pile and started with these new colours,' he says.

The 'new colours' were a range of screenprinting inks which allowed Riley the vibrancy of coloration he had seen in Namatjira's works.

Significant in Riley's subject matter is the rocky outcrop the Four Archers, an important ancestral ceremonial site which guards the entrance to his mother's country, the white-breasted sea eagle Ngak Ngak and the serpent/snake Garimala, a large taipan.

URBAN &
NEW FORMS
OF ART

Individuation and integration

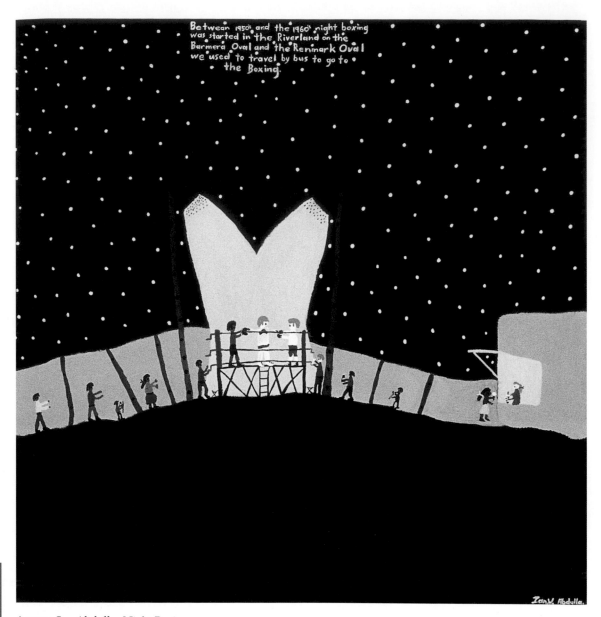

Between 1950's and the 1960's night boxing was started in the Riverland on the Barmera Oval and the Renmark Oval we used to travel by bus to go to the Boxing.

ABOVE: Ian Abdulla, *Night Boxing* (1991). Abdulla's gentle, often whimsical subject matter and use of clearly defined colours make his paintings distinctively original.

RIGHT: William Barak, *Ceremony* (1895). This early painting typifies Barak's style of depicting men performing corroborees while being watched by other clan members wearing possum-skin cloaks.

Paralleling the growth of art in the land-based Aboriginal communities was that of indigenous artists in Australia's urban areas. With the changing social climate of the 1970s, in which land rights and other affirmative movements focused on Aboriginal issues, artists of Aboriginal heritage began to express, through their art, both their personal experiences and those of Aboriginal people in general.

The history of urban Aboriginal art, however, dates from a far earlier period.

Urban art in the 1800s and beyond

During the 1800s, several Aboriginal people living in settlements or camps in New South Wales and Victoria, painted and drew figurative renditions of their lives, daily activities and traditional stories. William Barak (1824–1903), a leader of the people living at the Coranderrk Aboriginal Station in Healesville, Victoria, recorded both the rapidly disappearing traditional ceremony and daily life at the mission in distinctive silhouetted ochre and charcoal drawings. At the same time, in the 1880s and 1890s, Tommy McRae, who lived near Lake Moodemere near the

PREVIOUS SPREAD: Rosella Namok, *Raining down at Aangkum* (2001). *'Sitting in a boat out fishing … a big storm poured straight down on us. Good fishing … caught heaps … but we couldn't cook on the beach.'*

URBAN & NEW FORMS OF ART
Individuation and integration

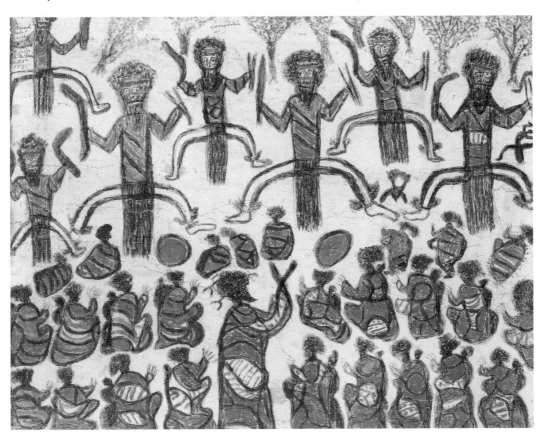

Murray River Town, was drawing images in coloured pencil of both Aboriginal life and past and contemporary activities of European settlers. On the New South Wales coast near Ulladulla, the artist known only as Mickey was similarly recording daily events—especially those related to the sea such as fish, fishing activities and boats. The work of these artists, the most well known of the handful of Aboriginals recording life in the late nineteenth and early twentieth centuries, is stylistically linked by use of the silhouetted form, depicted in horizontal bands across the page.

In the 1960s, Ronald Bull (1942–79) painted realist landscapes of his area surrounding the Lake Tyers mission in eastern Victoria and, in Western Australia, Revel Cooper (1933–83) painted his land. Unquestionably the most renowned Aboriginal artist to adopt a Western tradition was Albert Namatjira (page 28), who became famous from the mid-1930s, sparking an entire school of watercolour painting which has been in practice ever since.

Bicentennial—a black day in Aboriginal history

In 1988, the bicentennial of official European landing in Australia was celebrated as a huge commemorative event. Costing many millions of dollars, it comprised a year-long festival and provided funding for hundreds of community and other projects. For Aboriginal people and many others sympathetic to their history, however, the year was one of mourning. Many artistic projects in differing art forms reflected these concerns. One of the most major of these is the National Gallery of Australia's *Aboriginal Memorial* (pages 167 and 169). Originated and carved by the men of Arnhem Land's Ramingining area, the 200 hollow log coffins mourning 200 years of white occupation form one of the most powerful artistic and political statements of any artwork in the country.

At an individual level, artists such as Brisbane-based Gordon Bennett and Adelaide's Trevor Nickolls produced works expressing a powerful indictment of European treatment of Aboriginal people. Nickolls's 1993 *Uluru Dreaming Three* (right) takes a facetious view of the impact of tourism on Australia's most famous land formation, while Bennett's 1992 *Myth of the Western Man (White Man's Burden)* offers a strong 'reverse' stylistic appropriation by incorporating elements of modern Western art

in a Jackson Pollock-like overlay of paint, with an Aboriginal dot motif. A series of flags, fluttering on a clothes line, represents an alternative, black view of Australia's history, by commemorating dates overlooked in its formal history—such as those of massacres of Aboriginals, the death of the last Tasmanian Aboriginal and significant land rights cases. In 1991, Bennett won the prestigious Moet & Chandon Fellowship for artists of less than thirty-five years of age with an equally graphic painting, as did, in 1995, Judy Watson, another urban-based Aboriginal artist, with a work of a quite different nature.

Watson's works, such as her 1986–87 *the guardians/guardian spirit* in the collection of the Art Gallery of New South Wales often have a sculptural quality. In this work, the shape of the 'guardians' resembles simultaneously coffins, anthills and targets in a shooting gallery, their ghostly figures reminiscent also of the wrapped bones traditional to the customs of Watson's Queensland ancestors.

In 1990, Adelaide's Trevor Nickolls and Kimberley painter Rover Thomas were the first Aboriginal artists to represent Australia at the Venice Biennale (Emily Kngwarreye, Judy Watson and weaver Yvonne Koolmatrie represented Australia in 1997). Whereas Thomas's ochre paintings are 'landmaps' of his Kimberley country, Nickolls works, such as the 1993 *Uluru Dreaming Three*, offer both cynical comments on the changes which have occurred in Aboriginal societies and a strong cry for justice for Aboriginal people. As with Bennett, Nickolls pulls no

Trevor Nickolls, *Uluru Dreaming Three* (1993). Social comment is a major component of this major contemporary Aboriginal artist's work.

Ellen Jose, *Life in the balance* (1993). Based on a traditional Torres Strait fish trap, but incorporating symbols of the contemporary world, this Islander artist's work fuses the old and the new to make a lyrically powerful statement about the fragility of traditional life.

punches in making a political and social point through often complex and detailed imagery.

The brightly coloured screen prints of Perth-based artist–writer Sally Morgan, whose award-winning book *My Place* created awareness of some of the problems of the adopted generation of Aboriginal people, have attracted international attention for their direct storytelling imagery.

Strong colours in paintings very different in nature are also employed by Sydney's Bronwyn Bancroft, South Australian painter Ian Abdulla, the New South Wales artist H. J. Wedge and the land-based Western Australian artist Mary Pitjinji McLean. McLean won the 1995 National Aboriginal and Torres Strait Islander Art Award with *Ngura Walkumunu—Being in a Good Camp*, which, with its tumbling black figures, stylised dogs, bright colours and flattened perspective, shows a place notable for its good water and abundant food. While their personal experience and the stories they relate are very different, McLean's, Wedge's and Abdulla's works all employ an 'art naif' style with

foreshortened perspective, bright colour, simple figuration and a sense of spontaneity.

The New South Wales-based three-dimensional artist Treanha Hamm works in a variety of media, such as seen in her 1996 National Aboriginal Heritage Award-winning piece, *Remains to be seen*. Her combination of materials includes wood gathered from her home country along the banks of the Murray River with Western techniques such as printmaking to create subtle composites reflecting a personal interpretation of her heritage.

The first Heritage Award winner Lin Onus (1948–97) had, like Hamm and many other urban-based Aboriginals, come to portray more of their Aboriginal perspective as their careers progressed.

Three-dimensional works are also integral to Torres Strait Islander Melbourne resident Ellen Jose, whose work, such as the Art Gallery of New South Wales's *Life in the Balance* (page 206), evokes concern for environment, the balance between the organic and inorganic, and the fact that practices of the past may be employed towards the salvation of the world.

Photography has proved a rich medium for a number of urban-based Aboriginal artists, such as Leah King Smith's hauntingly poignant multi-layered high-gloss cibachromes. Spanning the generations are works such as *Number 17 from Over the Garden Wall Series* (above) through the superimposition of nineteenth-century sepia photographs of people on reservations taken for 'scientific purposes' with misty landscapes and views of today's urban life. Photography, too, forms the basis of the very different work of Sydney artist-curator Brenda Croft, whose photographs of flowers convey a myriad of references to Aboriginal and women's lives. In a different strain, Melbourne-based Destiny Deacon's 'found' object photographs, in which Deacon offers commentaries on urban life and girls' (and so

Leah King-Smith, *#17 from Over the Garden Wall Series* (1995). Subtle superimposition of images makes this leading photographer's large cibachromes both memorable and haunting.

women's) experiences, do as well. Fiona Foley's photographs have become similarly well known for a different portrayal of women through unadorned portraits of faces and bodies, while her installations include both these and references to the universal Aboriginal link with the land.

Urban art in the 1990s

While the urban Aboriginal art movement has grown in significance during the 1990s, its emphasis—along with that of Aboriginal art in general—has also shifted from being regarded as a marginalised art form to one joining, without differentiation, the mainstream of contemporary Australian art.

Many Aboriginal artists such as Gordon Bennett, the late Lin Onus and Tracey Moffat insist on not being categorised as 'Aboriginal' artists, but simply as 'artists'.

Increasingly, public gallery curators are also including works from Aboriginal Australia—from both urban and land-based artists—in survey or theme shows and in order to present an Aboriginal view (both contemporaneously and historically) wherever possible.

With this, Aboriginal art, whether land or urban-based, is being pushed to be judged on its aesthetic qualities rather than its storytelling properties. Emily Kame Kngwarreye (c. 1910–1996) was instrumental in this development, as was the Kimberley's Rover Thomas and Jimmy Pike, bark painters from Yirrkala and Maningrida, the Ngukurr artist Ginger Riley, the Balgo artist Eubena, Papunya's Mick Namarari and Melville Island's Kitty Kantilla, to name just a handful of those engaged in a vibrant and evolving artistic journey.

Emerging forms in land-based art

While the majority of land-based Aboriginal art continues to be that of the acrylic and ochre paintings and carvings, new forms are also constantly emerging. Amongst these, the glass-making project of Western Australia's Warburton Ranges and various printmaking projects such as those conducted by the Australian Print Workshop and the Northern Territory University's printmaking department stand out. The Warburton glass project, started in 1988 by a visiting glass-maker, involves the making of often large panels and platters using the slumped glass technique in which artists make the glass itself from the desert sands, and

RIGHT: Tjapartji Bates, *Tjukurrpa Kungkarangalpa* (1997). Sand painting enters a new dimension in the works of Western Australian Warburton Ranges artists, such as this 1998 winner of the National Indigenous Heritage Art Award in which the artist uses desert sand as raw material for glass panels, which are moulded and decorated with Dreaming stories.

etch into it traditional storytelling designs. These designs, as in painting, relate to traditional journeys and special sites.

In the late 1990s, Queensland's Lockhart River Community started an exciting screenprinting program, which developed out of a secondary school training course. A number of other collaborative print projects between master printmakers and art communities have yielded exciting images at affordable prices (A Buyer's Guide, page 219).

Throughout the Central Desert, art and craft making have also blossomed since the 1980s. These include the carved and decorated sculptures, screenprinted T-shirts and jewellery made by the people of Aputula Arts at the Finke community (450 kilometres south of Alice Springs); the batik making and colourful paintings of around thirty artists at Fregon community's Kaltjiti Crafts (500 kilometres south west of Alice Springs); the decorated fabrics, beads and more recently paintings of Keringke Arts based at Santa Teresa Aboriginal community (80 kilometres southwest of Alice Springs); and the painted silks of about thirty artists of the Utju Arts Centre (240 kilometres west of Alice Springs). At Uluru (Ayers Rock), the Mutjijulu community's Maruka Arts and Crafts Centre was established in 1984 and has since grown to become one of central Australia's most prolific producers of wood carvings of animals, birds and reptiles, as well as utilitarian objects such as the carrying bowl, or coolamon—many decorated with the distinctive burnt patterned pokerwork.

There are also a number of Aboriginal craft centres throughout the Top End and Arnhem Land, which is the centre

for Australia's didgeridoo production, as well as woven mats and baskets, many carved products and a variety of fabrics. Centres include Gumbarnum Arts and Crafts at One Arm Point, north of Broome, Western Australia, which produces polished troicus shells and jewellery; Mimi Arts and Crafts at Katherine, Northern Territory, which produces bark and acrylic paintings and artefacts; and Nambara Arts at Nhulunbuy, Northern Territory, which produces bark paintings, carvings and weavings.

An age of evolution

Such evolution and growth, both within individual artist's oeuvres and in the constant emergence of new artists and schools of art, are the keys to the success of contemporary Aboriginal art—whether it be the acrylic paintings of the desert areas, the barks of the Northern Territory or the work of urban-based artists. It is still, however, a movement dependent for its success in both an artistic and cultural sense on the retention and reinterpretation of a strong traditional and spiritual base.

It is the combination of these qualities—of innovation within tradition allied with a strong visual sensibility and skill—that has made the art of Aboriginal Australia unique in worldwide contemporary art practice. And it is their continued existence which will ensure that this art maintains its success both as an innovative and exciting art form and as a unique expression of cultural survival.

Some urban artists

Abdulla, Ian; Bancroft, Bronwyn; Barak, William; Bell, Richard; Bennett, Gordon; Brown, Jonathon Kumintjara; Bull, Ronald;

Campbell, Robert; Casey, Karen; Cole, Robert; Deacon, Destiny; Foley, Fiona; Hamm, Treanha; King Smith, Leah; Meeks, Arone Raymond; Koolmatrie, Yvonne; Moffat, Tracey; Morgan, Sally; Nickolls, Trevor; Onus, Lin; Quaill, Avril; Watson, Judy; Wedge, Harry J.

Where to see and buy the art

Works by artists of the nineteenth century, especially William Barak, appear occasionally at Australia's leading auction houses such as Sotheby's, Christie's, Deutscher Menzies, Joel's and Phillips. Works of contemporary urban-based artists are found in a variety of Australia's commercial galleries. Sydney's Boomalli Aboriginal Arists Co-op—an Aboriginal owned and operated collective—is a major outlet for the work of contemporary Aboriginal artists, including Bronwyn Bancroft, Brenda Croft, Fiona Foley and many others.

Melbourne-based Gallery Gabrielle Pizzi, having concentrated on displaying art mainly from the Central Desert areas during the 1980s, has broadened its artists' stable to include many urban-based artists such as Leah King-Smith, Harry Wedge and Destiny Deacon, as well as numerous others. Sydney's Stephen Mori Gallery represents Judy Watson; Melbourne's William Mora, Ellen Jose; Melbourne's Sutton Galleries and Brisbane's Belles Gallery, Gordon Bennett; Alice Springs's Gallery Gondwana, Mary McLean; Melbourne's Lauraine Diggins Fine Art, Karen Casey; and Adelaide's Greenaway Gallery, Ian Abdulla. Other galleries regularly showing the work of contemporary Aboriginal artists include Perth's Indigenart, Melbourne's Australian Print Workshop, Brisbane's Fireworks Gallery and Adelaide's Tandanya Aboriginal Cultural Centre.

Recommended reading

For publication details see Recommended Reading page 233. *Aboriginal Art*, Wally Caruana, 1993; *Aboriginal Artists of the Nineteenth Century*, Andrew Sayers, 1994; *Aboriginality: Contemporary Aboriginal Paintings and Prints*, Jennifer Isaacs, 1992; *Fluent*, catalogue of Australia's 1997 Venice Biennale exhibit, Australia Council, 1997. Individual artist's monographs, including *The Art of Gordon Bennett*, Ian McLean & Gordon Bennett, 1996; *The Art of Sally Morgan*, 1996; *Wiradjuri Spirit Man*, H. J. Wedge, 1996; *Yiribana*, Margo Neale, 1994.

LEFT: Rea, *for 100% Koori (Rea-probe Series)* (1998). Photographic triptych. Joint runner-up for the Normandy Heritage Art Prize of the National Indigenous Art Awards in 1998, artist Rea describes this as a symbolic work relating to her personal memorial and cultural memories about her birthplace of Gunadah Hill.

URBAN

LIN ONUS

b. 4/12/1948, Melbourne. d. 24/10/1996, Melbourne.

A self-taught artist born of a Scottish mother and Victorian Yorta Yorta (from the Murray River area) father, Onus's graphic-based paintings of the 1970s underwent a considerable change following visits to the

RIGHT: Lin Onus receiving the 1995 National Aboriginal Heritage Award for his painting of his Yorta Yorta people's Murray River country.

Maningrida area of Arnhem Land in the early 1980s. From their illustrative qualities derived from Western culture, his paintings evolved to reflect aspects of the Arnhem Land Aboriginal culture he was taught by senior men. Onus's father, William, was a strong Aboriginal activist, dedicated to the fostering of Aboriginal culture. William Onus set up a centre for the making of art and artefacts in Melbourne's Dandenong Ranges—an area Lin Onus lived in for most of his life. Paintings of this lush, forested area were interspersed with those of the Yorta Yorta people's northern river and forestry areas around the Murray River. Onus's style was striking for a super-real quality softened by luminous colours and a hazy atmospheric subtlety.

A talented sculptor and three-dimensional installation artist, Onus displayed a strong sense of irony and humour. This can be readily seen in works such as the *Fruit Bats* sculpture in the collection of the Art Gallery of New South Wales and the Queensland Art Gallery's *A stronger spring for David—toas for a modern age*. This latter work was a highlight

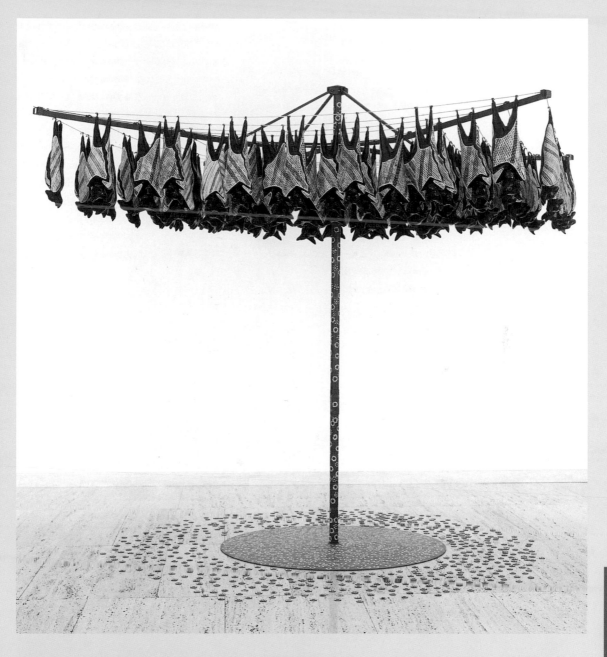

of that gallery's 1996 Asia Pacific Triennial of Contemporary Art.

Winner of the 1988 National Aboriginal and Torres Strait Islander Art Award and the 1995 Aboriginal Heritage Award, Onus was also a dedicated champion of Aboriginal and human rights, and an important voice in black–white relations. He was a member of the Aboriginal Arts Board of the Australia Council from 1986, its chair in 1989 and received a medal of Australia for services to the arts and Aboriginal issues. He died suddenly in Melbourne of a heart attack at the age of forty-seven.

Lin Onus, *Fruit Bats* (1991). This is one of Onus's most memorable sculptures, which contains the irony, wit, crosscultural references and fine artistic sensibilities for which he became so well known.

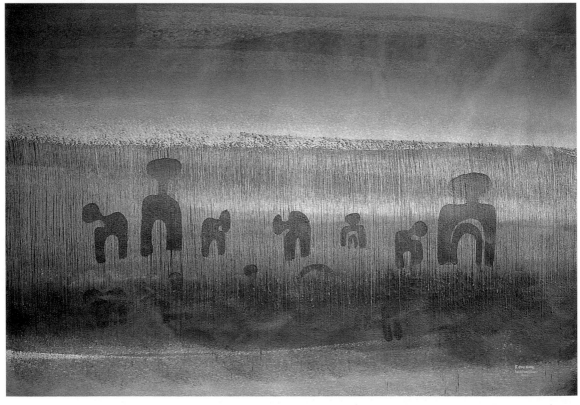

When I left school I was like all the other mothers in Lockhart— I stayed home, had no job, got bored. Then Rosie Lloyd came and asked me to work at the art room at the school. From there my life started getting better. I thought to myself ... what the hell ... I'm not going to waste my life sitting at home all the time ... I'm going to get out and make a name for my family.

Fiona Oomenyeo, born in 1981, is from the Far North Queensland community of Lockhart River and part of the group which calls itself the Lockhart River 'art gang'. Eight hundred and fifty kilometres north of Cairns on the eastern coast of Cape York Peninsula, Lockhart River was established as a missionary community in 1924. It was moved to its present location, near a former WWII airstrip in 1965.

Its 'art gang' grew out of an alternative education program in which teenagers had the choice of continuing with formal education or taking art and craft classes. In 1995 volunteers Geoff and Fran Barker decided to help set up an extended community art practice with the then teenagers. Original prints were the first artworks made—almost immediately drawing attention from leading public and commercial galleries.

Now acrylic painting on canvas is the main medium, with sculpture in concrete also being made.

The success of the art movement lead to the establishment of an art and culture centre in a former medical clinic, with several exhibition rooms and expansive work spaces, including a large verandah and slat-sided room in which artists work. Traditional crafts by the senior women, such as the fine basket weaving of the area, have also been revived with the renewed interest in art and culture.

The style of Lockhart River art varies widely with each of its twelve main artists—and is, as one describes, 'modern but traditional'. Most of the young artists have drawn inspiration from the stories they sought from their elders.

Most well known of the 'art gang' is Rosella Namok, whose works have attracted attention since she produced her first prints in 1997. Since then her paintings have been selected for leading public survey exhibitions such as the Adelaide Biennal and the Wynne Prize. A continuing series focuses on the two 'sides' or 'moieties' of her family, which she depicts in concentric ovals or rectangles ranging from monochromatic shades to multi-hued colours. The beach and sea are also key elements in her work as

LOCKHART RIVER
A vibrant 'art gang' emerges

TOP LEFT: Samantha Hobson, *Bust 'im up* (2000). Painting what she experiences and observes as well as stories garnered from her older relations, Samantha Hobson does not shy away from recording in paint issues such as domestic violence, or, as in this large painting, fights between women and girls in the community.

BELOW LEFT. Fiona Oomenyeo, *Two parrot sisters flying up to high country* (2001). The story of the parrot sisters who were kidnapped by a jealous man on the eve of their marriage to the sea eagle's son has become a favoured traditional story for this artist.

she carves out designs in thick layers of white, blue, brown and red shining acrylic to mirror the ripples on the sand made by strong tidal pulls. Other images are based on the sacred 'Ngaachi Kincha' ground still used for ceremony, the tangled roots of the mangroves, traditional fish traps, 'para' (European) 'nother way' and abstract representations of generations and houses in the community.

Fiona Oomenyeo's more narrative pictures and concrete sculptures often tell the story of the parrot sisters who were kidnapped by a jealous man the night before they were to marry the son of the sea eagle. *'The sea eagle still goes up and down the coast looking for them'*, she says. Her images include ghostly figures appearing as though through a fog, silhouetted figures of the sisters and their protective eagle.

Different again are the paintings of Samantha Hobson, whose expressionist abstract works often deal with the subjects of domestic violence and the effects of alcohol. Hobson is not painting to consciously confront; this is what she experiences and what she observes on a daily level, so it is what she paints. They are not the only subjects or styles of her work, which also includes subtle abstracts. One of Hobson's most colourful recent works is an almost three-metre long canvas called 'Bust 'im up' (page 214) in the collection of the National Gallery of Victoria. Swirls of fluorescent pinks, yellows and reds riot over the entire canvas.

'Mainly on Thursday and Friday [pay day] everybody gets drunk everywhere,' says Hobson. *'When a girl gets into a fight with another girl ... the loser she goes and calls her friends or relatives. The other girl also has her friends and relatives ... and they fight each other with sticks and cans—end up at the clinic. And when they get over it they start busting each other up again.'*

It's a subject few in the indigenous or non-indigenous world have had the courage—or maybe the desire—to express through art.

'Sometimes what I see really upsets me,' says Hobson. *'What [people] do and what happens to them ... That makes me hurt inside too ... that painting, makes the bad feeling go away.'*

The variety of imagery and widespread appreciation of the work of these artists—most of whom are only in their twenties—

ABOVE: The calm waters of the sea and river mouths near the Lockhart River community provide fertile fishing ground, are the sites of traditional stories and are important places to relax.

speaks for both their singularity of vision and the integrity and energy of their coordinators which have combined to create such a vibrant art movement within half a decade.

ABOVE: Rosella Namok, *Yiipay and Kungkay* (2001). '*Tradional yet modern*' says Namok of her work. This shining acrylic represents the boundaries of two Lockhart River area tribes separated by the rippled sand of the wide beach front at low tide.

Some Lockhart River artists
Clarmont, Sammy; Hobson, Samantha; Hobson, Silas; King, Adrian; Namok, Rosella; Oomenyeo, Fiona; Platt, Terry.

Where to see and buy the art
The Cairns Regional Gallery frequently includes Lockhart River works in displays. Their works are also included in the collections of the Art Gallery of South Australia, the Queensland Art Gallery, the National Gallery of Australia, and the National Gallery of Victoria. They are seen in exhibitions and stocked by Sydney's Hogarth Galleries, Brisbane's Andrew Baker Gallery, Melbourne's Gallery Gabrielle Pizzi, Niagara and Vivien Anderson and Broome's Short Street Gallery.

Further reading:
An explorer's guide to Lockhart River, R & A Edwards and the Lockhart River Art Gang, 1999; *The Message Stick: Art from North Queensland's Lockhart River community*, 2000. *You—me Mates eh!*, J. Warby, 1999.

One of the aims of this book is to introduce the range of contemporary Aboriginal art to the interested buyer. 'Where to see and buy the art' and 'Recommended reading' sections at the end of each chapter are intended for this purpose. There are some more general questions, however, that potential buyers may like to consider.

One of the differences between the work of Aboriginal and non-Aboriginal artists is the wide variations in price one finds in the works by the same artist. One painting for example by Mick Namarari or Clifford Possum can fetch $20 000 to $50 000 or more at auction, while another, perhaps later work by the same artist can be bought in an Alice Springs or a capital city gallery for several thousand dollars. This is a far greater price range than seen in the work of non-Aboriginal artists of a similar stature, prices of which are far less variable.

What leads to this price variation and would a lower priced work by a well-known artist automatically treble in value in years to come? Would that art buying were so simple! One of the great truisms in art, however, is that even wonderful artists produce inferior works. This is particularly so with contemporary Aboriginal art in which a variety of factors, not least the pressures on artists to produce, contributes to the huge range of quality. As a result, buying on name alone is no guarantee of either quality or potential financial reward.

A BUYER'S GUIDE

How to choose your purchase

LEFT: Colourful painted beads are made by many of the women in different communities throughout the Central Desert.

Defining your motivations—why are you buying?

Most important before buying any art is to define why exactly you are making the purchase. Is it for investment? Because you want a souvenir of a journey, place or person? Or have you simply fallen in love with an artwork and have to purchase it come what may? After all, some of the most important collections are built on this. If you are on holiday, say, and want just a small, inexpensive reminder of your stay, then it probably does not matter if you choose a work which you like, but which is unlikely to have any resale value.

It seems a pity, however, not to investigate further when, for probably only slightly more, you could be buying a work which not only will give you pleasure, but will also grow in significance and maybe value over the years. This is, of course, crucial if one is considering collecting seriously, no matter at how modest a scale, or if you wish to be a bit more adventurous in your buying.

Self-education—an enriching discipline

Opening your mind and training your eye to differentiate between works by the same artist and identifying those from the same area are vital for the informed collector.

Most important in this is self-education—looking, reading and, to a lesser but important extent, listening. At first much Aboriginal art—especially the acrylic works of the Central Desert and the barks of Arnhem Land—may seem to be almost indistinguishable. You may think you will never be able to tell one artist's work from another. The first step in tackling this is both to visit Australia's public galleries and to buy the catalogues of their Aboriginal collections. In the public collections, you will see a refined and highly selected version of that in the commercial sector. Quality, too, as would be expected, is almost always of the highest level—remembering both the works and your reaction to them will stand you in good stead when assessing works in a more general environment. The catalogues of these collections or exhibitions (details of which are found both in the chapters relating to specific areas in this book and in the bibliography at the back) will both reinforce your initial reactions and provide follow-up material to acquaint yourself with the names of the artists and the areas in which they work. First, stylistic differences will become apparent, then an artist's individual style.

Reading, too, is essential. One of the most comprehensive and most easily affordable books is Wally Caruana's *Aboriginal Art* in the Thames and Hudson World of Art series. *Dreamings*, the book of a major exhibition in America (edited by Peter Sutton with essays by a number of well-respected specialists) has been, rightly, regarded as one of the most important illustrated texts on the subject since it was first published in 1988. All the books by Sydney writer Jennifer Isaacs—one of the major general writers on Aboriginal art and culture—are well worth buying (even if published some time ago, such as the 1989 *Australian Aboriginal Paintings* and her texts on bush tucker). So, too, is the hard-to-locate, large catalogue of the 1991 European–UK–Australian exhibition Aratjara. The catalogue *Nungara* by private dealer Hank Ebes of his private collection, although rather confusingly organised, contains many wonderful photographs and much information of interest. Vivien Johnson's *Biographical Dictionary of Western Desert Artists* gives good information on the individual

histories of artists and development of art in this area. The Art Gallery of New South Wales's *Yiribana* catalogue divides the works in its collection into themes rather than areas or chronological development, providing an interestingly different interpretation.

The National Gallery of Victoria has three major and 'must buy' publications on art from specific areas, all edited and largely written by its curator of Aboriginal art, Judith Ryan. These are *Mythscapes*, on the art of the Central and Western desert; *Spirit in Land*, on Arnhem Land art; and *Images of Power*, on Kimberley art.

The Art Gallery of South Australia's major Aboriginal publication is *Dreamings of the Desert* by Vivien Johnson—with excellent reproductions and a lively and highly informative essay on the artists, art and its development in this region, as well as the growth of the gallery's collection.

The Sydney-based magazine *Australian Art Collector* frequently contains articles on individual Aboriginal artists and reports on the Aboriginal art scene, making it an essential reference for the consumer or interested gallery-goer, while the Canberra-based *Art Monthly* often publishes articles on either issues surrounding or aesthetic considerations relating to Aboriginal art. For general gallery information covering all states, the small monthly publication *Art Almanac* is an essential reference.

When visiting commercial galleries, don't be afraid to ask questions and to ask to see works in the stockroom if the style of a particular artist appeals. It is only through such simple exchanges that knowledge is built. And if you find a gallery whose staff is indifferent or unwilling to help, before you leave you could perhaps quietly point out that you were a potentially serious purchaser, but, as there seemed to be a lack of interest, you will be going elsewhere.

Identifying the 'real' in Aboriginal art

Since the huge increase in interest in Aboriginal art from the late 1980s, the most problematic issue has been that of authenticity. Faking of paintings in Western art and that of a number of other societies has been around as long as money or other gain has been possible. The issue of Aboriginal art fraud gained momentum in the 1990s when doubts arose over the authenticity of works by the late Emily Kngwarreye. Similar doubts have been

raised about the work of other major artists such as Clifford Possum Tjapaltjarri and Rover Thomas, as well as some of the early Papunya board paintings from the 1970s. To date, none of these claims has been substantiated in that concrete proof has not been found. Although dealers may publicly deny it, however, it is quite widely known within the art trade that works of dubious authenticity by these and a number of other artists are circulating.

Also, as indigenous art curator Margo Neale described, the hand that made the painting may not own the Dreaming.[1] This is due in part to the different notions of authorship in the Aboriginal world and the Western art market. In most Aboriginal societies, it is accepted practice for a person who 'owns' a particular story through heritage, to allow another person to either paint that story or to assist them in painting it. The problem in the Western context is that, as is often the case, the level of assistance or even the existence of the other painter may not be acknowledged. This was highlighted in the 1997 revelations that Ray Beamish, the former white de facto husband of 1996 National Aboriginal and Torres Strait Islander Art Award winner, Utopia artist Kathleen Petyarre, had devised and largely completed her award-winning painting and about fifty others in a similar style. The attention which the case attracted put the award-givers—the Museum and Art Gallery of the Northern Territory—in an invidious position. The dilemma was solved some months later by their decision that, although Petyarre's husband had been responsible for some (he maintained at least 80 per cent) of the painting of the work, Petyarre was the painting's Dreaming story owner and hence its author.[2]

There are more direct levels of fraud, however, especially with the work of well-known artists. These range from the situation in which a work by the 'name' painter may be not by them, but by relatives or others in their community copying their style, and attributed as the main painter's work by dealers, to the out-and-out copying of paintings by white forgers.

Choosing the real thing
How prevalent is this practice and how is the potential buyer guaranteed of purchasing a genuine work? First, we should not automatically consider all Aboriginal art as potentially problematic. As in non-Aboriginal art, an artist's work is only

copied when there is a sizeable sum of money to be made. As, in Aboriginal art, this applies to only a small percentage of top artists, the great majority of work sold is absolutely legitimate.

In 2000 an authenticity labelling system was introduced but not all galleries need or abide with its use. Documentation from the official artists' cooperative of the community where the work has been made is a good guarantee—although unfortunately there have also been a small number of fraudulent certificates found. Most reputable galleries offer this as a matter of course. Such certificates of authenticity will state, as well as the artist's name, the title of the work, a diagram of it and its story, the community in which it was produced, and the number and year of the work.

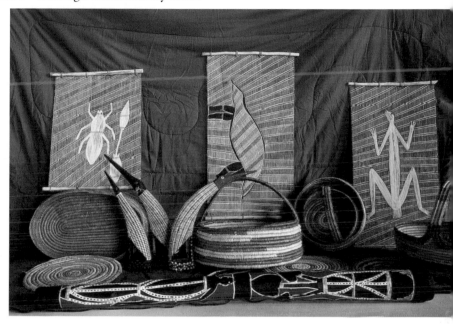

In many areas, however, there is no artists' cooperative and artists work directly through wholesale dealers. So, the lack of an authenticity certificate does not in itself mean that the work is unauthentic. Many dealers have long-lasting relationships with artists to whom they may supply canvases and who sell work which is exactly what it says it is. In contrast, there are too many instances in which works are sold with meaningless 'authenticity' certificates.

ABOVE: This group of artefacts from various Top End communities shows the range and variety of craft produced.

How does one tell the difference? The most often heard advice from the gallery sector when offering guidance to the potential customer is to choose a reputable dealer. Sound advice, but how does one go about recognising a sound dealer from a plausible one? Education, getting to know some of those involved and, in the end, relying on your own instincts, knowledge of an artist's style and technique, and the qualities you respond to in the work are the only answers.

Where do you buy?

The volume of Aboriginal art on offer is vast. Alice Springs's Todd Mall has the largest concentration of galleries in Australia

specialising in Aboriginal art. Some fifteen or more jostle for attention along the short strip, flaunting everything from the wonderful to the mediocre to the downright sloppy. Melbourne's Flinders Lane/top end of Bourke Street area offers the other most concentrated collection of specialist galleries in that city, while Sydney's eight or so specialist galleries are more widely spread. Darwin has at least three major galleries of Aboriginal art and Broome at least two, as do Perth, Adelaide, Brisbane and Canberra. During the 1990s, a number of well known non-Aboriginal art specialist galleries began regularly including shows by Aboriginal artists in their exhibition programs.

Selecting where to buy of course depends on which works appeal (outlets for art from the major communities are identified within each section) and from whom you feel most comfortable buying.

Details of the major galleries are given on page 227.

Original prints—an inexpensive option

During the 1980s and 1990s, a number of collaborative print projects between skilled Western printmakers and Aboriginal artists yielded a wide variety of images. Etchings, screen prints, lithography and other forms of limited edition printmaking (different to the photographic reproductions commonly used for posters and 'look-alike' paintings) are an excellent method of acquiring exciting images for between $50 and around $350.

Major printmaking projects have included those organised by Adrian Newstead of Sydney's Coo-ee Gallery with various Kimberley and Arnhem Land communities and printmakers in the Northern Territory; the printmaking of Lockhart River's young artists; those initiated by the Kimberley's Waringarri Arts Centre; those by Yirrkala's Buku Larrngay Mulka arts centre with the printmaking department of the University of the Northern Territory, Darwin; and those initiated by Melbourne's Martin King, master printmaker with the Australian Print Workshop.

Buying for investment

If you are determined to buy art with the prime aim of making a return on investment, it is essential to do one of two things: you can employ the services of a consultant or you can embark upon an even more rigorous program of self-education—including charting the numbers and prices of works by whichever artists

you are interested in over some years. It should be noted, however, that art buying, even more so than the sharemarket, can be both a variable and a highly speculative business. The 'safe' way of investing is probably to come in at the mid to top end of the range and buy the best earliest works from the most highly regarded artists on the resale market—after, of course, being satisfied that the work is genuine.

A greater return can potentially be made from the more speculative purchase of works by the not so well known artists. This, however, requires both good instincts and courage.

Important, too, is to regard any art for investment's sake as a long-term proposition. One of the vagaries of the contemporary art market (which applies not only to Aboriginal art) is that the purchaser of a painting bought from an artist's exhibition of new work for 'x' amount of dollars is unlikely to be able to resell that painting instantly, or even in the short term, for the amount for which it was purchased—although some galleries do offer to buy back some works, or enable the purchaser to 'trade them in' for a work of equivalent or higher value. This practice is not common, however, and should never be assumed to exist.

It should also be noted that most art collectors who have ended up recouping from their investment have also been quite passionate about the art they acquire and have bought it not solely for its potential investment, but also because of the pleasure it brings.

Two of the most important questions you should ask yourself when deciding to buy are: Will this work continue to inspire/challenge/intrigue? Do I respect the artist and will it be a work I think I will want to look at time and time again?

Arts centres

Aputula Arts, CMB Finke, via Alice Springs NT 0872. Phone: 08 8956 0976 Fax: 08 8956 0900

Buku Larrngay Mulka Arts, Yirrkala, via Nhulunbuy NT 0880. Phone: 08 8987 1701 Fax: 08 8987 2701 Email: yirrkala-arts@octa4.net.au

Bula 'bula Arts, Ramingining PMB 161,Winellie NT 0822. Phone: 08 8979 7911 Fax 08 8979 7919 Email: bulabula@octa4.net.au

Elcho Island Arts & Crafts, Galwinku, Elcho Island NT 0822. Phone: 08 8987 9252 Fax: 08 8987 9074 Email: elchoart@alice.topend.com.au

Ernabella Arts Inc, PMB Ernabella, via Alice Springs NT 0872.
Phone: 08 8956 2954 Fax: 08 8956 7940 Email: ernabel@alice.topend.com.au

Hermannsburg Potters, c/- Ntaria School, PMB 4, Hermannsburg, via Alice Springs NT 0872. Phone: 08 8956 7414 Fax: 08 8956 7414 Email: potters@topend.com.au

Ikuntji Women's Centre, PMB Haasts Bluff, via Alice Springs NT 0872. Phone: 08 8956 8783 Fax: 08 8956 8783 Email: ikuntji@topend.com.au

Injalak Arts, PMB 131, Injalak via Darwin NT 0822. Phone: 08 8979 0190 Fax: 08 8979 0119

Jilamara Arts and Crafts, PMB 96, Milikapiti, via Winellie NT 0822. Phone: 08 8978 3901 Fax: 08 8978 3903 Email: jilamara@msn.com.au

Jukurrpa Artists, PO Box 8875, Alice Springs NT 0871. Phone: 08 8953 1052 Fax: 08 8953 1309 Email: jukart@ozemail.com.au

Keringke Arts, PMB Santa Teresa, via Alice Springs NT 0872. Phone: 08 8956 0956 Fax: 08 8956 0956

Lockhart River Arts and Culture Centre, C/- PO Lockhart, Qld, 4871.
Ph: 07 4060 7341 Fax: 07 4060 7341

Mangkaja Arts, PO Box 44, Fitzroy Crossing WA 6755. Phone: 08 9191 5272 Fax: 08 9191 5279 Email: Mangkaja_Arts@bigpond.au

Maningrida Arts and Culture, PMB 102, Winellie NT 0822. Phone: 08 8979 5946 Fax: 08 8979 5996 Email: gallery@maningrida.bu.aust.com

Maruka Arts & Crafts, CMA Ininti Store, via Ayers Rock NT 0872. Phone: 08 8956 2153 Fax: 08 8956 2410 Email:maruk@bigpond.com.au

Munupi Arts, Pularumpi, Melville Island NT 0822. Phone: 08 8978 3975 Fax: 08 8978 3975 Email: munupi@bigpond.com.au

Papunya Tula Artists Pty Ltd, PO Box 1620, 78 Todd Mall, Alice Springs NT 0872. Phone: 08 8952 4731 Fax: 08 8953 2509

Tiwi Designs, PMB 59, Winnellie NT 0822. Phone: 08 8978 3982 Fax; 08 8978 3982 Email:tiwitides@octa4.net.au

Urapuntja Artists of Utopia, PMB Utopia, PO Box 9219, Alice Springs, NT 0871. Phone: 08 8956 9506 Email: simon@urapuntja-artists.com

Warburton Arts Project, PO Box 71, Warburton Community, via Alice Springs NT 0872. Phone: 08 8954 0017 Fax: 08 8954 0047 Email: avwarts@bigpond.com

Waringarri Aboriginal Arts, Speargrass Road, PO Box 968, Kununurra WA 6743. Phone: 08 9168 2212 Fax: 08 9169 1044 Email: waaknx@agn.net.au

Warlukurlangu Aboriginal Artists Association, PMB 103, Yuendumu, via Alice Springs NT 0872. Phone: 08 8956 4031 Fax: 08 8956 4003 Email: warlu@ozemail.com.au

Warlayirti Artists, PMB 20, Balgo Hills, via Halls Creek WA 6770. Phone: 08 9168 8960 Fax: 08 9168 8889 Email: info@balgoart.org.au

Warmun Art Centre, PMB Turkey Creek, via Kununurra WA 6743. Phone: 08 9168 7496 Fax: 08 9169 7444 Email: warmunac@hobbit.com.au

Warnayaka Art Centre, CMB Lajamanu, via Katherine NT 0852. Phone/Fax: 08 8975 0330

Warumpi Arts, PO Box 2211, Alice Springs NT 0871. Phone: 08 8952 9066 Fax: 08 8956 9066 Email: warumpi@topend.com.au

Resource bodies

ANKAA, Frog Hollow Centre for the Arts, PO Box 2152, Darwin NT 0801. Phone: 08 8981 6134 Fax: 08 8981 6084 Email: ankaa@octa4.nct.au

Desart, PO Box 9219, Alice Springs NT 0821. Phone: 08 8953 4736 Fax: 08 8953 4517 Email: desart@ozemail.com.au

Recommended commercial art galleries

Specialist Aboriginal art galleries.

Aboriginal & Pacific Art*, 8th Floor, Dymock's Building, 428 George St, Sydney NSW 2000. Phone: 02 9223 5900 Fax: 02 9223 5959 Stocks a range of contemporary and early Aboriginal art.

Aboriginal Art Galleries of Australia*, 35 Spring St, Melbourne Vic 2000. Phone: 03 9654 2516 Fax: 03 9654 3534 Email: gallery@unite.com.au Shows regular displays of Central Desert art by major artists.

Aboriginal Art Print Network, 68 Oxford St, Darlinghurst, Sydney NSW 2010. Phone: 02 9332 1722 Fax: 02 9332 2001 Email: art@aboriginalartprints.com.au Represents a huge range of printworks from indigenous artists in all parts of Australia.

Aboriginal Desert Art Gallery*, 87 Todd Mall, Alice Springs NT 0870. Phone: 08 8953 1005 Fax: 08 8952 8915 Holds some of the largest stocks of Aboriginal paintings and artefacts in Alice Springs.

Aboriginal Fine Arts Gallery*, 1st Floor, Cnr Mitchell & Knuckey Sts, Darwin NT 0801. Phone: 08 8981 1315 Fax: 08 8981 1571 Email: aais@aaia.com.au Stocks a large range of good quality barks and other paintings from Arnhem Land communities as well as canvases from the Central Desert and the Kimberley.

Aboriginal Gallery of Dreamings*, 73–75 Bourke St, Melbourne Vic 3000. Phone: 03 9650 3277 Fax: 03 9650 3437 email: agod@bluep.com

Stocks a vast and interesting variety of works mainly from leading Central Desert artists.

Alcaston Gallery, 2 Collins St, Melbourne Vic 3000. Phone: 03 9654 7279 Fax: 03 9 650 3199 Email: info@alcastongallery.com.au Represents Ngukurr artists Ginger Riley and Djambu Barra Barra; Utopia/Adelaide artist Kathleen

DIRECTORY
of arts centres and art galleries

Petyarre; artists from Jilamara Arts, Melville Island; Hermmansburg Potters; Lajamanu and some Papunya artists.

Alison Kelly Gallery*, 845 High St, Armadale, Melbourne Vic 3143. Phone: 03 9500 9214 Fax: 03 9500 9724 Email: ak@alisonkellygallery.com One of Melbourne's newest indigenous art specialist galleries. Presents a wide range of good quality works from well established and newer artists from the Central Desert and Arnhem Land.

Ancient Earth*, Pier Marketplace, Pierpoint Rd, Cairns Qld 4870. Phone: 07 4051 0211 Fax: 07 4041 4544 Email: info@ancientearthart.com.au Sells good quality indigenous art from around Australia.

Andrew Baker Art Dealer, 8 Proe St, Fortitude Valley, Brisbane Qld 4006. Phone: 07 3252 2292 Email: info@andrew-baker.com. Features work by Lockhart River's artists amongst those of contemporary non-indigenous artists.

Aniyinginyi Arts, Stuart Highway, Tennant Creek NT 0860. Phone: 08 8962 2593 Fax: 08 8962 2594. Email: arts@anyinginyi.com.au

Aboriginal-owned, acts as a workshop and represents artists from the Barkly Tableland area.

Annandale Galleries, 110 Trafalgar St, Annandale, Sydney NSW 2038. Phone: 02 9552 1699
Fax: 02 9552 1689 Email: annandale@ozemail.com.au
Specialising in contemporary art. Shows also Arnhem Land's Yirrkala's 'big bark' paintings.

Artplace, Upstairs, 52 Bayview Terrace, Claremont, Perth WA 6010. Phone: 08 9384 6964
Fax: 08 9384 3432 Email: artplace@iinet.net.au
Holds regular mixed and individual exhibitions of Australian indigenous and non-indigenous contemporary works including the work of Butcher Cherel, Mulgra Jimmy Nerrimah and Julie Dowling.

Australian Print Workshop, 210 Gertrude St, Fitzroy Melbourne Vic 3065. Phone: 03 9419 5466
Fax: 03 94175325 Email: ausw@bigpond.com
Supports print making workshops and editions prints for several Aboriginal communities including Fitzroy Crossing's Mangkaja Arts, Melville Island's Jilamara Arts and artists of the Kalumbaru and Port Keats areas. Stocks a good range of prints.

Bett Gallery Hobart, 369 Elizabeth St, North Hobart Tas 7004. Phone: 03 6231 6511
Fax: 03 6231 6521 Email: dick@bettgallery.com
A leading exhibitor of contemporary non-indigenous work, one of the few in Tasmania to show the work of contemporary Aboriginal artists.

Boomalli Aboriginal Artists Co-Operative Ltd*, 191 Parramatta Rd, Annandale, Sydney NSW 2038.
Phone: 02 9560 2541 Fax: 02 9560 2566
Email: boomalli@optus.net.au
Aboriginal owned and managed. Represents a number of urban Aboriginal artists in solo and group exhibitions.

Chapman Gallery, 31 Captain Cook Cr, Manuka, Canberra ACT 2603. Phone: 02 6295 2550
Shows works by non-Aboriginal contemporary Australian artists as well as exhibitions by leading Aboriginal artists.

Coo-ee Aboriginal Art Gallery*, 98 Oxford St, Paddington, Sydney NSW 2021.
Phone: 02 9332 1544 Fax: 02 9360 1109
Email: cooeemp@ozemail.com.au
Stocks a large range of works by leading Aboriginal artists—especially those from the desert and Kimberley communities. Also stocks limited edition prints, fabric and artefacts.

DACOU Aboriginal Gallery*, Unit 1, 38-46 Barndioota Rd, Salisbury Plain, Adelaide SA 5001.
Phone: 08 8258 8610 Fax: 08 8258 4842
Email: dacou@dacou.com.au
Open by appointment and a supplier to other galleries also. Stocks a large range of Aboriginal works from the Utopia region including Emily Kame Kngwarreye, Gloria Petyarre, Greeny Petyarrre, Minnie Pwerle, Barbara Weir.

Desart Gallery, 4 Towns Rd, Rose Bay, Sydney NSW 2030. Phone: 02 9337 3577
Fax: 02 9388 8130 Email: desart@optusnet.com.au
Also at the cnr Stott Terrace & Bath Sts, Alice Springs NT 0870. Phone: 08 8953 6227
Fax: 08 8953 4517 Email: desart@ozemail.co.au
Set up by the resource group Desart, which represents over 30 Central Australian Aboriginal communities. Shows their work in individual shows and has a well stocked showroom.

Desert Designs Japingka Gallery*, 47 High St, Fremantle, Perth WA 6160. Phone: 08 9335 8265
Fax: 08 9335 8275 Email: japingka@linet.net.au
Opened to display the work of the Kimberley's Jimmy Pike. Stocks a wide range of indigenous art.

Duncan Kentish Fine Art, PO Box 629, North Adelaide SA 5006.
Phone: 08 8269 5153 Fax: 08 8342 5457
Open by appointment only. Represents the work of Kimberley and other artists including Jarinyanu David Downs, Jimmy Mulga Nerrima, Pijaju Peter Skipper and Butcher Cherel.

Fire-Works Gallery*, 678 Ann St, Fortitude Valley, Brisbane Qld 4006.
Phone: 07 3216 1250 Fax: 07 3216 1251

Email: fireworks@fireworksgallery.com.au
A large gallery which represents artists from Central Desert, Kimberley and Arnhem Land communities as well as some urban based artists.

Flinders Lane Gallery, 137-39 Flinders Lane, Melbourne Vic 3000. Phone: 03 9654 3332
Fax: 03 9650 8508 Email: heitlinger@bigpond.com.au
Included in its regular displays of contemporary Australian work are exhibitions and good stocks of work by Utopia and other indigenous artists.

Framed—the Darwin Gallery*, 55 Stuart Highway, Stuart Park, Darwin NT 0820. Phone: 08 8981 2994
Fax: 08 8941 0883 Email: framed@topend.com.au
A large gallery which represents artists from most Aboriginal Central Desert, Kimberley, Arnhem Land communities.

Gallerie Australis*, Forecourt Plaza, Hyatt Regency, North Terrace, Adelaide SA 5000.
Phone: 08 8231 4111 Fax: 08 8231 6616
Holds regular exhibitions and stock of artists from the Central Desert and Kimberley including Utopia artists Kathleen Petyarre and Abbie Loy, artists from the Balgo Hills community and Ernabella Arts.

Gallery Gabrielle Pizzi,*141 Flinders Lane, Melbourne Vic 3000. Phone: 03 9654 2944 Fax: 03 9650 7087 Email: gabrielle@gabriellepizzi.com.au
Shows works by many leading community centres as well as leading urban Aboriginal artists. Holds exhibitions internationally.

Gallery Gondwana*, 43 Todd Mall, Alice Springs NT 0871. Phone: 08 8953 1577 Fax: 08 8953 2441
Email: rpremont@ozemail.com.au
Stocks both a wide range of fine quality Aboriginal paintings and artefacts from the Central Desert, Kimberley and some Arnhem Land communities. Holds solo exhibitions by artists such as Dorothy Napangardi and 'Dr' George Tjapaltjarri, as well as group exhibitions of both newer and well established art producing centres.

Gallery Savah, 20 Glenmore Road, Paddington, Sydney NSW 2021. Phone: 02 9360 9979

Fax: 02 9331 6993 Email: savah@savah.com.au
Included in an exhibition program which includes the work of leading non-indigenous Australian artist, are works by leading Utopia artists.

Helen Maxwell Gallery, Level 1, 42 Mort St, Braddon, Canberra ACT 2612. Phone: 02 6257 8422
Fax: 02 6257 8424 Email: cmax@interact.net.au
Exhibitions of Aboriginal art are held alongside that of other contemporary Australian artists.

Hogarth Galleries/Aboriginal Arts Centre*, 7 Walker Lane (opp Liverpool St), Paddington, NSW 2021. Phone: 02 9360 6839
Fax: 02 9360 7069 Email: hogarthgal@bigpond.com
One of the earliest Sydney galleries to show the work of Aboriginal artists, it continues to hold regular exhibitions by major artists from the Central Desert, Kimberley and Arnhem Land.

Indigenart*, 115 Hay Street, Subiaco, Perth WA 6008. Phone: 08 9388 2899 Fax: 08 9381 1708
Email: gallery@indigenart.com.au
This large gallery shows and stocks a wide range of work by established Kimberley, Central Desert, Arnhem Land and urban-based artists, as well as that of emerging artists and communities.

Jinta Desert Art*, 120 Clarence St, Sydney, NSW 2000 Phone: 02 9290 3639 Fax: 02 9290 3931
Email: jinart@zip.com.au
Stocks a wide range of Central Desert and other works by leading artists.

Karen Brown Gallery, NT House, 1/22 Mitchell St, Darwin NT 0800. Phone: 08 8981 9985
Fax: 08 8981 9649 Email: karen.brown@octa4.net.au
Represents individual artists of Ngukurr and Lajamanu and other selected artists.

Kimberley Art*, 76 Flinders Lane, Melbourne Vic 3000 Phone: 03 9654 5890 Fax: 03 9654 6419
Email: flash@kimberleyart.com.au
Holds regular exhibitions and stocks the works of major artists from the Kimberley, the Central Desert and Arnhem Land.

Lauraine Diggins Fine Art, 5 Malakoff St, Caulfied,

Melbourne, Vic 3000. Phone: 03 9509 9855
Fax: 03 9509 4549 Email: ozart@eisa.net.au
Includes the work of Aboriginal artists in its regular
exhibitions by leading historical and contemporary
Australian artists.

Niagara Galleries, 245 Punt Road, Richmond,
Melbourne Vic 3141. Phone: 03 9429 3666 Fax: 03
9428 3571 Email: mail@niagara-galleries.com.au
Leading contemporary Australian art gallery. Includes
the work of select Aboriginal artists such as Utopia's
Angelina Pwerle, Warmun's Lena Nyadbi and
Lockhart River's Fiona Oomenyeo.

Northern Editions, School of Art & Design, NT
University, Darwin NT 0809. Phone: 08 894 66325
Fax: 08 894 66599
Email: northern.editions@ntu.edu.au
A leading printmaking school which has established
excellent working relationships with many
communities and sells an extensive range of prints.

Michel Sourgnes Fine Arts, 16 Stevenson St, Ascot,
Brisbane Qld 4007. Phone: 07 3868 2454
Fax: 07 3868 2428 Email: sourgnes@doc.net.au
Represents the work of several communities
including Ramingining's Bula'bula.

Ochre Gallery, 5E/26 Wellington St, Collingwood,
Melbourne Vic 3066. Phone/Fax: 03 9419 9985
Email: ochregallery@bigpond.com.au
Holds exhibitions and stocks works by Balgo Hills
artists, Central Desert and Kimberley artists.

Papunya Tula Artists Pty Ltd*, 78 Todd Mall, Alice
Springs NT 0872 Phone: 08 89 524 731
Fax: 08 89 532 509
Owned by the artists, this is the official outlet for
works from Papunya and represents several hundred
artists including all the leading Papunya painters.

Quadrividium, 2–50 Gallery Level 2, South Queen
Victoria Building, George St, Sydney NSW 2000
Phone: 02 9331 1919 Fax: 02 9331 5609
Email: quadrividium@bigpond.com.au
A pleasant space in this historic building combines
indigenous art with that of other contemporary

Australian art and craft.

Rainbow Serpent Gallery, 4 Towns Rd, Vaucluse,
Sydney NSW 2030. Phone: 02 9388 7684 Fax: 02
9337 2893 Email sales@rainbowserpent.com.au
Has three airport outlets for indigenous work as well
as stocking a good range of works and holding
regular exhibitions at its Sydney gallery.

Raintree Aboriginal Art Gallery*, 20 Knuckey St,
Darwin NT 0820. Phone: 08 8941 9933
Fax: 08 8981 1072
Holds large stocks of Arnhem Land and Central
Desert paintings as well as a variety of artefacts.

Red Rock Art, 223 Victoria Highway, Kununurra
WA 6743. Phone: 08 9169 3000 Fax: 08 9168 2607
Email: kevin@redrockgallery.com
A workshop and gallery which shows the work of
around fifteen Kimberley artists who paint for Red
Rock.

Short Street Gallery, 25 Carnavon St, Broome
WA 6275.
Phone/Fax: 08 9192 2658 Email: shortst@iinet.net.au
A small but impressive gallery. Shows the latest works
by Kimberley, Lockhart River and some Central
Desert artists.

Sutton Gallery, 254 Brunswick St, Fitzroy Vic 3068
Phone: 03 9416 0727 Fax: 03 9416 0731
A leading contemporary Australian gallery. Shows
Gordon Bennett as well as occasional exhibitions of
works from communities and acts as a representative
for major buyers of indigenous art at auction and in
the secondary market.

Tineriba Tribal Gallery, 77–79 Main St, Hahndorf
SA 5345. Phone/Fax: 08 8388 7218
Email: tineriba@bukartilla.com.au
Represents the work of Warmun artists as well as
some Central Australian artists and works of other
communities.

Tribal and Asian Art, 2 Cascade St, Paddington,
NSW 2021. Phone: 02 9331 8302 Fax: 02 9331 8306
Concentrates on older artefacts, paintings and objects
from Australia and Papua and New Guinea.

Tony Bond—Art Dealer, 358 Unley Road, Unley Park, Adelaide SA 5061. Phone: 08 8272 2232 Fax: 08 8357 8880 Email: tonybond@saenet.com.au Shows a selection of works by leading Central Desert Pintupi as well as older artefacts and bark paintings.

Utopia Art*, 2 Danks Street, Waterloo, Sydney NSW 2017. Phone: 02 9699 2900 Fax: 02 9699 2988 Originally established to represent artists from the Utopia area, this gallery has broadened to show the work of other leading Central Desert artists and works by newer art movements.

Vivien Anderson Gallery*, 470 Dandenong Road, Caulfield North, Vic. 3161. Phone: 03 9509 3138 Fax: 03 9509 3138 Email: vivien@comcen.com.au Shows the work of a wide variety of contemporary indigenous artists such as Trevor Nickolls, Dorothy Napangardi, Walawala Tjapaltjarri and Lockhart River's Samantha Hobson.

William Mora Galleries, 60 Tanner Street, Richmond, Melbourne Vic 3121. Phone: 03 9429 1199 Fax: 03 9429 68333 Email: mora@moragalleries.com.au Amongst its stable of leading contemporary Australian artists, shows the work of artists from communities such as Papunya Tula, Buku Larrngay and Warlayirti Artists.

Selected public galleries & museums

Australia's six major state and territory art galleries and the National Gallery of Australia have collections of modern indigenous art, but generally only small numbers of pre-1960s art and artefacts. The exception is the Art Gallery of New South Wales which holds material from indigenous field expeditions during the 1940s–50s.

Most of the early material collected by missionaries, representatives of museums and other ethnographers from the late 1800s resides in Australia's museums. Objects collected by these expeditions include secular barks and carvings and utilitarian objects, some materials used for ceremonial purposes, and articles of war and hunting.

Araluen Arts Centre, Larapinta Drive, Alice Springs NT 0870. Phone: 08 8951 1120 Features an Albert Namatjira gallery and holds regular exhibitions of Central Desert art.

Art Gallery of New South Wales, Art Gallery Road. Sydney, NSW 2000. Phone: 02 9225 1700 Holds important collections of 1950s–60s Arnhem Land works as well as Yiribana Gallery dedicated to a changing display of Aboriginal works.

Art Gallery of South Australia, North Terrace, Adelaide SA 5000. Phone: 08 8207 7000 Contains early (1947) collection of Yirrkala and Groote Eylandt works as well an important collection of early 1970s Papunya works and numerous works since.

Art Gallery of Western Australia, Perth Cultural Centre, James St Mall, Perth, WA 6000. Phone: 08 9492 6600. Contains a good collection of contemporary Aboriginal art, especially from the Central Desert and Western Australia.

Australian Museum, 6 College Street, Sydney NSW 2000. Phone: 02 9320 6000 Contains extensive Arnhem Land and other collections from the early 1900s.

Museum and Art Gallery of the Northern Territory, Conacher St, Fannie Bay, Darwin NT 0820. Phone: 08 8999 8201 Due to its long standing policy of collecting Aboriginal art contemporaneously, has one of the largest and most significant collections of Aboriginal works. Numbering around 5000 it includes 1300 bark paintings and over 200 early Papunya works, as well as numerous other examples of indigenous art, sculptures and weaving.

Museum of Contemporary Art, Circular Quay, The Rocks, Sydney, 2000. Phone 02 9252 4033 Contains a large collection of Maningrida and Ramingining works.

Museum Victoria, Nicholson Street, Carlton, Melbourne Vic 3053. Phone: 03 9292 2172

Contains important ethnographic collections including Central Australian artefacts and Northern Territory barks, as well as modern paintings and artefacts and Koori material from Victoria's indigenous population. Housed in an adventurous new building opened in 2000.

National Gallery of Australia, Parkes Place, Canberra ACT 2600. Phone: 02 6240 6411
Contains important collections of Arnhem Land, Kimberley and Central Desert works from the 1960s onwards, including the 200 work Aboriginal Memorial and a significant Rover Thomas collection.

The National Gallery of Victoria, Melbourne Vic. Closed for redevelopment until mid-2002 when it will open its 'Ian Potter: NGV Australian Art' gallery in Federation Square with a large ground floor display area devoted to its 1000 plus indigenous collection.

National Museum of Australia: First Australians: Gallery of Aboriginal and Torres Strait Islander Peoples, Acton Peninsula, Canberra ACT 2601. Phone: 02 6208 5370

Opened in mid-2001, in a large new building, the indigenous section of this national institution offers one of the most comprehensive displays of historical and contemporary indigenous art and artefacts in Australia.

Queensland Art Gallery, Queensland Cultural Centre, South Bank, Brisbane Qld 4101. Phone: 07 3840 7303
Contains a growing collection of largely modern Aboriginal works from all over Australia.

South Australian Museum, North Terrace, Adelaide SA 5000 Phone: 08 8207 7500.
A redesigned indigenous art display opened in 2000 containing a vast selection of elegantly-displayed historical artefacts and information about South Australia's indigenous population.

Tandanya Aboriginal Cultural Centre, 253 Grenfell St, Adelaide SA 5000.
Phone: 08 8224 3200 National Aboriginal cultural centre devoted to the display of Aboriginal works from around Australia through numerous changing exhibitions and sales outlet.

Aboriginal Art Galleries of Australia. *Shimmer*. Exhibition catalogue. Melbourne, 1997.

Aboriginal Art Galleries of Australia. *Tjinytjilpa: The Dotted Design*. Catalogue. Melbourne, 1998.

Amadio, N., J. Jones, D. Thomas & A. Blackwell. *Albert Namatjira: The Life and Work of an Australian Artist*. Macmillan, Melbourne, 1986.

Amadio, N. & R. G. Kimber. *Wildbird Dreaming: Aboriginal Art from the Central Desert*. Greenhouse Publications, Melbourne, 1987.

Art & Australia. Special Aboriginal issues. 13 Apr. 1976; 16 Apr. 1979; and 31 Jan. 1993.

Art Gallery of New South Wales. *Fluent*. La Biennale de Venezia, 15 June–9 November, 1997. Art Gallery of New South Wales, Sydney, 1997.

Artlink. Special Aboriginal issue. Autumn/Winter 1990 (reprinted 1992).

Bardon, G. *Papunya Tula: Art of the Western Desert*. McPhee Gribble/Penguin Books, Melbourne, 1991.

Battarbee, R. *Modern Australian Aboriginal Art*. Angus & Robertson, Sydney, 1951.

Berndt, R. (ed.). *Australian Aboriginal Art*. Collier-Macmillan, UK, & Ure Smith, Sydney, 1964.

Boulter, M. *The Art of Utopia: A New Direction in Contemporary Aboriginal Art*. Craftsman House, Sydney, 1991.

Buku Larnnggay Mulka. *Saltwater: Paintings from Yirrkala*, 1999.

Caruana, W. *Aboriginal Art*. Thames & Hudson, London, 1993.

Caruana, W. (ed.). *The Painters of the Wagilag Sisters Story 1937–1997*. NGA, Canberra, 1997.

Caruana, W. (ed.). *Windows on the Dreaming*. National Gallery of Australia, Canberra, & Ellsyd Press, Sydney, 1989.

Cowan, J. *Two Men Dreaming: A Memoir, A Journey*. Brandl & Schlesinger, Sydney, 1995.

Cowan, J. *Wiramanu: The Art of Balgo Hills*.

Craftsman House, Sydney, 1995.

Crawford, I. M. *The Art of the Wandjina: Aboriginal Cave Paintings in the Kimberley, Western Australia*. Oxford University Press, Melbourne, 1968.

Crumlin, R & A. Knight. *Aboriginal Art and Spirituality*. Dove Publications, Harper and Collins, Melbourne, 1991 (reprinted 1992, 1995).

RECOMMENDED READING

DESART: Aboriginal Art and Craft Centres of Central Australia. DESART, Alice Springs, 1993.

Ebes, H. *Nangara: The Australian Aboriginal Art Exhibition*. Exhibition catalogue. The Ebes collection, Melbourne, 1994.

Edwards, R. (ed.). *Aboriginal Art in Australia*. Ure Smith, Sydney, 1978.

Edwards, R. & A. & the Lockhart River Art Gang. *An Explorer's Guide to Lockhart River*, Lockhart River Arts and Culture Centre, 1999.

Horton, David et al. (eds), *The Encyclopedia of Aboriginal Australia*. Institute of Aboriginal Studies, Canberra, 1994.

Isaacs, J. *Aboriginality: Contemporary Aboriginal Paintings and Prints*. University of Queensland Press, Brisbane, 1989.

Isaacs, J. *Aboriginal Paintings*. Weldon Publishing, Sydney, 1989.

Isaacs, J. *Australia's Living Heritage: Arts of the Dreaming*. Lansdowne Press, Sydney, 1984.

Isaacs, J., T. Smith, J. Ryan, D. Holt & J. Holt. *Emily Kngwarreye Paintings*. Craftsman House, 1998.

Jilamara Arts & Crafts Association & Munupi Arts & Crafts Association. *Tiwi People of Melville Island.* 1994.

Johnson, V. *Aboriginal Artists of the Western Desert: A Biographical Dictionary.* Craftsman House, Sydney, 1994.

Johnson, V. *The Art of Clifford Possum Tjapltjarri.* Craftsman House, Sydney, 1996.

Johnson, V. *Dreamings of the Desert: A History of Western Desert Art, 1971–1996.* Art Gallery of South Australia, Adelaide, 1996.

Johnson, V. *Michael Jagamara Nelson.* Craftsman House, Sydney, 1997.

Kleinert, S. & Neale, M., (eds.) *Oxford Companion to Aboriginal Art and Culture,* Oxford University Press, Melbourne, 2000.

Layton, Robert. *Rock Art: A New Synthesis.* Cambridge University Press, Cambridge, UK, 1992.

Lockhart River Art Gang, *The Message Stick: Art from North Queensland's Lockhart River Community,* 2000.

Lowe, P. & J. Pike. *Jilji: Life in the Great Sandy Desert.* Magabala Books, Broome, 1992.

Luthi, Bernard (ed.). *Aratjara: Art of the First Australians. Traditional and Contemporary Work by Aboriginal and Torres Strait Islander Artists.* Exhibition catalogue. Aboriginal Arts Board of the Australia Council. Bernhard Luthi & Gary Lee, Germany, 1993.

McLean, I. & G. Bennett. *The Art of Gordon Bennett.* Craftsman House, Sydney, 1996.

McGuigan, C. (ed.). *New Tracks Old Land: Contemporary Prints from Aboriginal Australia.* Exhibition catalogue. Aboriginal Arts Management Association, Sydney, 1992.

Morgan, S. (introduction by Jill Milroy). *The Art of Sally Morgan.* Viking/Penguin Books, Melbourne, 1996.

Morphy, H. *Aboriginal Art,* Phaidon, London, 1999.

Mountford, C. *Nomads of the Australian Desert.* Rigby, Adelaide, 1976.

Museum & Art Gallery of the Northern Territory. *Hermmansburg Potters.* Exhibition catalogue. Museum and Art Gallery of the Northern Territory, 1996.

Museum & Art Gallery of the Northern Territory. *National Aboriginal & Torres Strait Islander Art Awards.* Annual catalogues, 1990–.

Neale, M. (ed.) *Urban Dingo: The Art and Life of Lin Onus 1948-1996,* Queensland Art Gallery, 2000.

Neale, M. (ed.). *Emily Kame Kngwarreye—Alhalkere: Paintings from Utopia.* Queensland Art Gallery/Macmillan Australia, Melbourne, 1998.

Neale, M. *Yiribana.* Catalogue of the Aboriginal and Torres Strait Islander Art collection. Art Gallery of New South Wales, Sydney, 1992.

O'Ferrall, M. *Jimmy Pike: Desert Designs, 1981–1995.* Art Gallery of Western Australia, Perth, 1995.

O'Ferrall, M. *Tjukurrpa—Desert Dreamings: Aboriginal Art from Central Australia 1971–1993.* Art Gallery of Western Australia, Perth, 1993.

Perkins, H. *Aboriginal Women's Exhibition.* Exhibition catalogue. Art Gallery of New South Wales, Sydney, 1991.

Perkins, H. & Fink, H. *Papunya Tula: Genesis and Genius,* Art Gallery of New South Wales, Sydney, 2000.

Ryan, J. *Images of Power: Aboriginal Art of the Kimberley.* National Gallery of Victoria, Melbourne, 1993.

Ryan, J. *Mythscapes: Aboriginal Art of the Desert.* National Gallery of Victoria, Melbourne, 1989.

Ryan, J. *Spirit in Land: Bark Paintings from Arnhem Land.* National Gallery of Victoria, Melbourne, 1991.

Sayers, A. *Aboriginal Artists of the Nineteenth Century*. Oxford University Press, Melbourne, 1994.

Smith, Heide. *Tiwi: The Life and Art of Australia's Tiwi People*. Edition Books, Sydney, 1996.

Sotheby's Australia. *Contemporary and Aboriginal Art*, sale catalogue, Melbourne, 18 June 1995; *Fine Aboriginal and Contemporary Art*, sale catalogue, Melbourne 17 June, 1996; *Fine Contemporary and Aboriginal Art*, sale catalogue, Melbourne, 5 October, 1994; *Fine Contemporary and Aboriginal Art*, sale catalogue, Melbourne, 28 November 1995; *Fine Tribal Art and Aboriginal Paintings*, annual sale catalogues, Sydney, 1992–; *Important Aboriginal Art*, sale catalogue. Melbourne, 30 June 1997; *Important Aboriginal Art*, sale catalogue, 29 June 1998; *Important Aboriginal Art*, 28 June 1999; *Aboriginal Art*, 26–27 June 2000; *Aboriginal Art*, 9 July 2001.

Stanton, J. E. *Painting the Country: Contemporary Aboriginal Art from the Kimberley Region*. University of Western Australia Press, Perth, 1989.

Strocchi, M. (ed.). *Ikuntji: Paintings from Haasts Bluff 1992–1994*. IAD Press, Alice Springs, 1994.

Sutton, P. (ed.). *Dreamings: The Art of Aboriginal Australia*. Viking, New York, 1988.

Thomas, Rover with K. Akerman, M. Macha, W. Christensen & W. Caruana. *Roads Cross*. Exhibition catalogue. National Gallery of Australia, Canberra, 1994.

Tweedie, P. *Spirit of Arnhem Land*. Australian Geographic, Sydney, 1998.

Wallace, D., M. Desmond & W. Caruana. *Flash Pictures*. Exhibition catalogue. National Gallery of Australia, Canberra, 1991.

Walsh, G., E. J. Brill & R. Brown. *Australia's Greatest Rock Art*. Bathurst, 1988.

Warby, J. *You-me Mates eh!*, Cairns, Qld, 1999.

Warlukurlangu Artists. *Kurawarri: Yuendumu Doors*. Aboriginal Studies Press, Canberra, 1992.

Wedge, H. *Wiradjuri Spirit Man*. Craftsman House, Sydney, 1996.

West, M. (ed.). *The Inspired Dream: Life as Art in Aboriginal Australia*. Museum and Art Gallery of the Northern Territory, Darwin, 1988.

West, M. *Rainbow Sugarbag and Moon: Two Artists of the Stone Country—Bardayal Nadjamerrek and Mick Kubarkku*. Museum and Art Gallery of the Northern Territory, Darwin, 1995.

Preface

1. D. Langsam, *Art Monthly*, March 1996.
2. Ibid., p. 21.
3. Ibid., p. 22.

Introduction

1 G. Bardon, *Papunya Tula: Art of the Western Desert*, McPhee Gribble/Penguin, Melbourne, 1991, p. 19.
2. Ibid., p. 20.
3. V. Johnson, *Dreamings of the Desert*, Art Gallery of South Australia, Adelaide, 1996, p. 22.
4. As told to art adviser John Kean in 1984, 'Dreamtime and modern painting', in ed. P. Sutton, *Dreamings: The Art of Aboriginal Australia*, Viking, New York, p. 102.
5. B. Smith & T. Smith, *Australian Painting*, Oxford University Press, Melbourne, 1992, p. 120.
6 C. Mountford, *Nomads of the Australian Desert*, Rigby, Adelaide, 1976, pp. 95–96.
7 P. Sutton (ed.), *Dreamings: The Art of Aboriginal Australia*, Viking, New York, 1988, p. 24.
8. Bardon, *Papunya Tula*, p. 36.
9. Interview with the author, 1996.
10. Ibid.
11. Interview with the author, 1997.
12. Ibid.
13. Ibid.
14. V. Johnson, *Dreamings of the Desert*, p. 89.
15. V. Johnson, *Aboriginal Artists of the Western Desert: A Biographical Dictionary*, Craftsman House, Sydney, 1994, p. 36.
16. C. Mountford, in *Australian Aboriginal Art*, Ure Smith, Sydney, 1964, p. 21.
17. Tony Tuckson, ibid., p. 63.
18. H. Morphy, *Artlink*, special Aboriginal issue, Autumn/Winter 1988 (reprinted 1990).

Central and Western Desert

Introduction

1. A. Brody, *Utopia: A Picture Story*, Heytesbury Holdings, Perth, 1990, p. 12.

Papunya

1. G. Bardon, Papunya *Tula: Art of the Western Desert*, McPhee Gribble/Penguin, Melbourne, 1991, p. 21.
2. G. Bardon, in J. Ryan, *Mythscapes: Aboriginal Art of the Desert*, National Gallery of Victoria, Melbourne, 1990, p. 85.

Yuendumu

1. Geraldine Tyson, assistant art coordinator Yuendumu, in interview with author, April 1996.
2. Paddy Stewart, Japaljarri, in *Yuendumu Doors: Kuruwarri*, Aboriginal Studies Press, Canberra, 1992, p. 3.
3. E. Michaels, ibid. p. 135.
4. Interview with the author, Yuendumu, April 1995.
5. Ibid.
6. W. Caruana, *Aboriginal Art*, Thames & Hudson, London, 1993, p. 155.

Utopia

1. A. M. Brody, *Portrait of the Outside*, in ed. M. Neale, *Emily Kame Kngwarreye—Alhalkere: Paintings from Utopia*, Queensland Art Gallery and Macmillan, Melbourne, 1997, p. 10.
2. Conversation with the author, Utopia, September 1996.
3. Brody, *Utopia: A Picture Story*, Heytesbury Holdings, Perth, 1992, pp. 24–25, and A. Brody, in ed. M. Neale, *Emily Kame Kngwarreye—Alhalkere: paintings from Utopia*, Queensland Art Gallery and Macmillan, Melbourne, 1997, p. 13.
4. Interview with the author, 1995.
5. Interview with the author, August 1995.
6. E. Kngwarreye, in ed. M. Neale. *Emily Kame Kngwarreye—Alhalkere: Paintings from Utopia*, Queensland Art Gallery and Macmillan, Melbourne, 1997, p. 10.

Lajamanu

1. J. Ryan, *Mythscapes: Aboriginal Art of the Desert*, National Gallery of Victoria, Melbourne, 1993, p. 11.
2. V. Johnson, *Aboriginal Artists of the Western Desert: A Biographical Dictionary*, Craftsman House,

Sydney, 1994, p. 38.

Ernabella

1. V. Johnson, *Dreamings of the Desert*, Art Gallery of South Australia, Adelaide, 1997, p. 90.

Hermannsburg

1. J. Keane & M. West (eds), 'Lyate Nwerne Urrkngell Mpareme (now we are working with clay),' *Hermannsburg Potters*, 1996, p. 9.

2. Ibid., pp. 6–7.

Haasts Bluff

1. M. Strocchi (ed.), *Ikuntji: Paintings from Haasts Bluff 1992–94*, IAD Press, Alice Springs, 1994, p. 12.

2. Ibid., p. 6.

Kimberley

Kimberley introduction

1. J. Ryan, *Images of Power: Aboriginal Art of the Kimberley*, National Gallery of Victoria, Melbourne, 1993, p. 3.

2. Interview with the author, October 1996.

3. *Footprints across Our Land*, Magabala Books, Broome, 1995, p. 118.

4. J. Ryan, *Images of Power*, p. 40.

Warmun

1. Interview with the author, 1995.

2. J. Ryan, *Images of Power: Aboriginal Art of the Kimberley*, National Gallery of Victoria, Melbourne, 1993, p. 44.

Kalumburu

1. A. Elkin, in ed. R. Berndt, *Australian Aboriginal Art*, Collier-Macmillan, UK, 1964, p. 15.

2. J. Ryan, *Images of Power: Aboriginal Art of the Kimberley*, National Gallery of Victoria, Melbourne, 1993, p. 15.

Fitzroy Crossing

1. J. Ryan, *Images of Power: Aboriginal Art of the Kimberley*, National Gallery of Victoria, Melbourne, 1993, p. 66.

2. M. O'Ferrall, & J. Pike, *Jimmy Pike: Desert Designs 1981–1995*, Art Gallery of Western Australia,

1995, p. 10.

3. Ibid., p. 11.

Arnhem Land

Introduction

1. R. Berndt, *Australian Aboriginal Art*, Methuen, Sydney, 1951, p. 87.

ENDNOTES

Oenpelli

1. M. West, *Rainbow, Sugarbag and Moon: Two Artists of the Stone Country—Bardayal Nadjamerrck and Mick Kubarrkku*, Museum & Art Gallery of the Northern Territory, Darwin, 1995, p. 10.

Maningrida

1. Conversations with the author, 1994–96.

2. Interview with the author, Maningrida, 1995.

3. D. Moon, in *Artlink*, special Aboriginal issue, Autumn/Winter 1988

4. Conversations with the author, 1994–96.

Ramingining

1. W. Caruana, *Aboriginal Art*, Thames & Hudson, London, 1993, p. 207.

2. V. Johnson, in *Copyrites: Aboriginal Art in the Age of Reproductive Technology*, Macquarie University, Sydney, 1996.

3. J. Ryan, *Spirit in Land: Paintings from Arnhem Land*, National Gallery of Victoria, Melbourne, 1991, p. 18.

4. W. Caruana, & N. Lendon, *The Painters of the Wagilag Sisters Story*, National Gallery of Australia, Canberra, 1997, p. 9.

Yirrkala

1. B. Luthi, *Aratjara: Art of the First Australians*,

Aboriginal Arts Board of the Australia Council.
Bernhard Luthi & Gary Lee, Germany, 1993, p. 69.

2. Ibid., p. 71.

3. Interview with the author, April 1995.

Bathurst Island

1. D. Conroy in 'Tiwi Designs: An Aboriginal silk
screening workshop', in R. Edwards, *Aboriginal Art
in Australia*, Ure Smith, Sydney, 1978, pp. 50–51.

2. Ibid., pp. 51–52.

3. K. Barnes, in 'Tiwi Designs', *Artlink*, special
Aboriginal issue, Autumn/Winter, 1988 (reprinted
1990).

Elcho

1. J. Ryan, *Spirit in Land: Paintings from Arnhem Land*,
National Gallery of Victoria, Melbourne, 1991,
pp. 10–11.

Ngukurr

1. S. McCulloch, *The Australian*, 15 July 1997, p. 5.

A Buyer's Guide

1. M. Neale, in S. McCulloch, 'The authentic
forgery', *The Australian*.

2. S. McCulloch, 'Black art scandal', *The Australian*,
8 Nov. 1997, pp. 1–3.

FRONT COVER: Photograph Penny Tweedie, Wildlight Agency, Sydney.

BACK COVER: Lin Onus, *Barmah Forest* (detail), 1994. Synthetic polymer paint on linen, 183 x 244 cm. Collection of the Australian Heritage Commission, Canberra. Reproduction courtesy Onus family and Viscopy.

p. 1 Lin Onus, *Dingoes, dingo proof fence*, 1989. Collection of NGA.

p. 2 Michael Nelson Jagamara, *Wild Yam*, 1998. Synthetic polymer paint on linen, 201 x 176 cm. Collection of Queensland Art Gallery.

p. 4 Enraeld Djulabinyanna, *Double-sided Tiwi Figure representing Bima's Friend*, c. 1955. Natural earth pigments and bush gum on carved softwood, height 51 cm. Lot 39, Sotheby's, 9 November 1997. Private collection. Courtesy Sotheby's auctions.

p. 5 Bob Burruwal, *Wulka-Fish at Bolkjdam*, 1997. Natural ochres on eucalyptus bombax ceiba, 215 x 15 x 10 cm. Private collection. Courtesy Gallery Gabrielle Pizzi, Melbourne.

pp. 12–13 Photo Grenville Turner, Wildlight Agency.

p. 14 Photograph Department of Tourism, NT.

p. 18 Anatjari Tjakamarra, *Kangaroo Rat Dreaming*, 1972. Synthetic polymer on paint on composition board, 66 x 57 cm. Collection of AGWA. Courtesy Sotheby's.

p. 19 Photograph courtesy WA Department of Tourism.

p. 20 Molly Napangardi, *Honey Ant Convergence*, 1986. Acrylic on tarpaulin, 284 x 230 cm. Collection NGV.

p. 21 Clifford Possum Tjapaltjarri, *Yuelamu Honey Ant Dreaming*, 1980. Synthetic polymer paint on canvas, 366.5 x 229.5 cm. Collection of AGSA.

p. 22 Charles Mountford, c. 1965, in *Nomads of the Desert*, plate 9, p. 60.

p. 23 Emily Kame Kngwarreye, *Untitled (Awelye)*, body paint design, 1994. Acrylic on polycotton, 90 x 60 cm. Private collection. Courtesy Utopia Art.

p. 25 Photograph Andrew Rankin, Wildlight Agency.

p. 31 Photograph Grenville Turner, Wildlight Agency.

p. 32 Rover Thomas, *Nyuk Nyuk The Owl*. Natural materials on canvas. Private collection. Courtesy Kimberley Fine Art.

p. 35 Mick Namarari Tjapaltjarri, *Bush Tucker Story*, 1972. Ochre and synthetic polymer on board. Lot 293, Sotheby's, June 1995. Courtesy Sotheby's.

p. 36 Photograph Mark Lang, Wildlight Agency.

p. 37 Alec Mingelmanganu, *Wandjina*, 1980. Earth pigments and natural binder on canvas, 122 x

SOURCES OF ILLUSTRATION

65 cm. Lot 128, Sotheby's, November 1997. Private collection. Courtesy Sotheby's.

p. 38 Photograph Grenville Turner, Wildlight Agency.

p. 39 George Milpurrurru, *Pythons with their eggs*, 1987. Ochres on bark, 158 x 77 cm. Collection of NGA.

p. 41 Various artists, *Bark Petition, Yirrkala*, 1963. Collection of Parliament of Australia.

p. 45 Yvonne Koolmatrie, *Eel Trap*, 1997. Official Australian representation Venice Biennale, 1997.

pp. 48–49 John Warangkula Tjupurrula, *Rain Dreaming*, 1972 (detail). Synthetic polymer paint on board. Collection of MAGNT.

p. 50 Photograph Philip Quirk, Wildlight Agency.

p. 52 Photo Baldwin Spencer and Frank Gillen, 1912.

p. 54 Mick Namarari Tjapaltjarri, *Bush Tucker Story*, 1971–72. Acrylic on composition board, 51.5. x 36 cm. Sotheby's, Lot 38, June 1996. Private collection.

p. 55 Photograph David Haigh. Courtesy Ernabella Arts.

p. 56 Ronnie Tjampitjinpa, *Untitled*, 1971–1972. Acrylic on composition board, 45.5 x 32 cm. Private collection. Courtesy Sotheby's Australia.

p. 57 Turkey Tolson Tjupurrula, *Straightening Spears at Ilyingaungau*, 1990. Synthetic polymer paint on canvas, 181.5 x 243.5 cm. Collection of AGSA.

p. 58 Billy Stockman Tjapaltjarri, *Wild Potato (Yala)*

Dreaming, 1971. Synthetic polymer powder paint on composition board. 54.5 x 46 cm. Sotheby's, June 1998. Private collection. Courtesy Sotheby's.

p. 62 Dorothy Napangardi, *Mina Mina Women's Dreaming*, 1998. Acrylic on canvas. 152 x 122 cm. Courtesy Aboriginal Gallery of Dreamings, Vic.

p. 65 Michael Jagamara Nelson, *Lightning*, 1998. Acrylic on canvas, 201 x 176.5 cm. Collection of QAG.

p. 66. *Kiwirrkura Women's Painting*, 1999. Acrylic on canvas, 257 x 257 cm. Courtesy Papunya Tula Artists, Alice Springs.

p. 66 Charlie Tararu Tjungurrayi. *An audience with the Queen*, 1989. Acrylic paint on canvas, 121 x 121 cm. Private collection. Courtesy Sotheby's.

p. 67 Naata Nungurrayi, *Untitled*, 2000. Acrylic on canvas, 122 x 122 cm. Private collection. Courtesy William Mora Gallery, Melbourne.

p. 68 Clifford Possum Tjapaltjarri, *Untitled (Bushfire Dreaming)*, c. 1986. Synthetic polymer on canvas, 170 x 255 cm. Private collection. Courtesy Lauraine Diggins Fine Art.

p. 69 Clifford Possum Tjapaltjarri, *Love Story*, 1972. Synthetic polymer/powder paint on board, 61 x 45 cm. Courtesy The Ebes Collection.

p. 70 Maggie Watson, *Jinti-parnta Jukurrpa (Native Truffle Dreaming)*, 1992. Synthetic polymer paint on canvas, 152 x 91 cm. Lot 130, Sotheby's, June 1996. Private collection. Courtesy Sotheby's.

p. 72 Paddy Japaljarri Stewart, *Puurdakurlu manu Wnalijikirli (Yam and Bush Tomato)*, 1984. Door 7, Yuendumu Doors. Collection of SA Museum.

p. 73 Paddy Japaljarri Sims, *Kunajarrayi Jukurrpa (Mount Nicker Dreaming)*, 1986. Synthetic polymer on canvas. 169 x 152.5 cm. Collection of AGWA.

p. 75 Various artists, *Ngarlu Jukurrpa*, 1993. Synthetic polymer paint on Belgian linen, 300 x 300 cm, Collection of AGWA.

p. 76 Darby Jampitjinpa Ross, *Ngapa Manu Yankirri Jukurrpa (Water and Emu Dreaming)*, 1989. Acrylic on canvas, 183 x 152.5 cm. Lot 102, Sotheby's, June 1996. Private collection. Courtesy, Sotheby's.

p. 78 Simon Tjakamarra, *Tingari Men at Pilintjinya*, 1985, synthetic polymer paint on canvas. 152 x 106.5. Lot 91, Sotheby's, June 1996. Private collection. Courtesy Sotheby's.

pp. 78–79 Donkeyman Lee Tjupurrula, *Tingari Dreaming at Walla Walla*, 1989. Synthetic polymer paint on canvas, 120 x 180 cm. Collection of NGV.

p. 80 Emily Kame Kngwarreye, *Alhalkere*, 1996. Acrylic on canvas, 106 x 120 cm. ID no. 106. Ebes Collection, Melbourne. Courtesy Hank Ebes.

p. 82 Ally Kemarre, *Untitled*, 1989. Batik on silk, 90 x 60 cm. Private collection. Courtesy Utopia Art.

p. 83 Photograph Andrew Rankin, Wildlight Agency.

p. 84 Billy Petyarre, *Dog*, 1996. Acrylic on hardwood. Private collection. Courtesy Utopia Art.

p. 85 Gloria Tamerre Petyarre, *Untitled (Leaves)*, 1995. Synthetic polymer on polyester, 200 x 130 cm. Private collection. Courtesy Utopia Art.

p. 86 Ada Bird Petyarre, *Awelye for the Mountain Devil Lizard*, 1994. Acrylic on canvas, 180 x 205 cm. Collection of AG of NSW.

p. 87 Minnie Pwerle, *Bush Melon*, 2000. Acrylic on canvas. 165 x 356.5 cm. Private collection. Courtesy Alison Kelly Gallery, Melbourne.

p. 87 Barbara Weir, *Grass Seed Dreaming* (2001).Acrylic on canvas.183 x 122 cm. Private collection. Courtesy Alison Kelly Gallery, Melbourne.

p. 88 Emily Kame Kngwarreye, *Alalgura (Alhalkere)—My Country*, 1991. Synthetic polymer paint on canvas, 152 x 122 cm. Lot 36, Sotheby's, August 1998. Private collection. Courtesy Sotheby's.

p. 89 Emily Kame Kngwarreye, *Untitled batik*, 1988. Private collection. Courtesy Utopia Art.

p. 90 Abie Jangala, *Falcon Dreaming*, 1987. Acrylic on canvas, 130 x 100 cm. Ebes Collection, Melbourne. Photograph Neil McLeod. Courtesy Hank Ebes.

p. 93 Lorna Fencer Napurrula, *Bush Potato*, 2000. Acrylic on canvas, 150 x 100 cm. Courtesy Alison Kelly Gallery, Melbourne.

p. 94 Angkuna Kulyuru, *Batik on silk*. Courtesy Ernabella Arts.

p. 96 Alison Carroll, *Earthenware Bowl*, 1977. Underglazed terracotta, diameter 310 mm. Private collection. Courtesy Ernabella Arts.

p. 97 Nyupaya, *Walka*, c. 1974. Acrylic on paper, 200 x 180 cm. Courtesy Ernabella Arts.

p. 98 Beryl Ngale Entata, *Hentye (Pink Galahs)*, 1995. Handcoiled terracotta, underglazes, glaze (interior), applied decoration, 30.5 x 19 cm. Collection of MAGNT. Courtesy Hermannsburg Potters.

pp. 100–101 Various artists, *The Cycle of Life: Amphibians and reptiles from the Hermmansburg Area*, 1994. Terracotta tiles, underglazes, applied decoration, 314 x 114 cm. Mural for the Taronga Park Zoo, Sydney. Courtesy Hermannsburg Potters.

p. 102 Gwen Mpetyane Inkamala, *Tyelpe (Quoll)*, 1996. Handcoiled terracotta, underglaze (interior), applied decoration, 17 x 14.5 cm. Collection MAGNT.

p. 103 Albert Namatjira, *Anthewerre*, c. 1955. Watercolour on paper, 24.5 x 35.2. cm. Collection NGA. Reproduced by permission of Legend Press.

p. 104 Long Tom Tjapanangka, *Ulampawarru*, 1996. Acrylic on canvas, 153 x 182 cm. Private collection. Courtesy Niagara Galleries.

pp. 106–107 Mitjili Napurrula, *Kulata Tjuta's spears from Uwalki (the artist's country south of Kintore)*, 1996. Acrylic on linen, 73 x 168 cm. Private collection. Courtesy Niagara Galleries

pp. 108–109 Charlie Numbulmoore, *Wandjina*, 1970. Ochres on bark, 111.5 x 71.5 cm. Collection NMA.

p. 110 Photograph Mark Lang, Wildlight Agency.

p. 112 Photograph Tony Ellwood.

p. 113 Madigan Thomas, *Untitled*, 1997. Natural ochres on canvas. Courtesy Kimberley Art.

p. 114 Miliga Napaltjarri, *Purrunga*, 1991. Acrylic on canvas, 100 x 50 cm. Lot 162, Sotheby's, June 1996. Private collection. Courtesy Sotheby's.

p. 116 Jack Britten, *Purnululu (The Bunge Bungle Ranges)*, 1996. Natural ochre on canvas. Courtesy Kimberley Art, Melbourne.

p. 116 Photograph Grenville Turner, Wildlight Agency.

p. 119 Paddy Jaminji & Rover Thomas, *The Spirits Jimpi & Manginta*, 1983. Natural pigments on plywood, 120 x 60 cm. Collection of NGA.

p. 120 Patrick Mung-Mung, *Ngarrgooroon Country (Bream Gorge)*, 2001. Ochres on canvas. 120 x 180 cm. Private collection. Courtesy Warmun Arts Centre, WA.

p. 121 Queenie McKenzie, *Three massacres and the Rover Thomas story*, 1996. Natural ochres on canvas. Private collection. Courtesy William Mora Galleries, Vic.

p. 122 Lena Nyadbi, *Jimbala Ngarrankgkani (Spearhead Dreaming)*, 2001. Ochres on canvas. 200 x 140 cm. Private collection. Courtesy Warmun Arts Centre, WA.

p. 122 Alan Griffiths, *Boornooloobun Cave*, 2001. Natural pigments on canvas. 120 x 90 cm. Private collection. Courtesy Red Rock Art, Kununurra.

p. 123 Billy Thomas, *Sandhills in the Great Sandy Desert*, 2001. Natural pigments on canvas. 80 x 60 cm. Private collection. Courtesy Red Rock Art, Kununurra.

p. 124 Rover Thomas, *Ruby Plains Killing*, 1990. Ochres on canvas. Private collection. Courtesy Kimberley Art.

p. 125 Rover Thomas, *Cyclone Tracy*, 1995. Natural pigment with acrylic binder on linen, 90 x 120 cm. Private collection. Courtesy Utopia Art, Sydney.

p. 126 Lily Karedada, *Wandjina*, 1990. Ochres on canvas, 110 x 70 cm. Collection of NGV.

p. 128 Artist unknown, *Untitled Spirit Figures*, 1960. Ochres on bark, 60 x 34 cm. Lot 87, Sotheby's, Nov 1998. Private collection. Courtesy Sotheby's.

p. 129 Bobyin Nongah, *Kungmanggur Story (Spider and Snakes)*, pre-1963. Natural earth pigments on eucalyptus bark, 71 x 21.5 cm. Lot 66, Sotheby's, June 1998. Private collection. Courtesy Sotheby's.

p. 129 Artists unknown, *Group of carved and decorated pearl shells surrounding a glass spear point (c. 1940–1950s)*. Lots 141–144, Sotheby's, November 1998. Private collection. Courtesy Sotheby's.

p. 130 Eubena Nampitjin, *Untitled*, 1992. Acrylic on canvas, 180 x 120 cm. Private collection.

p. 131 Photograph Philip Quirk, Wildlight Agency.

p. 132 Bai Bai Napangati, *Hair String Dreaming at Yimurr*, 1992. Synthetic polymer paint on canvas, 60 x 120 cm. Lot 165, Sotheby's, June 1996. Private collection. Courtesy Sotheby's.

p. 134 Donkeyman Lee Tjupurrula, *Tingari Dreaming at Tarkun*, 1990. Polymer paint on canvas, 180 x 120 cm. Lot 169, Sotheby's, June 1996. Private collection. Courtesy Sotheby's.

p. 135 Elizabeth Nyumi, *Parwalla*, 2001. Acrylic on canvas. 120 x 80 cm. Private collection. Courtesy Warlayirti Arts Centre, Balgo Hills.

p. 136 Jarinyanu David Downs, *Moses Belting the Rock in the Desert*, 1989. Ochres and synthetic polymer on linen, 152 x 106 cm. The Holmes à Court Collection.

p. 138 Stumpy Brown, *Untitled*, 1994. Watercolour on paper. Courtesy Kimberley Art.

p. 139 Daisy Andrews, *Lumpu-Lumpu*, 1994. Watercolour on paper. Courtesy Mangkaja Arts.

p. 140 Jimmy Pike, *Jumu Yirrjin*, 1991. Colour screenprint. Edition 95, 42.2 x 59.5 cm.

p. 141 Jimmy Pike, *Pirnini Country 1*, 1987. Screenprint, edition 75, 32.5 x 31.8 cm.

pp. 142–143 Djambu Barra Barra, *Cypress Pine Mortuary Rite* (detail), 1994. Acrylic on canvas. Private collection. Courtesy Alcaston Gallery.

p. 144 Photograph Tom Keating, Wildlight Agency.

p. 147 Photograph Carolyn Jones, Wildlight Agency.

p. 148 Peter Marralwanga, *Djirbaykbaykk, the snake man, Kawalan, the Goanna, and a woman*, c. 1975. Ochres on eucalyptus bark, 97.5 x 52 cm. Collection of NGA.

p. 151 Yirawala, *Luma Luma and Wind Mimi*, 1971. Ochres on bark, 70 x 30.5 cm. Lot 56, Sotheby's, June 1998. Private collection. Courtesy Sotheby's.

p. 152 Photograph Verity Chambers.

p. 155 Mathaman Marika, *Morning Star Myth*, late 1950s. Ochres on bark, 172 x 42 cm. Lot 26, Sotheby's, June 1996. Private collection. Courtesy Sotheby's.

p. 156 Gabriel Maralngurra, *Freshwater Croc & Black Bream*, 1994. Natural pigments on paper, 56 x 76 cm. Courtesy Axia Gallery, Melbourne.

p. 158 Mick Kubarkku, *Namarrkon, the Lightning Spirit*,

1991. Natural pigments on paper, 75 x 104 cm. Private collection.

p. 159 Crusoe Kuningbal, *Morkuy Figures*, c. 1970s. Ochres on bark, 103.5 x 48 cm. Lot 61, Sotheby's, June 1996. Private collection. Courtesy Sotheby's.

p. 160 Jack Wunuwun, *Banumbirr, the Morning Star*, 1987. Ochres on eucalyptus bark, 178 x 125 cm. Collection of NGA.

p. 162 Baku Ray, *Hollow Log Coffin*, late 1950s. Ochres on carved log, h. 66 cm. Lot 20, Sotheby's, November 1997. Private collection. Courtesy Sotheby's.

p. 163 John Mawurndjul, *Ngalyod and the Yawk Yawk girls*, 1980. Ochres on eucalyptus bark, 124.5 x 77.5 cm. Collection of NGA.

p. 164 John Bulun Bulun, *Mortuary Story*, 1982. Ochre on bark, 111 x 97.1 cm. Collection MAGNT.

p. 165 Bob Burruwal, *Walka-Fish at Bolkjdam*, 1997. Ochres on eucalyptus bark, 215 x 15 x 10 cm. Private collection. Courtesy Gallery Gabrielle Pizzi, Vic.

p. 166 George Milpurrurru, *Guramati Magpie Geese and Water Python*, 1987. Ochres on eucalyptus bark, 158 x 77 cm. Collection of NGA.

p. 167 Photograph Philip Quirk, Wildlight Agency.

p. 169 Various artists, *The Aboriginal Memorial, 200 hollow log coffins*, 1988. Natural pigments on wood. Collection of NGA.

p. 170 Philip Gudthaykudthay, *Witij, olive python*, 1984. Ochres on bark, 123 x 81 cm. Collection NGA.

p. 172 Dawidi, *The Wagilag Story*, 1967. Natural earth pigments on eucalyptus bark, 109 x 54 cm. Lot 107, Sotheby's, June 1996. Private collection.

p. 173 Dawidi, Nguja, *Feathered head ornament*, 1965. Feathers, wood, resin, natural pigments, 26 x 10 x 3 cm. Collection of NMA. Courtesy Sotheby's.

p. 174 Naritjin Maymura, *Aspects of the Napilingi Myth*, c. 1965. Ochres on bark. Lot 423, Sotheby's, November 1995. Private collection. Courtesy Sotheby's.

p. 177 Yanggarriny Wunungmurra, *Gangan*, 1997. Ochres on bark, 299 x 97.5 cm. Collection of MAGNT.

p. 179 Photograph Grenville Turner, Wildlight Agency.

p. 180 Mani Luki (Harry Carpenter Wommmatakimmi),

Purukapali and Bima, c. 1962. Enamel paint on carved hardboard, height 360 cm. Enamel paint on carved hardwood, height 180 cm. Lot 74, Sotheby's, November 1997. Private collection. Courtesy Sotheby's.

p. 181 Various artists, *Group of Tiwi Spears*. Carved ironwood, 99–101 cm. Lots 55–58 & 66, Sotheby's November 1997. Private collection. Courtesy Sotheby's.

pp. 182–183 Various artists, *Pukumani Grave Posts*, 1958. Snake Bay, Melville Island. Natural pigments on ironwood, various sizes from 147.3 x 29.9 x 254 x 33 cm. Collection of AG of NSW.

p. 184 Fiona Puruntatameri, *Jungle Fowl*, 1996. Acrylic on paper. Private collection. Courtesy of Munupi Arts.

p. 185 Various artists, *Untitled*, 1996. Ochre on cotton duck, 88 x 190 cm. Private collection. Courtesy Alcaston Gallery.

p. 186 Photograph Tommy Chandler. Courtesy Department of Tourism, NT.

p. 190 Mick Daypurryun, *Djang'kawu ancestral landscape*, 1982. Ochres on eucalyptus bark, 127 x 57 cm. Collection of NGA.

p. 192 Djawa I, *Mangrove Crabs*, 1978. Ochre on bark, 118.5 x 49 cm irregular. Collection MAGNT.

p. 193 Mandjuwi, *Morning Star Poles*, 1979. String, feathers, ochre on wood, 102 x 5 x 5 cm. Collection of MAGNT.

p. 194 Djambu Barra Barra, *Cypress Pine Mortuary Rite*, 1994. Acrylic on canvas. Courtesy Alcaston Gallery.

p. 197 Willie Gudabi (deceased), *Alawa story*, 1995. Acrylic on board, 250 cm x 150 cm. Courtesy Alcaston Gallery.

p. 198 Ginger Riley, *Garimala, wet season*, 1990. Synthetic polymer on canvas, 126 x 176 cm. Courtesy Alcaston Gallery.

p. 199 Ginger Riley, *Nyuk Nyuk in Limmen Bight Country*, 1944. 120 x 140 cm. Courtesy Alcaston Gallery.

pp. 200–201 Rosella Namok, *Raining Down at Aangkum*, 2001. Acrylic on canvas. 200 x 184 cm. Private collection. Courtesy Andrew Baker Art Dealer, Brisbane.

p. 202 Ian Abdulla, *Night Boxing*, 1991. Acrylic on canvas, 81 x 122 cm. Courtesy Gallery Gabrielle Pizzi.

p. 203 William Barak, *Ceremony*, 1895. Natural pigments, charcoal and pencil on linen, 60 x 75 cm. Lot 103, Sotheby's, November 1998. Private collection. Courtesy Sotheby's.

p. 205 Trevor Nickolls, *Uluru Dreaming Three*, 1993. Acrylic on canvas, 76 x 60.5 cm. Courtesy Gallery Gabrielle Pizzi, Melbourne.

p. 206 Ellen Jose, *Life in the balance*, 1993. Mixed media, 260 x 170 x 120 cm. Collection of AG of NSW.

p. 207 Leah King-Smith, *#17 from Over the Garden Wall Series*, 1995. Cibachrome photograph, 77 x 105 cm. Courtesy Gallery Gabrielle Pizzi, Melbourne.

p. 209 Tjarpartji Bates, *Tjukurrpa Kungkarangalpa*, 1997. Slumped glass panel, 200 x 120 x 10 cm.

p. 210 Rea, *for 100% Koori (Rea-probe Series)*, 1998. Photographic triptych. Private collection.

p. 212 Photograph News Limited.

p. 213 Lin Onus, *Fruit Bats*, 1991. 100 fibreglass polychrome bats, Hills hoist, polychromed wooden disks, 250 x 250 x 250 cm. Collection of AG of NSW.

p. 214 Samantha Hobson, *Bust 'im up*, 2000. Acrylic on canvas. 133 x 104 cm. Collection NGV. Courtesy Lockhart River Art and Culture.

p. 214 Fiona Oomenyeo, *Two parrot sisters flying up to high country*, 2001. 92 x 132 cm. Private collection. Courtesy Lockhart River Art and Culture.

p. 216 Photo courtesy Geoff Barker, Lockhart River Art and Culture.

p. 217 Rosella Namok, *Yiipay and Kungkay*, 2001. Acrylic on canvas. 300 x 172 cm. Private collection. Courtesy Lockhart River Art and Culture.

p. 218 Photograph Andrew Rankin, Wildlight Agency.

p. 223 Photograph Carolyn Johns, Wildlight Agency.

INDEX

244